C.A.L.M.

Crimes Against Love Memories

C.A.L.M.
Crimes Against Love Memories

Jehnny Beth & Johnny Hostile

Published by White Rabbit

WHITE
RABBIT

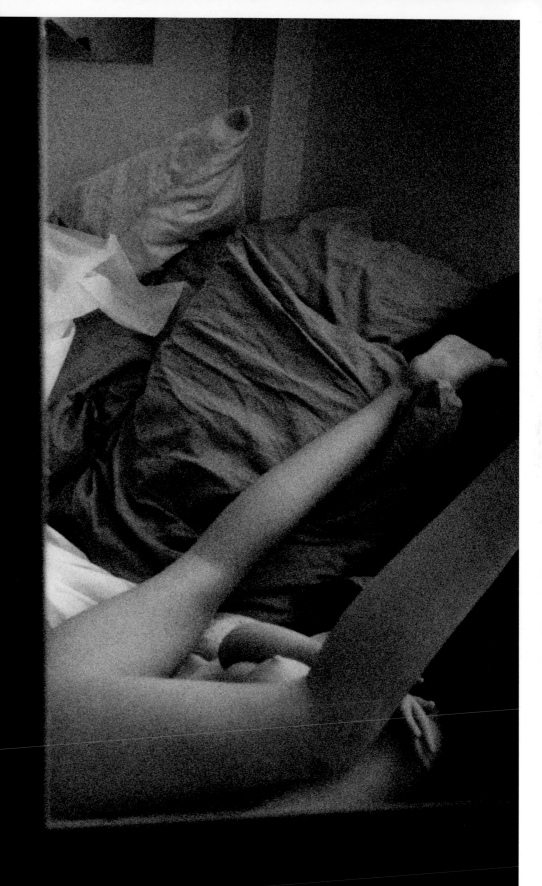

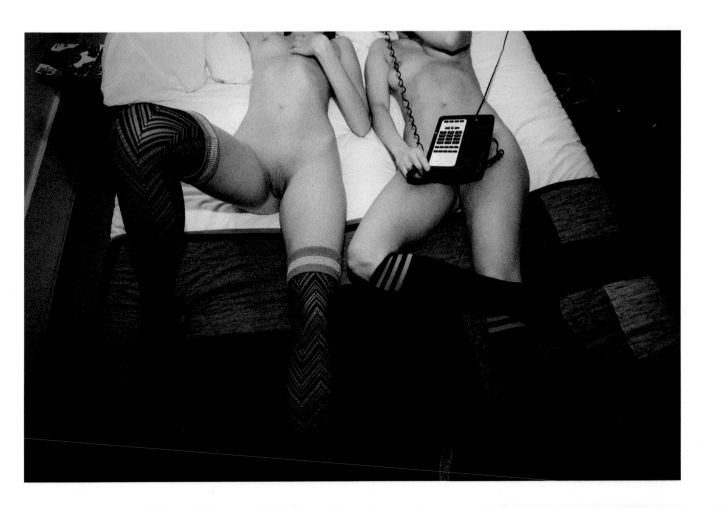

3

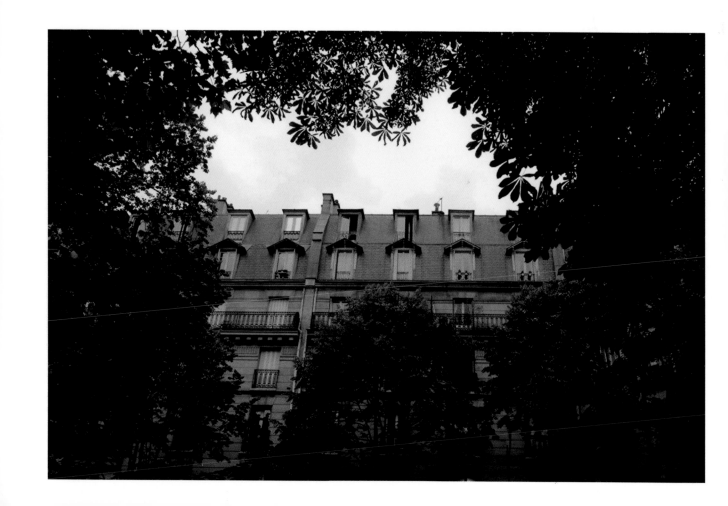

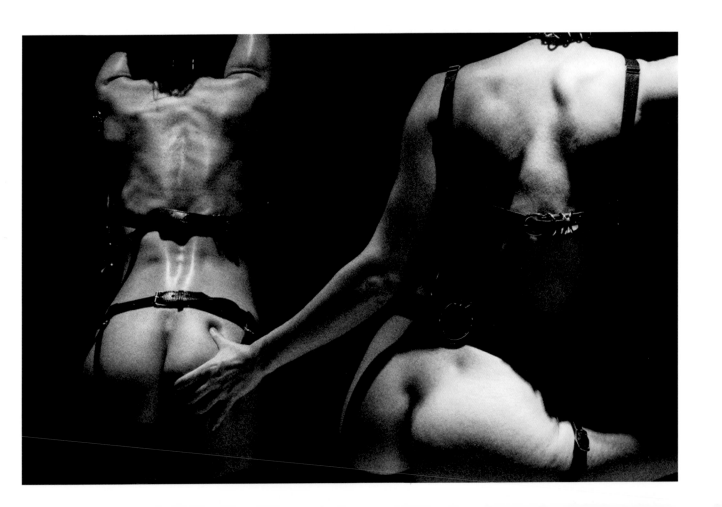

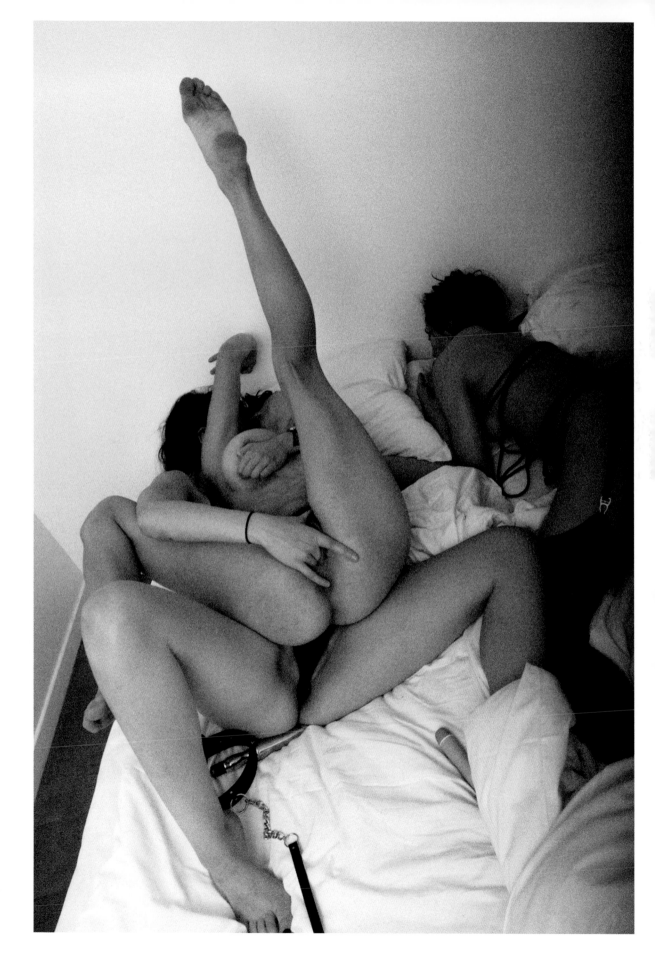

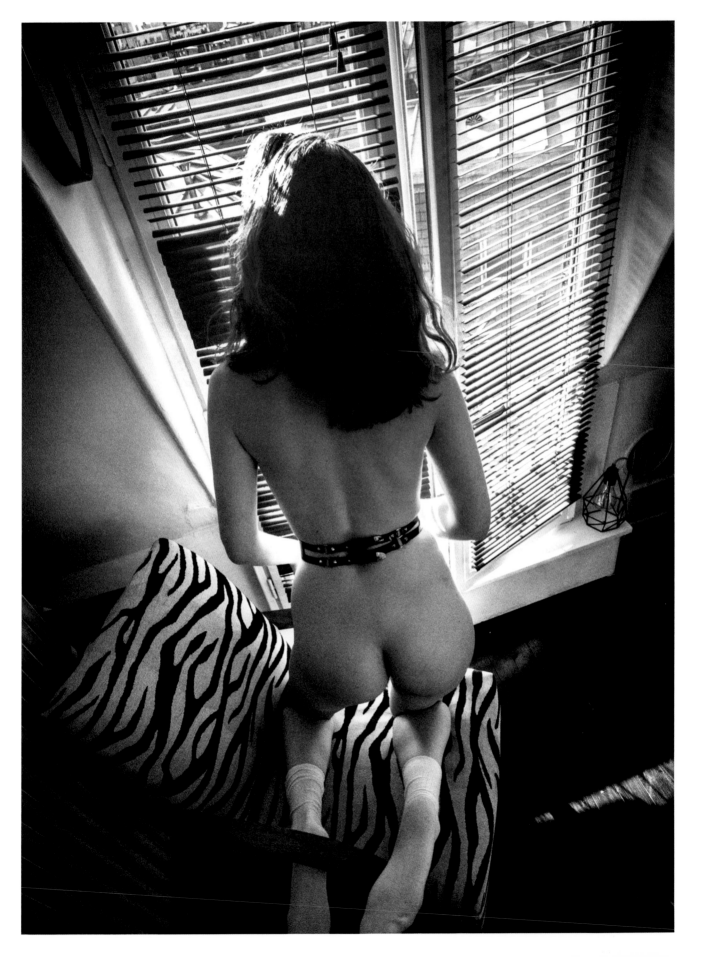

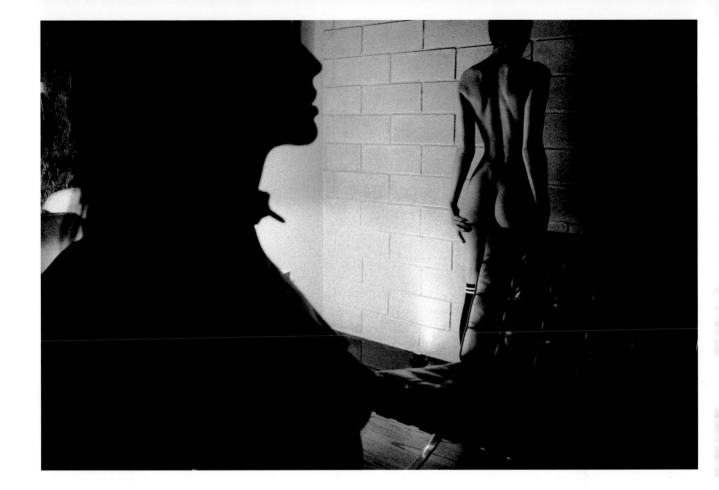

7

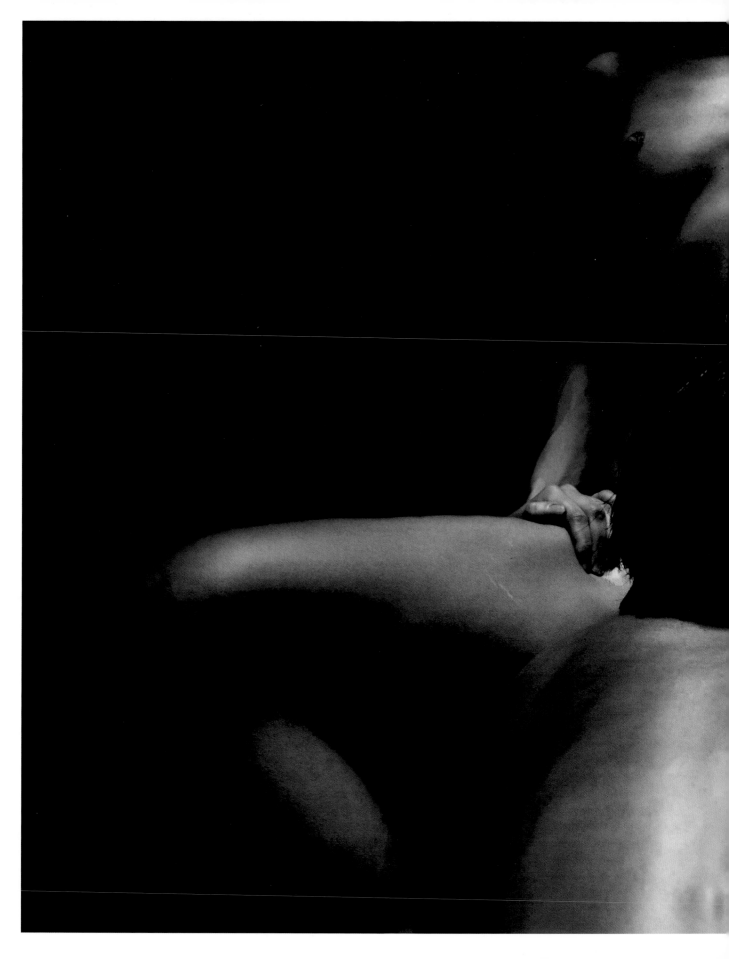

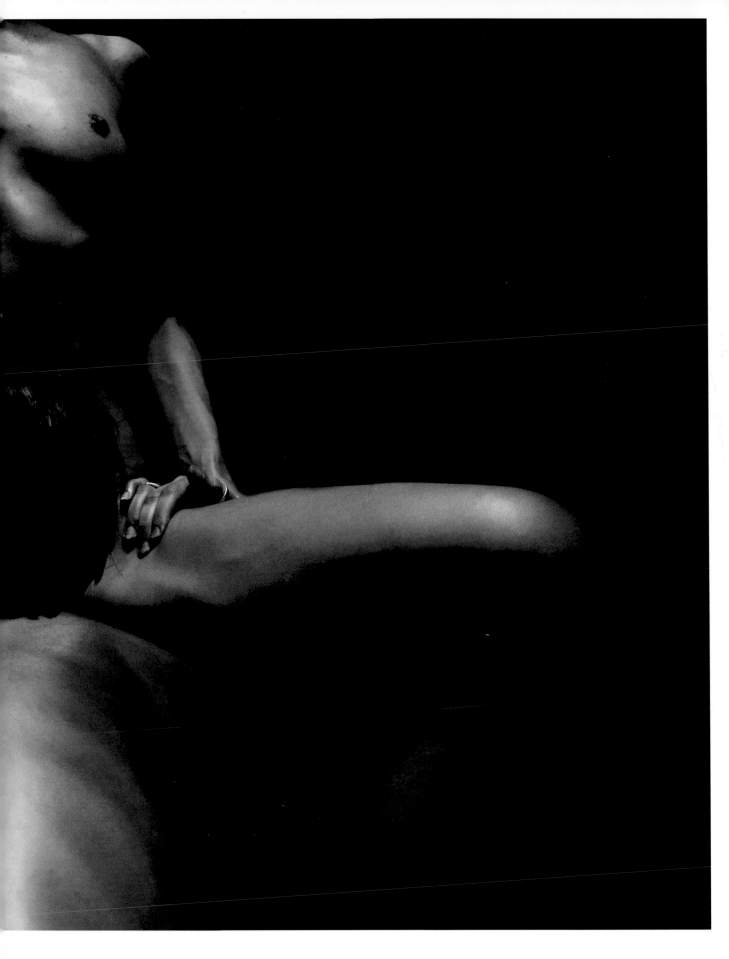

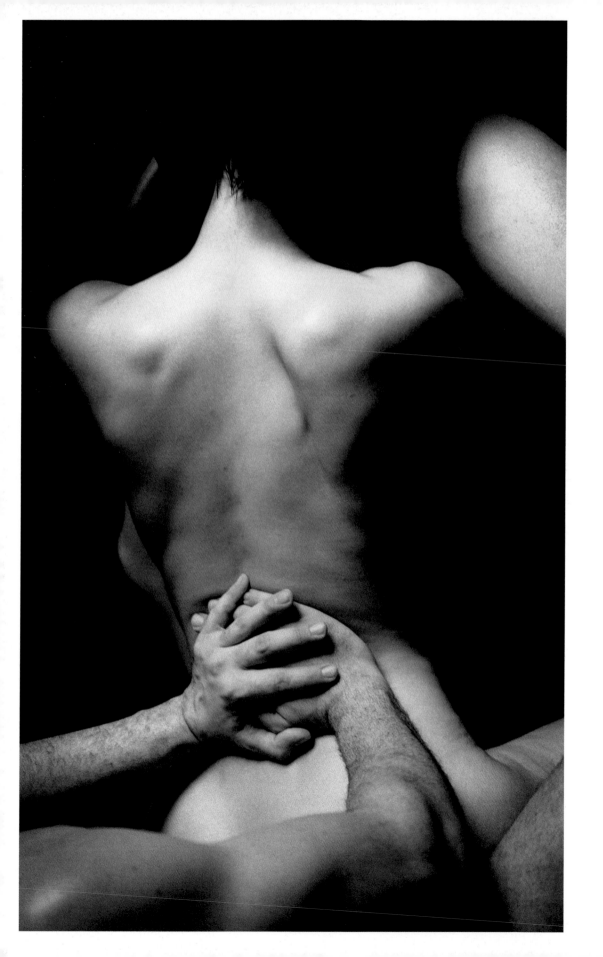

10

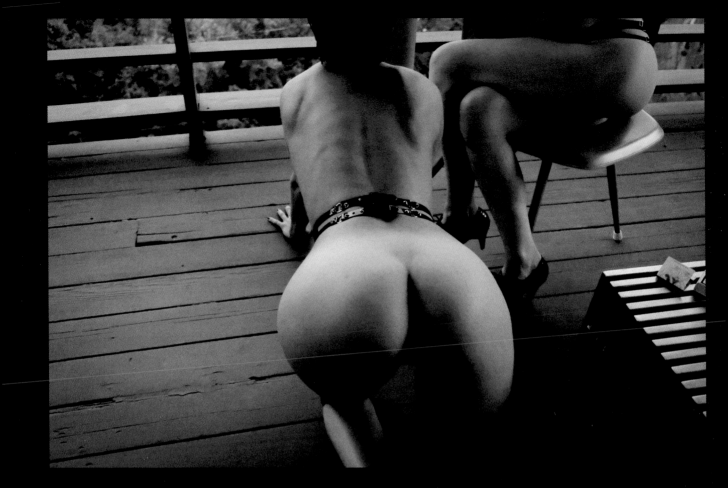

11

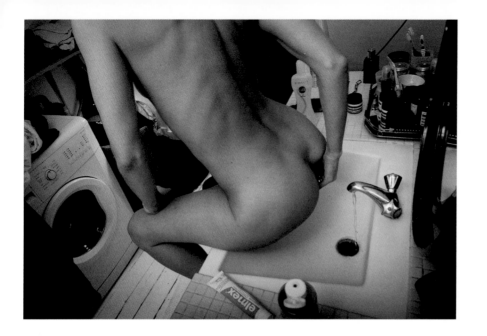

12

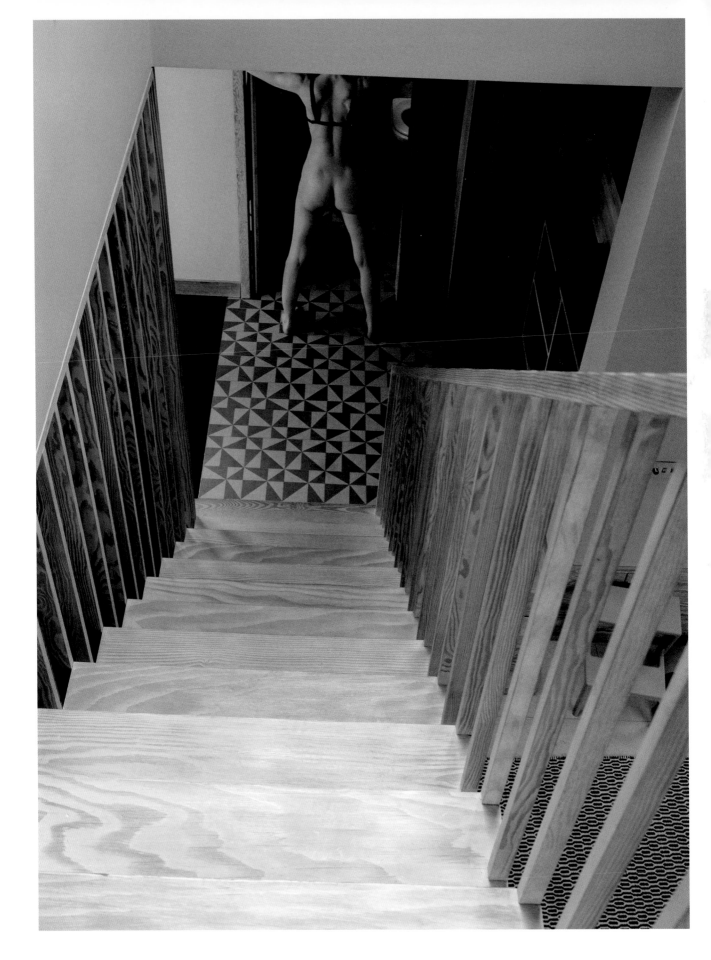

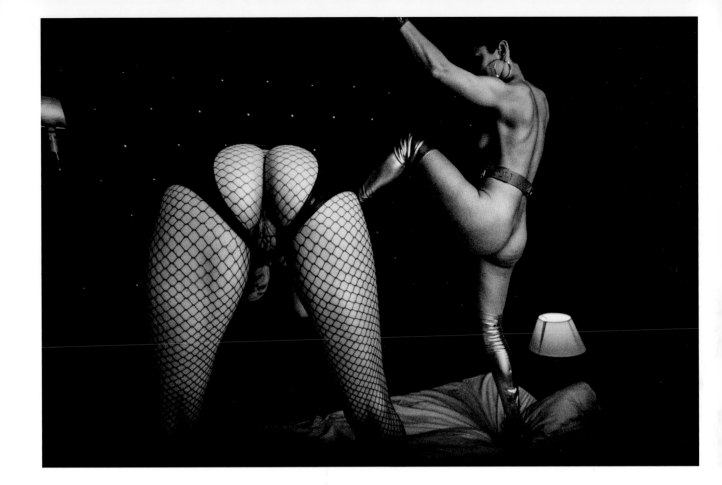

15

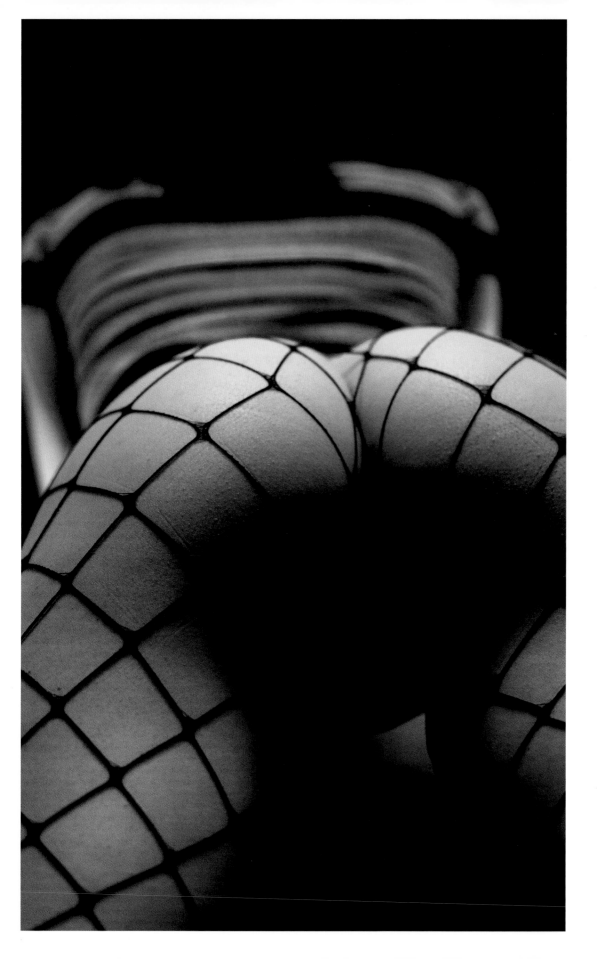

1

I am young and everyone's opinion about love strangles me like death. The doctors say it's normal and non life-threatening but I told them that if there was anything normal about me I wouldn't feel so uncomfortable all the time. I have been taken by fits of panic whenever I have felt the rings of romance encircle me, an extreme pressure on my throat as if the devil's hands came to force on me an important message that I could not understand. What the doctors saw in my eyes but didn't want to name, is the truth that dwells inside everyone of us, the things that we run from, madness, fear, obsessions ... Oh I will not sleep tonight. Too much pain and questioning. I will go out. I love the night and the big city, where all is false and incandescent. I want to pull down my panties and start to sing. Why not? There's nothing else to do in this world except burn.

2

I have never felt comfortable with the standards of romanticism imposed on relationships. Things that are considered important, that most people refer to as normal, the restrictions of what society has imagined for us, are toxic to me. I have seen too many friends shy away from the rewards of their own imagination. In public, they talk about the importance of freedom, pleasure and mutual respect, but the reality is that their joy is cheap, drips of love falling on big carpets of guilt. This is the real power: imagination. We must shape the world into our own desires, put our fantasies into action. Make it our superpower. I see everywhere the erection of buildings, I want to see the erection of my dreams. Reality is mine to sculpt like fingers in a fresh block of clay.

I asked a man to come to my address and sit on a bench in the park in front of my building. He didn't know I lived there, nor that I could see him from my bedroom window. Walking up my street, entering the little park, he sat on a bench as requested and looked around in the hope of finding me. I grabbed my pair of binoculars to take a closer look at his body. I felt aroused by his impatience, watching him not knowing what to do. I felt the extension of time passing drip by drip, like warm sand between my fingertips. I imagined the interpenetration of the universe within me and the universe within him, nothing separating us anymore. For him it was hell, his mind spiralling downwards in circles, the object of desire far away. For me it was ecstasy. I was bumping against him within myself.

After a few minutes, I stepped through the open window. When he looked up by chance and guessed my silhouette, I saw his body change position, gliding towards an infinite calm, free from the unknown that previously enchained it. Still looking at him with my binoculars I took off my dress, offering myself to the wind. My naked presence at the window was a gay suicide, the space between my legs opened like a coffin. The man stood up and looked around to see who else was enjoying the show. I burst with laughter thinking the universe was made from little hopes like this.

I had shut all the inside doors of my apartment so it was now essentially a black corridor. I was waiting for the man inside this dark rectangle of light, suspended in space, ready to push outside the possible. When I let him in, his body seemed more fragile, trembling from head to toe, there was madness in his hands as he stripped down naked. Next to his clothes on the floor we slid down on our knees, I felt his bare foot against my stomach, sudden gusts of pleasure in which I vanished and laughed at this insane hour. My corridor was moving, it became the heartbeat hanging below my ribcage, suspended above the city where we spiralled into oblivion. He left soon after, omitting to mention his name.

4

I long ago abandoned the debates about love and integrity. Which one is the parody, love or non-love? Is love the coward that does not love, or non-love the deserter? I am attracted to the purple dick, the naked woman, forces that keep pushing me into the dark. Everyone lies in the presence of love.

5

I met a woman at a bar who gave me three options: 1/ leave now and never hear from her again 2/ follow her to her apartment 3/ wait at the bar ten minutes and meet her at the address written on a piece of paper. Her hands behind her head, her face marvellously mysterious, she spoke with laughter, shyly with confidence, as if anything was good enough to precipitate her mockery. I took my time to respond. I thought this could be the last choice I take, my heart made a hiccup. I agreed to wait ten minutes and meet her at the address. It seemed the riskiest choice and I wanted to impress her. She laughed and left. I drank from my glass alone in silence and after ten minutes I exited the bar to walk in the right direction. The streets were cold and wet. I met no one until I found myself in front of the building.

Stepping into the elevator which took ages to rise, awaiting the disaster, the lights going out, I felt the cold of the night shrinking underneath my coat. The door of the apartment had been left open. I heard a blank voice say "come in", before I walked into a dark entrance. The voice asked me to close the door, drop my things, keep my heels, my underwear, and join. While I executed my orders I heard the sound of troubled chains rattling against metal, doubled with female moans. I couldn't see anything pass the darkness of the entrance. My body was cold and I felt a discomfort that made me sweat, like entering a theatre seconds before the actors start to play. I was listening to the sounds coming from the next room, happy with the strangeness of their cries, their anonymity gripping my bones.

A young woman, whose eyes were mad-open, was battling with chains on a metal chair. A rope fastened around her head was parting the two rows of her naked teeth. In a long muffled scream – such a scream had never pierced me before – she propelled her body towards me while I entered the room, calm, as a sacrificial animal who had rehearsed her part for the final ceremony. The feeling of an inevitable carnage from which nothing could save me now suddenly seized the whole surface of my skin. It seemed to me that the feeling was amplified by a word but that word exited my brain as soon as it entered it. It was accompanied by a perceptible movement: me walking to the middle of the room, standing in between these two women I knew nothing about. It felt impossible to choose my next action, as if an invisible force was telling me to leave, while a terrible desire was pushing me to seize my chance. My body was tense, exhausted by the sound of chains behind me. As I was staring into the dark, a new word – sharp like the cold of metal – echoed in the room. I could see nothing in the room but the room was seeing me.

Free from the thunder of the first steps, I felt the horns of joy burning my groin and forehead. In the infinite depth of the dark room formed some strange abstractions, objects of my desire, debris of my imagination, hiccups of ideas I would never have dared entertain before, reached me, crushed me, made me blind. Stupid, dripping with fear, I wasn't "me" anymore, still mortal, but bound to the fire of the belly who had engendered me, the roller coaster of life and death. In between my breasts I felt the blade of a knife, in between my legs the tongue of a viper, my assassin was free and I had willingly surrendered myself to become her captive.

Belly open, besieged, transparent, I said the words that were given to me, as part of the ritual to surrender myself: "All the way to the tears, all the way to the absence of hope, all the way to the whistle of death". The words were indocile, their number, their significance, betrayed the person I once was but could no longer reach. I did not laugh anymore. Nothing I saw was familiar.

In my hand I felt the hideous caress of a swamp, the tongue of the woman who had freed herself from her long chained nudity was licking my palm, soiling it with her lips. I saw the reflection of myself inverted in her eyes asking where I had been, saying "I missed you" with charity, but I, who had never seen her before, asked myself who she was. Soon I felt it, the teeth of the madwoman on my skin, a trickle of blood mixed with her saliva, bathing my hand. The purity of her execution, her shameless stare, were astonishing. I couldn't flee, bound by the oath I had proclaimed.

Abandoned in my head, my cries where shockingly loud and my pain lonely as the desert. As I grovelled in order to annihilate myself beneath these two women who kissed and stood gigantic in their marvellous nudity, I found my resistance to pain close to zero. With each bite, each spank, through my tears I could foresee my death. My distress made me nauseous. I was certain that my suffering would kill me, my desire resting like sobs on their feet. It was time for me to start loving death.

All the way to the tears, all the way to the absence of hope, all the way to the whistle of death.

"Enough I am tired." I said. "Enough I love you, sweet death, rest in my arms. Enough we are drunk, sobs have drowned the threshold of my pain. Enough I wish I were dead, instead of love making me agonise. Listen underneath my veins, the insistence of my life. Enough the bites, enough blood and tears and sweat, I want to see the stars, open your windows, let me feel the fresh air! Enough deformed mirrors and inverted reflections of myself. It is time to love the night, time to lick her wounds, it is time to feel the softness of her sheets, like the softness of water, it is time to sleep and dream of the beautiful morning sun."

6

The world will not possess me, I will possess the world. Not by hand – like the generals and emperors who have killed to overrule a fraction of the universe – but with

the power of my imagination. Admire the picture of the world on the canvass of my grotesque psyche: policemen with permanent erections, priests cuming in their cassocks ... I, born a woman, declared incurable by the doctors (for who does not understand the illness can not find the cure), will paint the contours of my sexual urges. Sex: I will imagine it, make plans for it, take great pleasure while doing it. What else there is to do with it?

7

A man came to my apartment to perform on me an hour of anal penetration. I waited for him in my living room with my face on the floor and my ass up to the ceiling. I never saw his face (he wore a mask) and I asked him to speak in Spanish – a language I understand enough without the intrusion of background stereotypes and origin. I found excitement in his anonymity, thinking about the probabilities of seating next to him in the underground train months after our meeting, unaware of his presence, while he, having recognised me, would think about the openness of my naked legs made soft like water by his heavy tongue. The night he came to my apartment, my anus hung lonely and docile like a silver empty tray. My intention was to make it sob with saliva so with the rosy head of his tongue, he would drink from the gash. Oh what an hour I have endured, burning like the sun. He left no seconds untouched, switching my behind to the foreground, opening it like a mouth into the shape of a marvellous star, mad devourer of skies! Measuring time with precision on his masculine watch, sixty minutes exactly, not one more, he left suddenly with the airiness of a ghost. I never saw him again.

8

Lara entered my corridor with her eyes blindfolded. She kissed every phalluses in the room including mine, a silicone purple horn poking out of a leather strap. Her and I were the only women in the room and my admiration for her went beyond everything. Even when she was standing still her lust made her tremble. She threw herself into the motions with the hunger of someone who has nowhere to

hide and no intention to run away. She seemed protected, present but inviolable, like a sailor who knows she is alone with the elements, the cold, the wind, her body and her strength. She was the youngest in the room and yet the most brave. She trusted without arrogance that her single body was the only thing in the universe that would give her the best time of her life.

I took Lara to the theatre. We sat in a box and chatted until the lights went down. Once in the dark, her attitude changed from timid to bold. Synchronising with the heavy curtains onstage she slid her hand inside my pants to part my two red lips. Members of the audience sat unaware, I fixed the back of their hair while holding myself to the wooden balcony. Lara knew when to slow down during an important dialogue so that I was able to follow the plot of the play, but when the actors ran and the music indicated a transition, cruel and sudden, she would rub my slit hard and turn my lust into ashes. "Must I give up" I told myself just before water ran down my hips. Lara stopped to smell her hand and say "I think this is not pee". Unstoppable, she did the same thing twice, and twice again, thinking we were safe – insanity! – until there in the dark a face turned back with the awkward look and screeching whispers. Lara, who did not care, continued her illicit work urgently, profoundly moved by it. She made me flood my chair again with the pressure of her fingertips, until we both filled the heavens with laughter like two idiots who felt safe and hold back nothing.

9

I wish the world opened like the mouth of Lara. I wish the world peed on my naked thighs and the trail of yellow liquid led me to a crypt where I could lay down with fatigue and vomit the earth, and cry. I wish the flaming ruby head of my wet behind, shiny by too much sipping, could alter the conscience of every man and woman and make it understand, more politeness, less terror, end the labours of birth and exorcise the too many wrongdoings. I wish all the pain that I chose to welcome into my life wasn't for nothing, could help someone, could change

something. My heart wrapped in lace plunged in a bath of perfume, came back to me free of its impurities, free of love, at last, free of everything.

10

Because a life lived in fear is equal to no life at all, I won't gamble my life on the fickle world of 'what will they think' and wake up one day thinking I have wasted the wonderful fact of my own existence. I won't worry about fear, jealousy, solitude, the system that weights duty against desire and pronounces desire the loser. They're all byproducts of love, unavoidable obstacles implanted in my core by generations of parents, grandparents and all the people who fall in love and yet are unhappy, and who blaming themselves for having lived too timidly will attack me for having dared. I live on the other side of their wall, I break through their rules of loving, searching for my own alternative ways, no matter the morals agreed collectively, the prudishness and punishments, the accepted forms of loving, family, monogamy, and far too much imprisonment. In secret, in the safety of my apartment, inside my head, I will create a space where they don't belong. A place where I am free. My neighbours won't know about it, my family won't know about it, and those who think they can be part of it but haven't made the sacrifice, are not welcome. There, I will practise my secret rituals with those who like me have defeated their fears, days and nights, out of sight and silently.

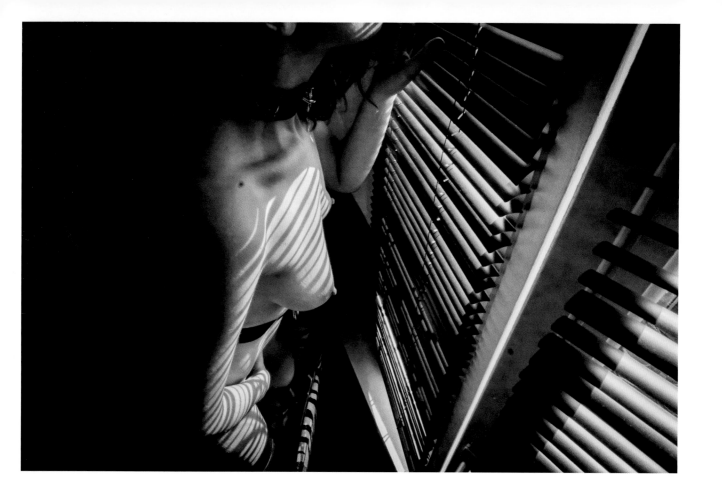

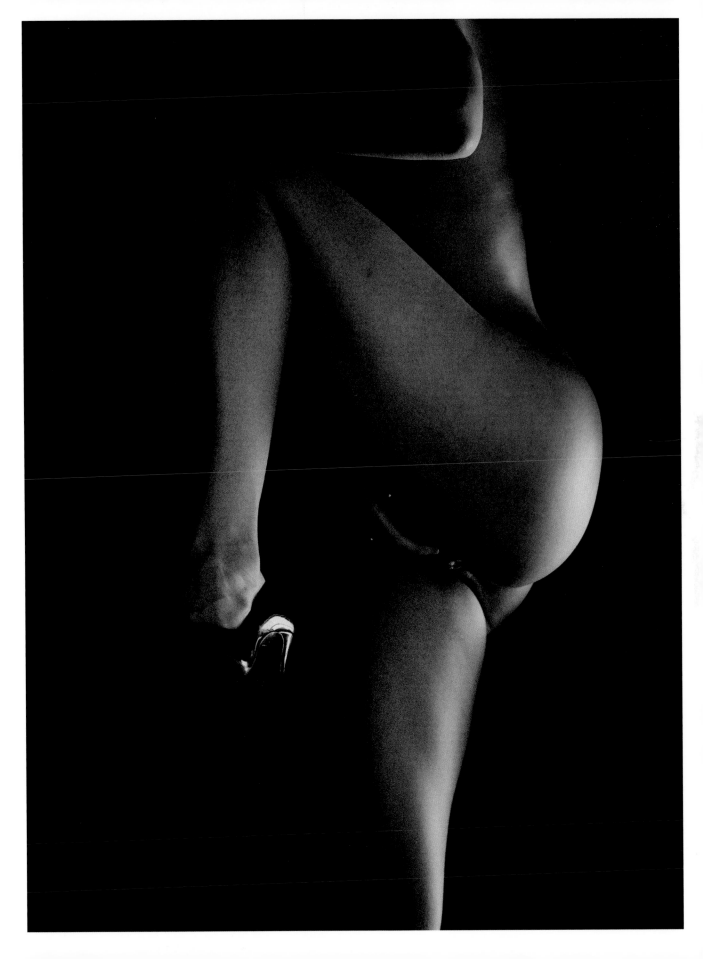

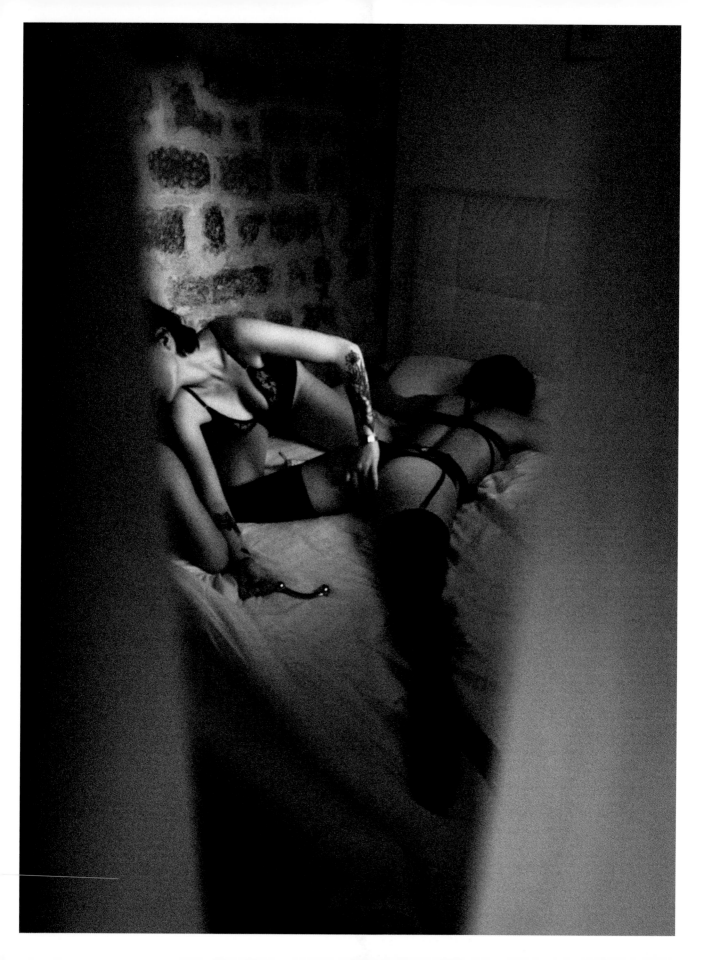

29

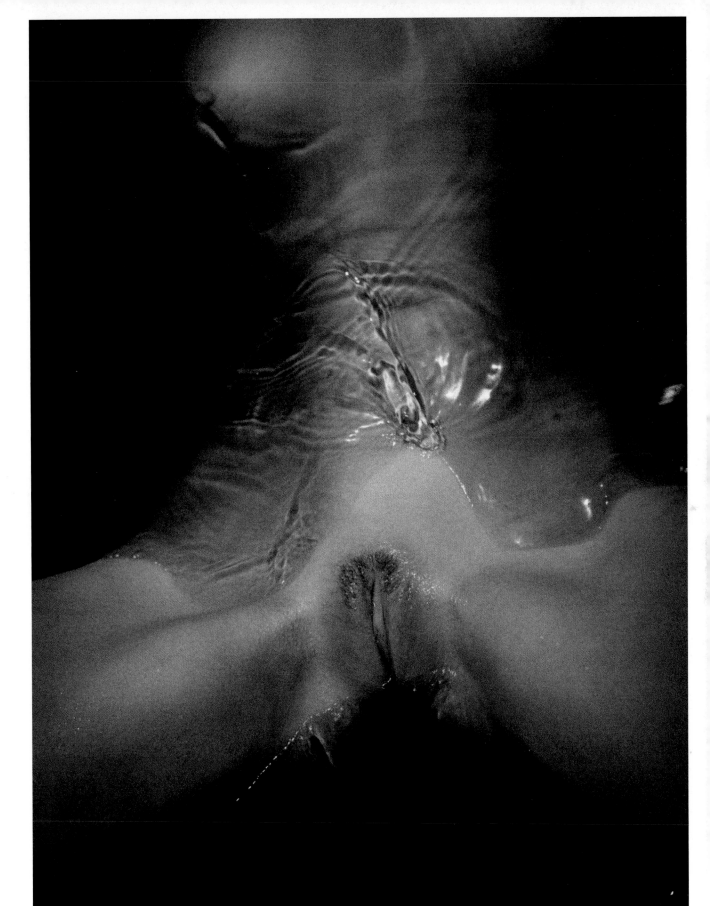

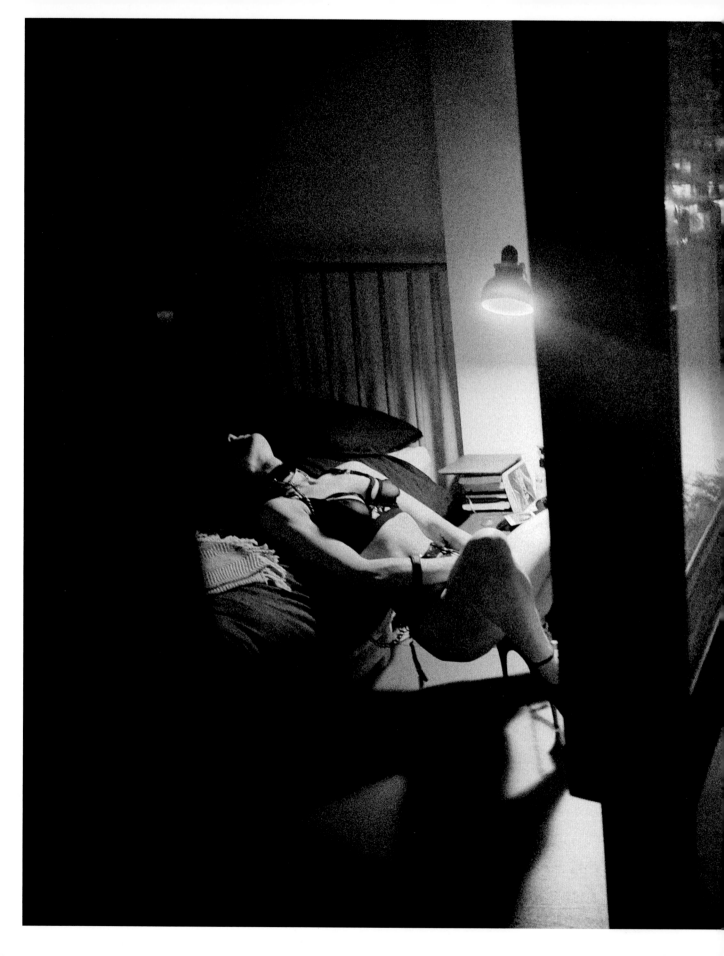

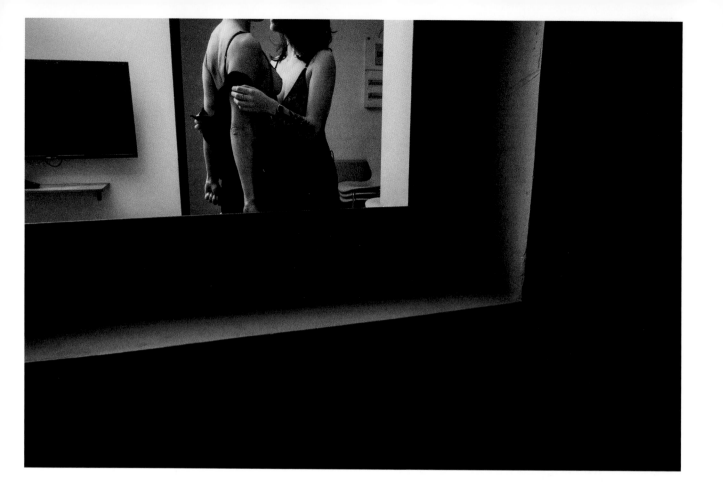

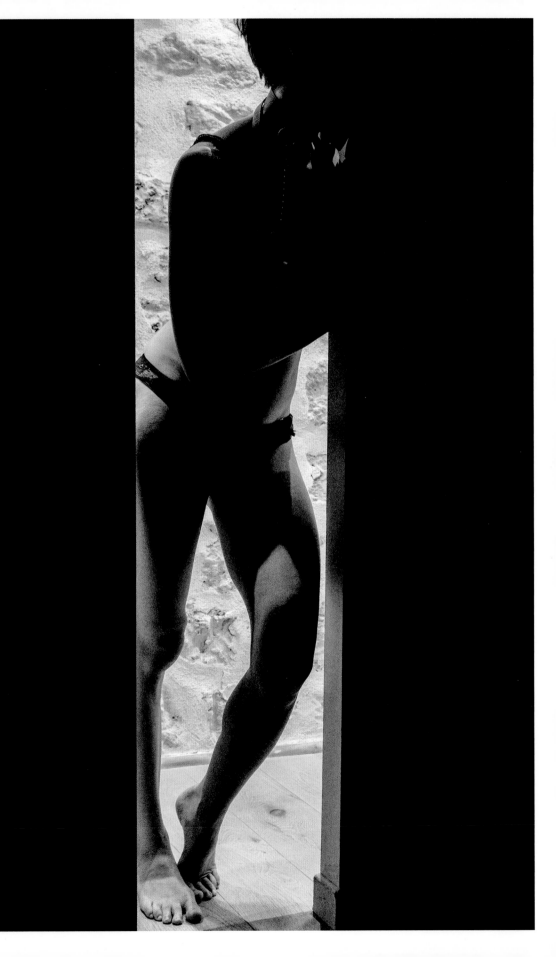

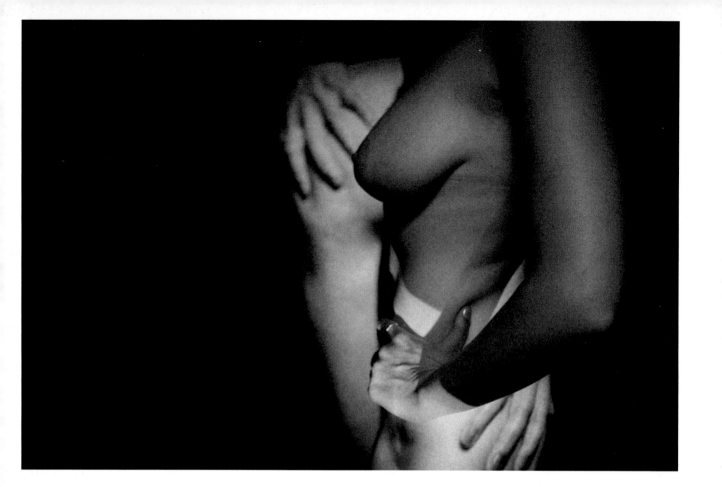

36

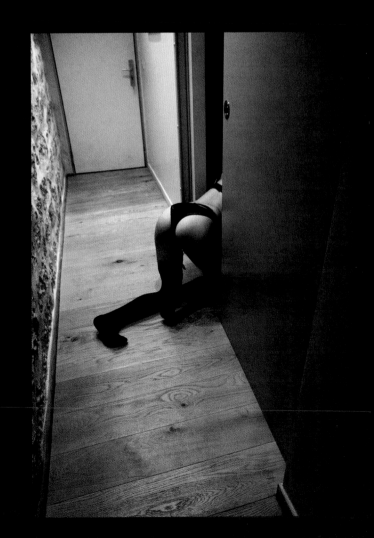

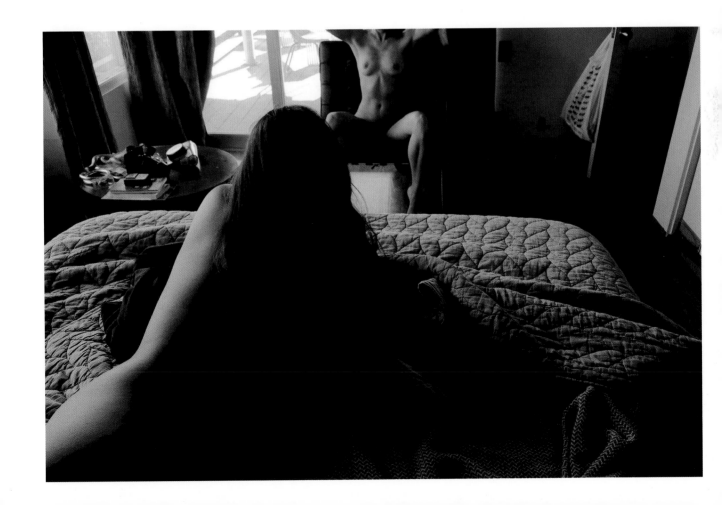

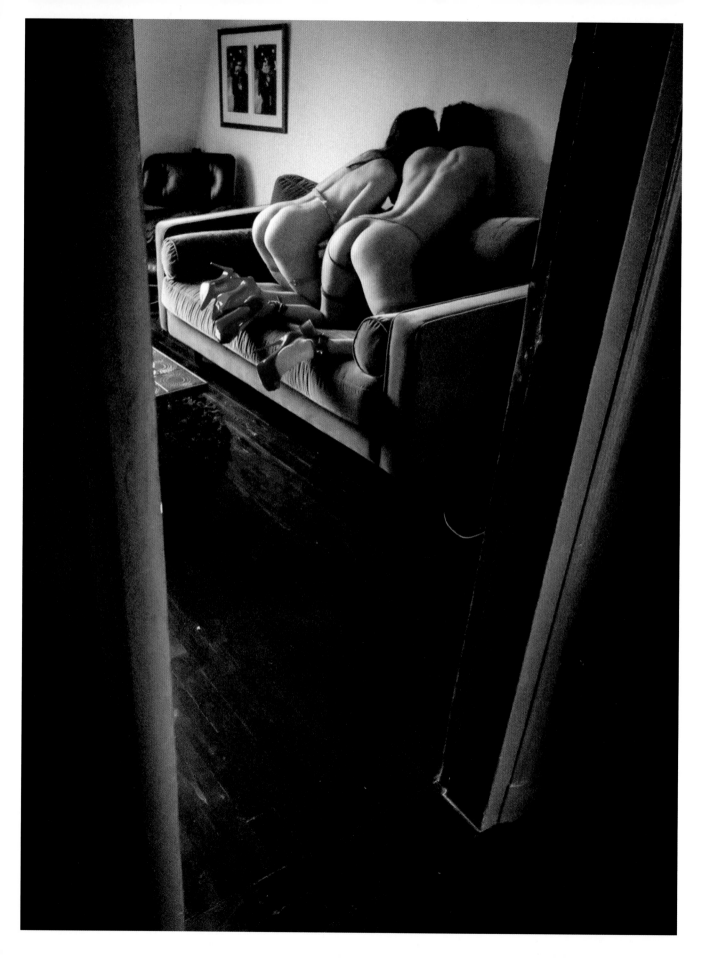

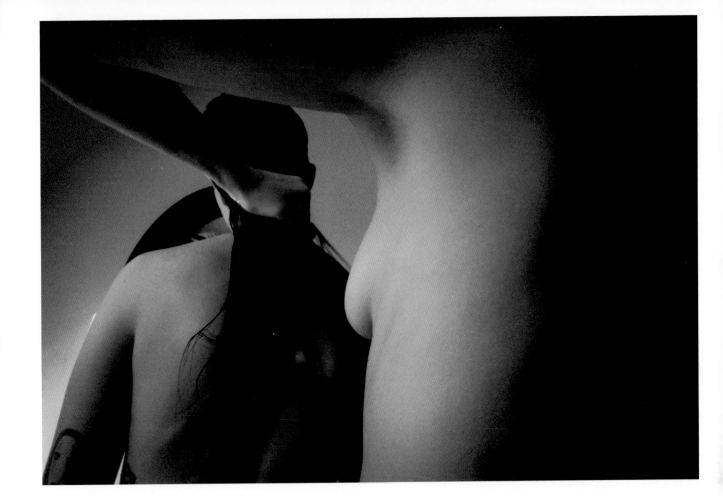

45

46

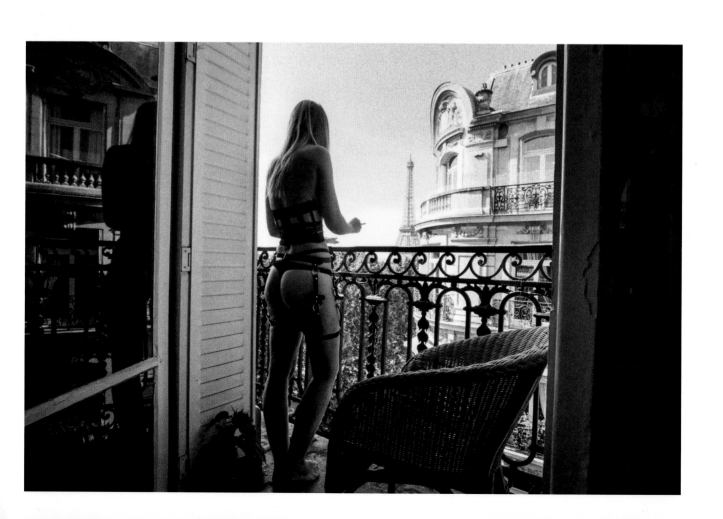

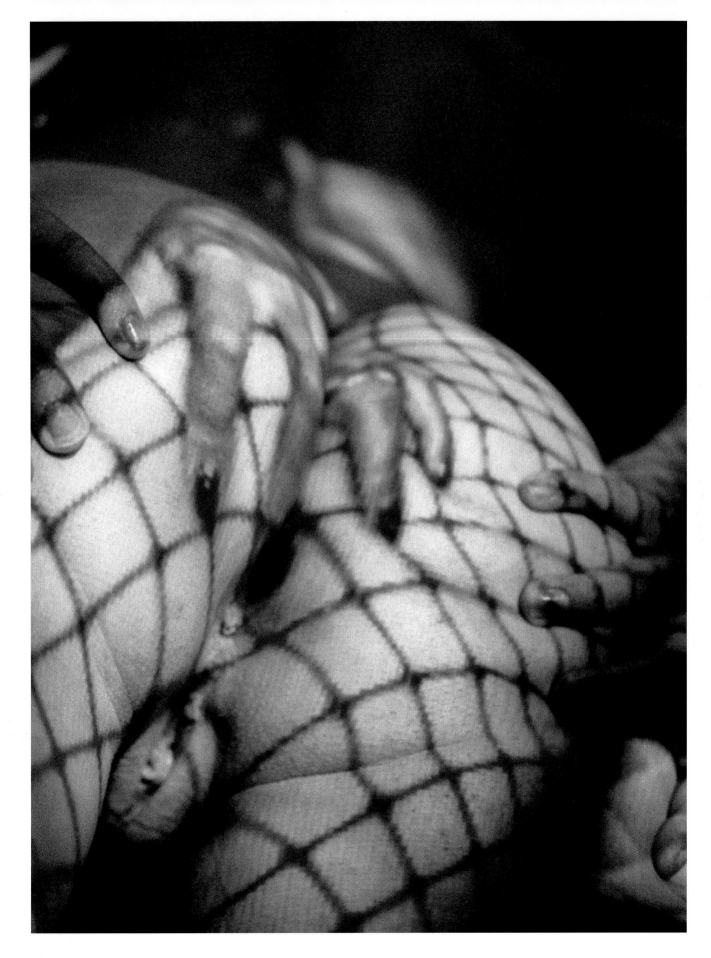

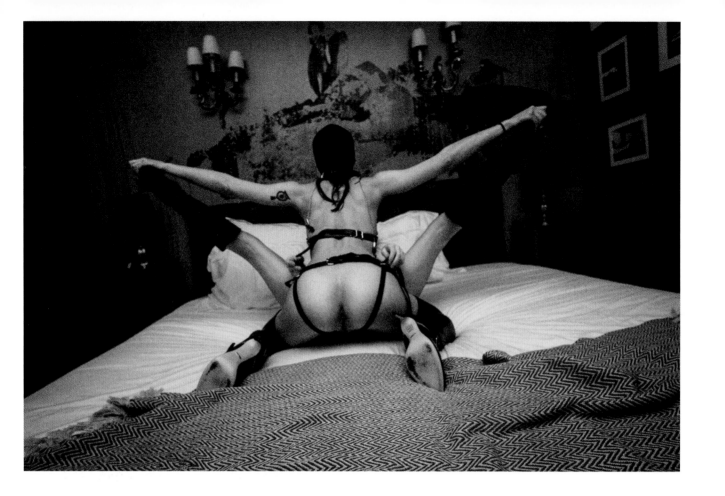

52

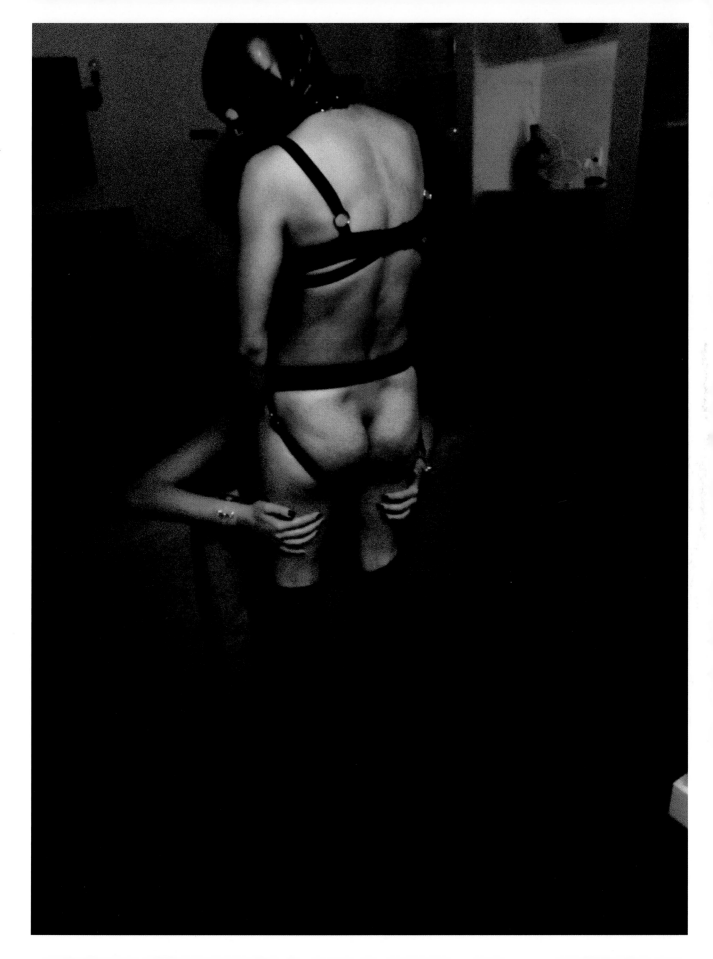

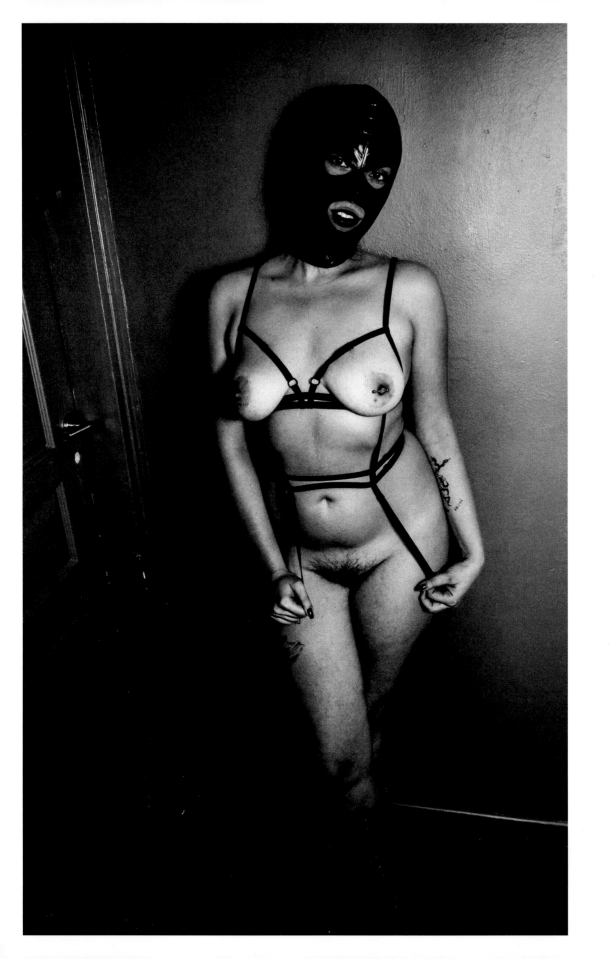

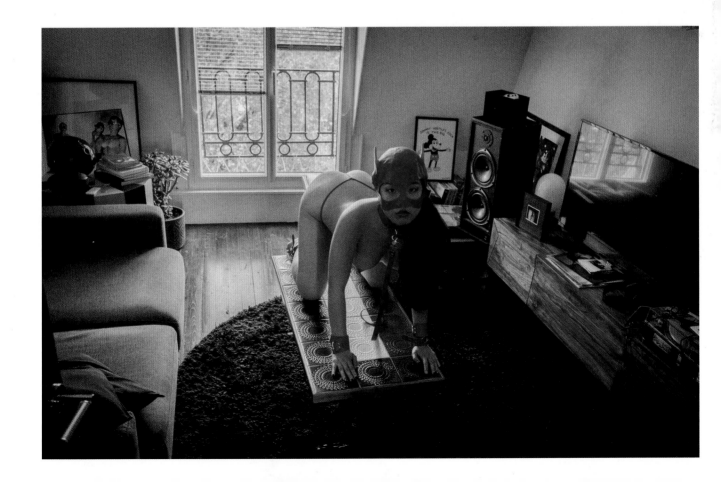

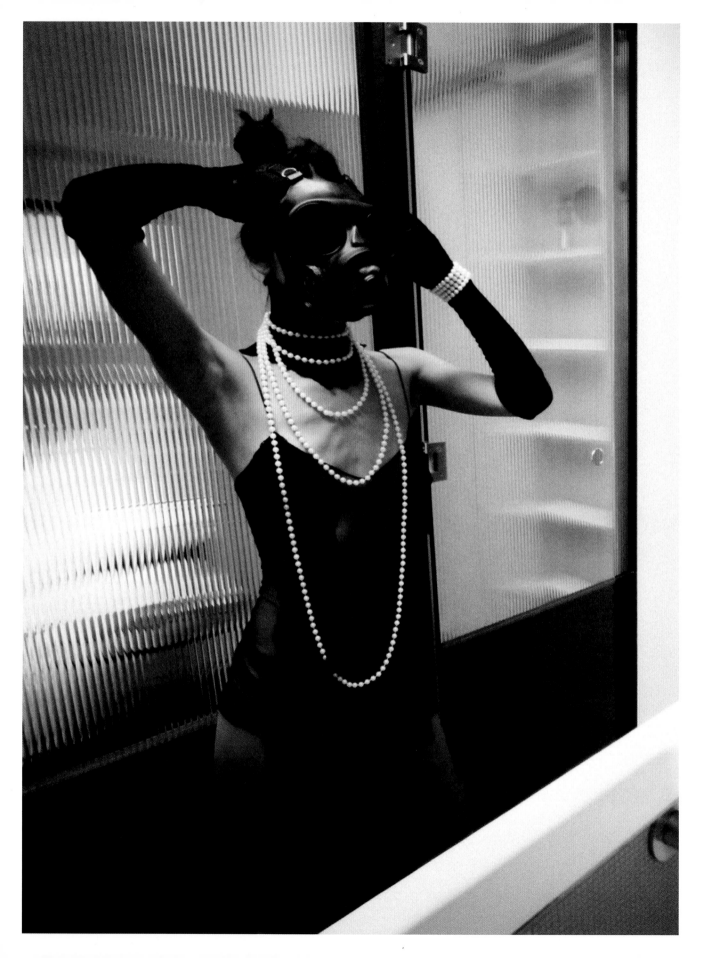

1

For as long as I can remember, I always imagined myself with different lovers. As a child, I heard friends and relatives of the same age tell about their dream-life and their desire to have children one day, what an incredible achievement that would be. I never had these kind of dreams. At night in bed, I dreamt about numbers. It was never gonna be just one lover, but many. Not just one orgasm at a time, but a multitude. Partly my desire was motivated by curiosity, but almost everything was motivated by the simple idea that I might die tomorrow.

2

I didn't think much of Tania the first time I met her, I was nineteen, never in my young life had I intended to be in a relationship, not a serious one anyway. For the first six months of knowing each other I kept changing my mind. Every day I would tell her I was leaving. I couldn't help but feel trapped in the confinements of a traditional monogamous relationship. I wasn't able to identify the real issue then, or propose anything to improve it. The only reason I could fathom was that I wasn't in love with her enough and so I had to stop it.

3

What kept us together was the way she reacted to my unsteadiness. Her answers intrigued me. Whenever I'd tell her "I don't think I really love you" she wouldn't feel hurt (or at least she wouldn't show it), instead she'd say "me neither, I'm not sure" in a neutral tone of voice, showing neither worry nor sadness. If I said "I don't think we should be together anymore" she'd reply "you are free to leave whenever you please", pointing at her car without

an ounce of despair or regret, indicating that she could drive me to the train station now if that's what I wanted. Whenever I would test my truth on her it would never scare her away.

4

Three years into our relationship and once again I gather all my courage to announce that I can't be with her anymore. In my young head I thought I couldn't be in love with someone if I was attracted to others. The idea of living a dishonest life was creating too much anxiety, I needed to come out clean. "I don't think we can be together anymore" I said. "We have to stop." She looked at me recognising the pattern. "We have to stop because, when I look at others, you know, I feel something, and I don't know if that's right by you. I love you but, that's not all I feel. I feel more, about others, and I don't think I can ever control it. It's the way I am. Maybe I need to figure things out and . . ." I didn't dare look at her. "And?" she said kindly. I didn't want to finish my sentence. "So you like people?" she said after a short silence. "Not just that" I said painfully "I fancy them, I want to have sex with them, all of them, all the time!" "Well, that's good, isn't it?" she said before taking a brief pause. I looked at her. She was smiling. What on earth was she smiling about? "I like it" she said "let's make sure you get what you want". I didn't expect such a response, but only later did I realise what she had just offered to me.

5

One evening when I came back from work, she told me to get ready to go out. Over the past several weeks I sensed she had been thinking about something secretive but nothing prepared me for what she had decided to put into action. If she enjoyed planning, I did not. When I heard the words "get ready, we're going out" I honestly feared what laid beneath. I'm not one of those sorts who thrive on conflict so I didn't share my apprehension. I just couldn't help but fear I would hate it, that I would hate doing it with her, or simply hate her because she made me do it, and turned my night into a tiresome unending

deluge of bestial sex that I knew my body couldn't possibly endure.

6

I roused no more enthusiasm than I would to prepare for shopping groceries. I proceeded in this fashion to put on an air of normality in the house that I knew she delighted in. But I also understood that trying to have a good time was more or less the same feeling as truly having one, and as soon as I agreed to hand over control (totally, not partially) pretend excitement wasn't shameful to me. I just had to make sure my actions never looked hollow so she could not distinguish between my feigned passion and the real thing.

7

Tania, on the other hand, assumed her role to perfection. Still giving me no information regarding our destination, she asked me to sit on the passengers seat of her car with no delay. She denied me any kind of satisfaction and I played into that. She wanted me to feel useless but she didn't make me feel unwanted. I wasn't disobedient. I followed my instructions with chilling precision and abided my humbling role, the rush of adrenalin rippling up through my body.

8

I admit I had hopes that at the end she would take me home without stopping anywhere or meeting anyone. I felt weak with laziness and hoped that maybe this was just a little car trip and she wouldn't ask me to get out and brave the cold in my outfit (my sole get-up consisted of a pair of stockings and heels underneath a long winter coat). On its far side I was of course willing to try anything, but at the centre of myself I felt apathy. I looked at her while she was driving and I felt I always knew what was in her mind except at that moment, her eyes fixed on the road, I could feel the growing distance between us and it felt necessary to insist on feeling it even harder now.

9

Tania mentioned that the journey was going to take a little longer – which confirmed that our excursion had a real purpose and a real destination – and asked that I start touching myself for the rest of the journey while she kept on driving. I stole a quick glance at the aloof expression of her face – not enough to start me off – and struggled to find some point of excitement. I stared glaze-eyed into the rear-view mirror. Rain had fallen with the night and a line of cars had formed behind us, their yellow lights broken by the regular movement of the windscreen wipers.

10

Behind us the cars tagged along at relatively slow speed and I had the sudden limp intuition that for some reason they had something to do with Tania. So far, I had not suspected anything about what was going on but my instinct was telling me now that if she had planned anything – this was it. My skin prickled all over as if connected to an electric wire. There were a lot of cars. I couldn't count them all as they never seemed to fit in one single straight line, but their lights felt like predatory eyes waiting for the opportunity to get me. I didn't mention my discovery, knowing too well that secrets bind those who know it but do not share it. I touched myself concentrating on that idea, feeling both apprehension and gratitude.

11

The cortege of cars became a blazing emblem, not only of what each driver could later do to me, but of what I would do to them. Because let's talk about it: in resorting to ultimate submission, I had gained ultimate power. Everything that evening, Tania, all the trouble behind it (how many phone calls, texting and emails to make this happen?) the cars parading through the rain, that was all for me. This revelation of Tania's true colours – the extent of her hard-working love – pleased me and made me feel privileged to be with her. I couldn't think of a better declaration of love than this slow procession of cars. But this was not the time for an incontinent outpouring

of emotion – I knew Tania disliked it – so I rerouted my affection for her into the masturbation she had prescribed for me.

12

It was approximately forty minutes after we had left that I said I needed to pee. She shot me a long black look, "we are almost there" she said, but I insisted. As soon as the car stopped I ran through the grass and hid behind the nearest bushes. My coat was already wet with rain when I raised my head and sighed at the release of long-held urine. The intimidating cars' headlights now lining up on the roadway behind Tania's car made me squint, the engines still fuming in the night. Then it was the oddest thing. One by one I observed several dark silhouettes getting out of their cars and a handful of those strangers slowly walking towards me. I hurried down my flow on the humid grass, leery of where this was heading. Tania, who had witnessed the scene from behind her seat, rushed out of the car to raise her hands and waved like a policewoman in charge of traffic: "She's only pissing" she shouted through the rain "we're almost there". I got back in the car and the cortege took off one more time towards its destination.

13

The closer we got, the more impatient I felt. I rubbed my inside thigh with both my hands, unable to sit still. Tania too seemed glad when we arrived. It was the perfect spot, a patch of open field at the centre of a big park outside the city. Her arm outside the window signalled the rest of the cars to park anywhere around the meadow, striking a light in the most abstract regions of my soul. Such a beautiful talent for perversity, I reflected. I would have been a shame to let it lie fallow. She blindfolded me with one of her scarves that bore her flowery scent. My vision went almost black. I now only saw short distances through mini scratches of light. She told me to open my door and sit sideways with my feet on the grass. The rain had stopped and some of the cars had left their headlights on. With my visual perimeter closed-in I couldn't guess

when someone was walking towards me, only seeing them when they stood in front of my feet.

14

I felt, at last, transported. This was at a time in my life when my own fantasies had come to bore me. I was happy to surrender them to Tania's vision. She wanted me sitting on the side of her car swallowing one by one the sexes that she had brought to me. How did that make her feel? When men presented their hard-ons and girls their wet slits, like close-ups of archeological figures pushing against my mouth, was I recreating the floating pictures born from her imagination? I wanted to be the subject of her painting, give her the exact texture and hue, everything chosen by her, even the scarlet colour of my lipstick which after several minutes of sucking had already lost its luster. My sensations weren't mushy and soft-focused, they were sharp and vivid, I felt every seconds of this mise-en-scène directed by the woman I loved and knew I'd remember them long after I would be through.

15

The queue of men and women waiting for their turn was interminable and yet I never paused nor complained while powering through my task unaffected. I was marching through the paces of submission like a soldier on parade. Men plunged their members to the deep end of my throat until they came inside, sometimes holding my two ears like the handles of a bike. Women rubbed themselves against my lips, sometimes with a hip flexibility that astonished me, then reversed their heads back to scream their orgasms. I didn't care to wipe the juices off my lips in between two customers, when one pulled back the next one immediately came in.

16

I never knew the extent of Tania's pleasure in those situations, and I liked it that way. I knew she was not romantic about the rewards of domination. For one, she demonstrated none of the stereotyped bossiness of the role. She was peculiar about almost everything in life,

from what she fought for to what she abominated, and that's why I wanted to trust her, for once, have a blind faith in someone.

17

Saying that Tania came to my rescue would be a false rendition of the events that followed. She might not name her emotions most of the time but I knew pity wasn't one of them. She took me away from my seat and asked me to lay my back on the bonnet of her car. Spreading my legs wide, she signalled the next person in line to get inside me. She knew very well that underestimating a submissive's sexual endurance was the oldest mistake in the book. "You have some big company tonight" she said close to my ear "show me how much you like it". "What if I don't like it?" I ventured hoping to keep her near. "Show me anyway" she said before stepping back.

18

My second assignment was less restrictive than the first. In the spirit of fair play she allowed me to look – which after hours in the dark felt like I had been gifted with clairvoyant eyes. The next man in line was heartbreakingly not handsome, and standing on two short legs his penis was unable to reach me. Not content to see him dismissed, I turned around and slid down the car side to level our parts. Grateful of my generous gesture, he mumbled banal courtesies before aiming his member slowly up my ass.

19

Men and women acted orderly and relaxed to the end. I never knew where they came from or how Tania got in contact with them in the first place. Apparently many people on this earth are drawn, like us, to uncomfortable experiences. That's my only explanation for their patience. I offered my holes for another hour or two, making sure everyone was treated the same, even though my pudendum had long lost its capacity for sensations. I was the receptacle of their cordial alliance, the living proof that a consensus between the two sexes was possible. Far back

in the dark in between two thuds on my thighs, I heard a chuckle. Tania was smiling the quiet smile of someone who doesn't think anyone is looking, which exuded the ascendant emotion of pride.

20

Back in the car on the way back I hold her hand for a second. She didn't respond but didn't move it away either. Her skin was warm and it gave me a foretaste of the peace when we would get home and curl up in bed under the duvet. I was longing to take a bath while she'd prepare two cups of tea, one of us breaking the silence only to share some banality, drenched by the emotions of the rainy night behind us. Something about our next day would eventually snap us out of this silly beatitude, but right now I had never felt more calm.

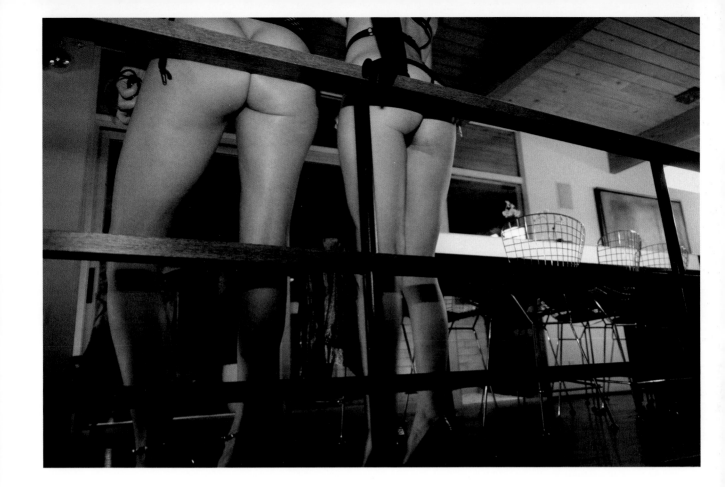

65

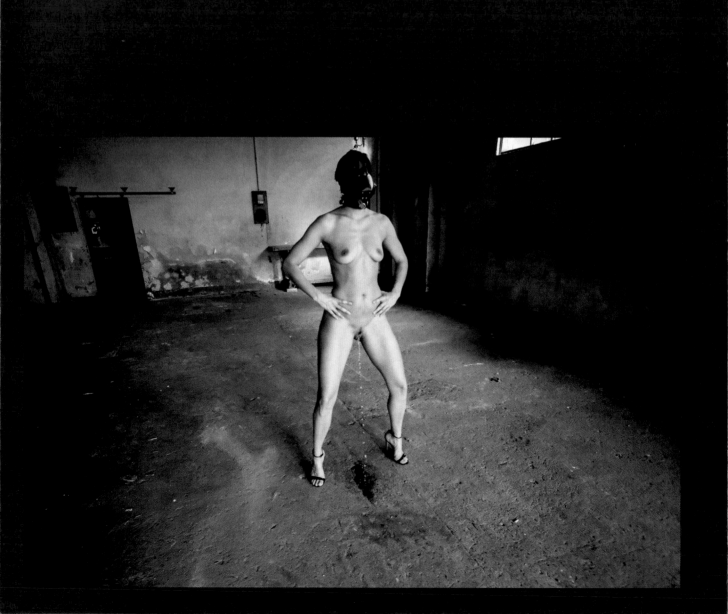

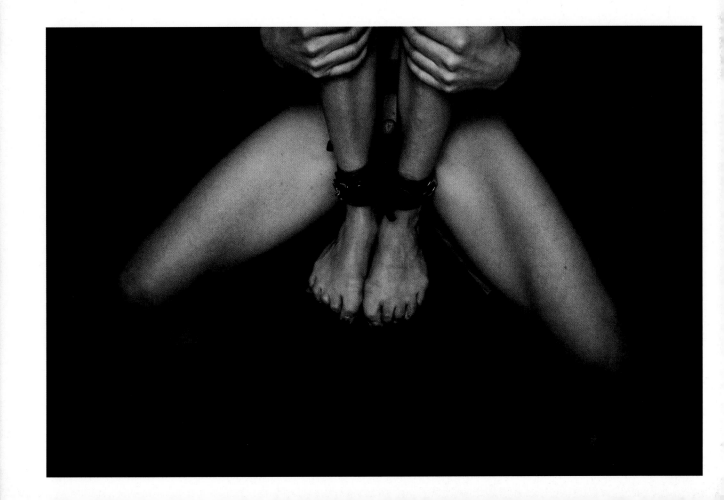

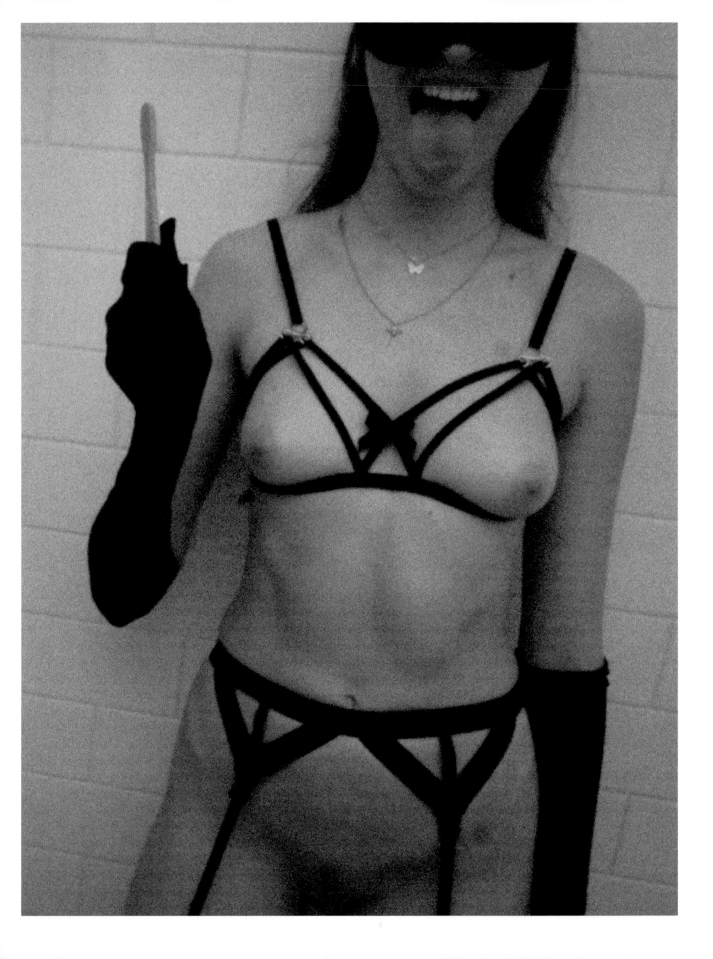

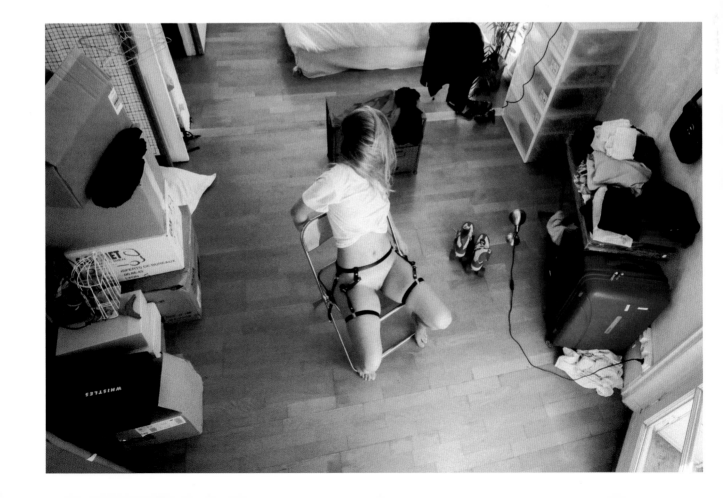

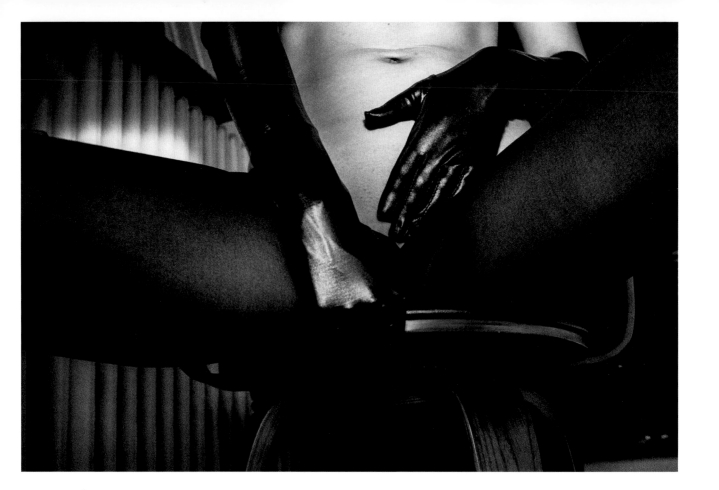

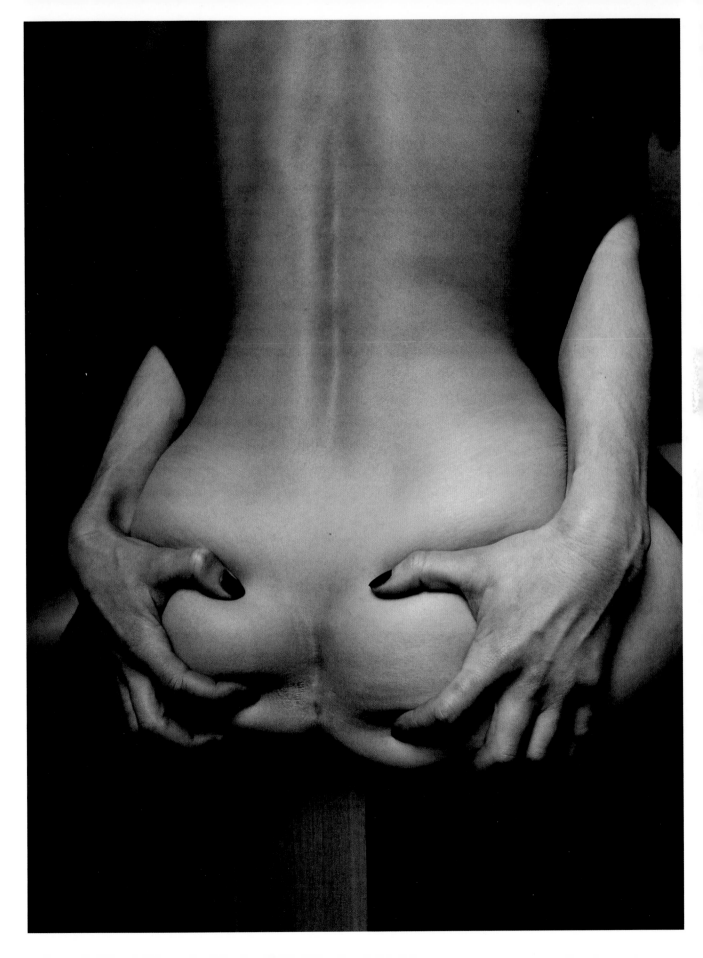

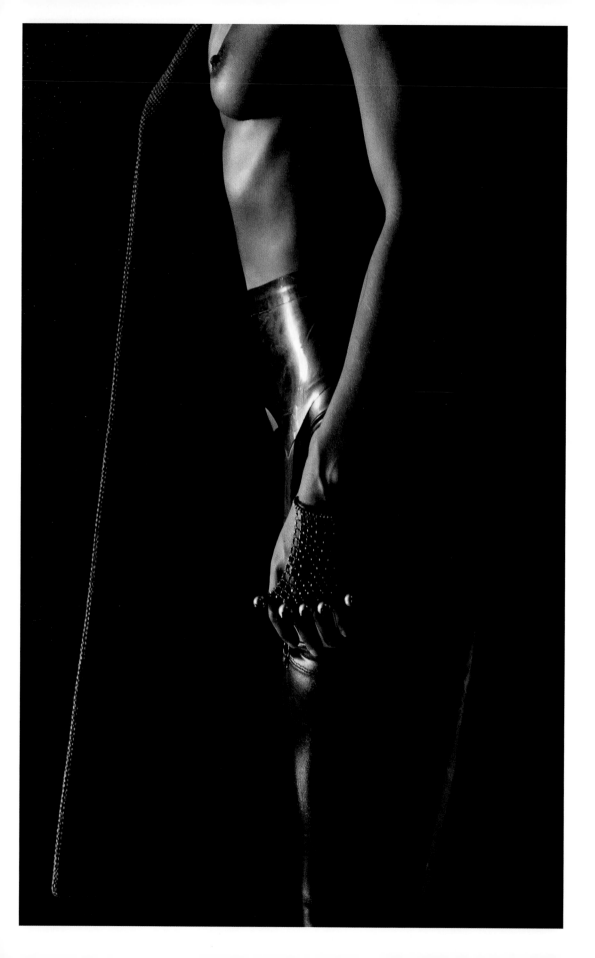

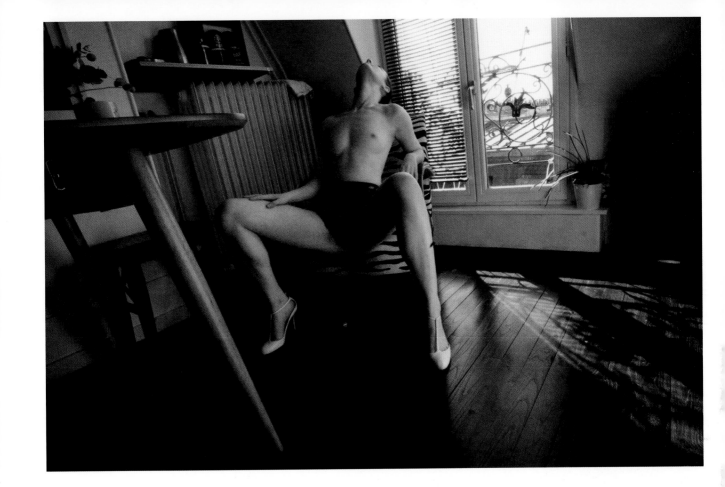

75

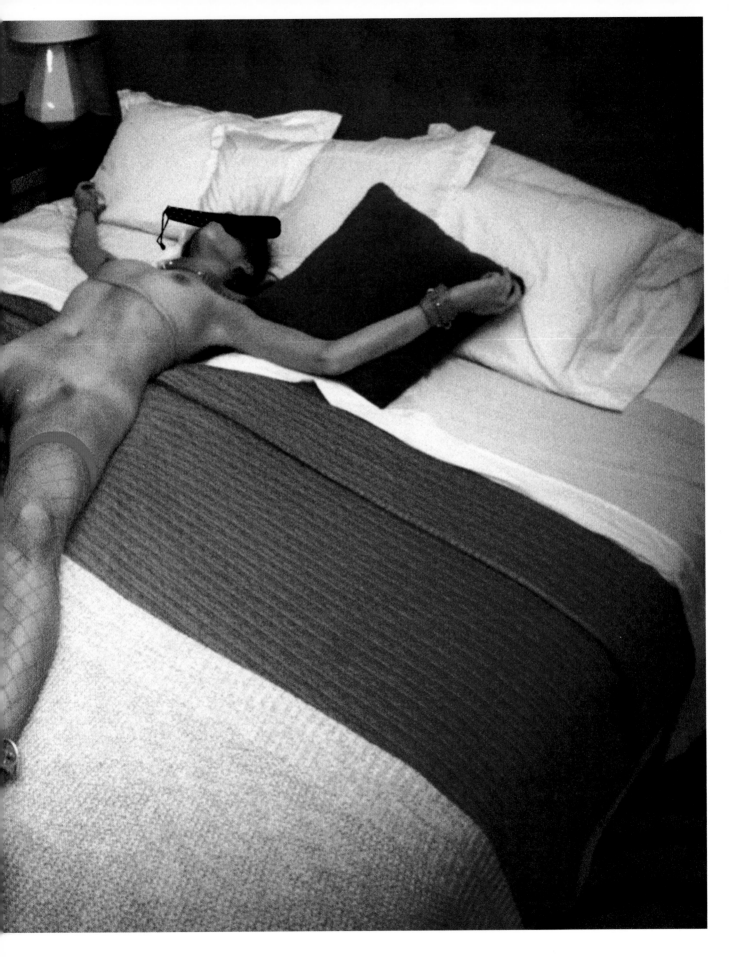

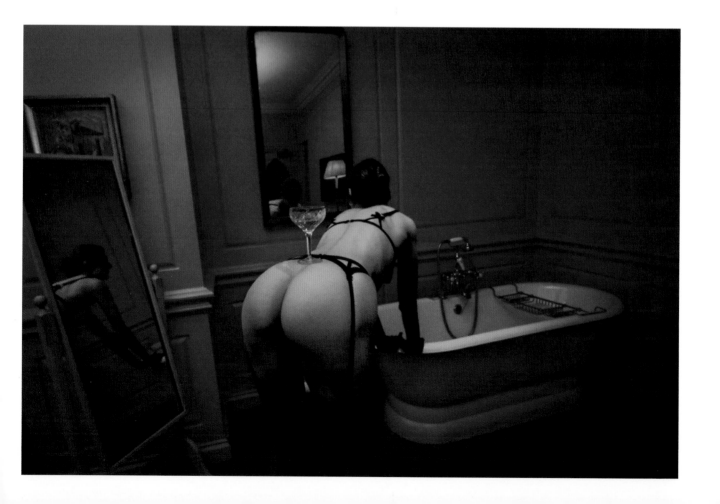

79

80

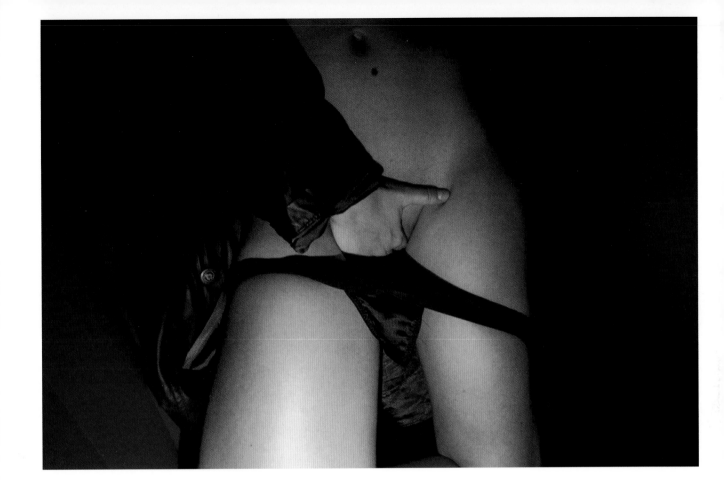

81

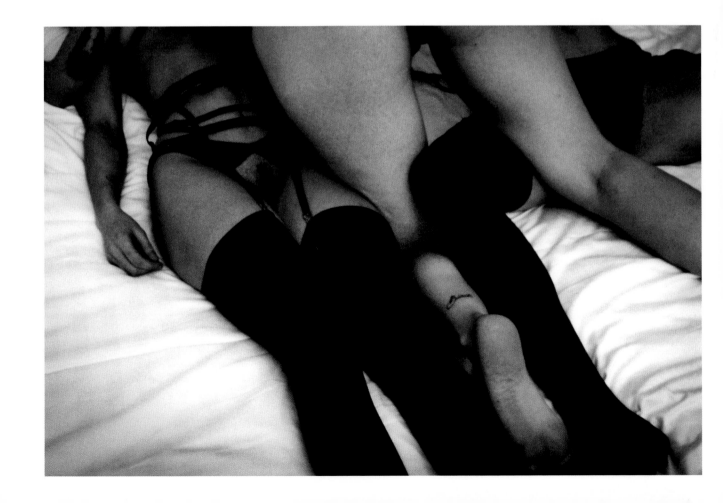

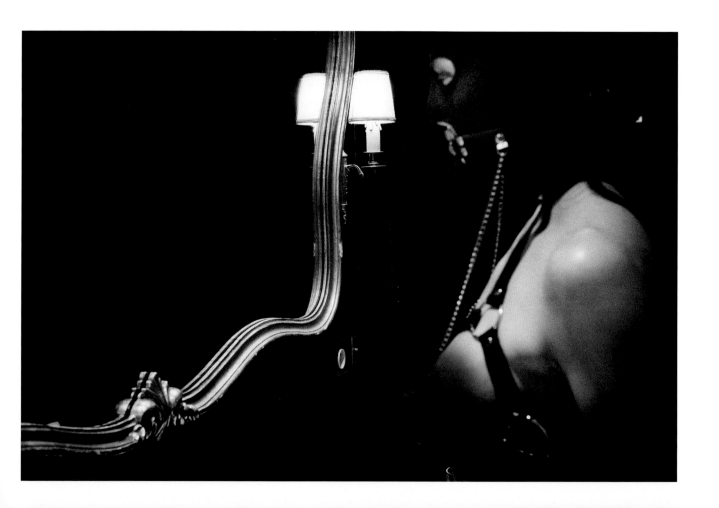

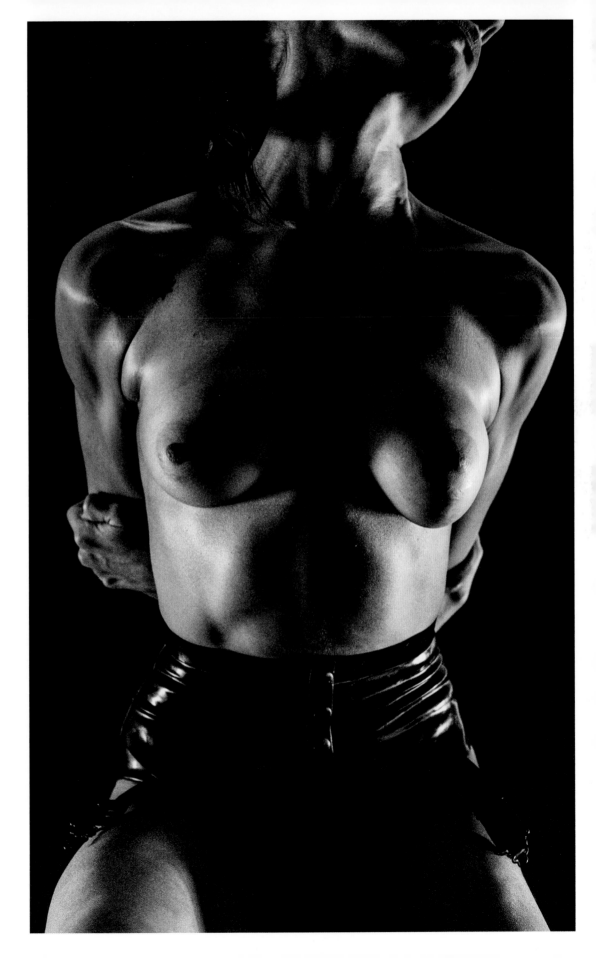

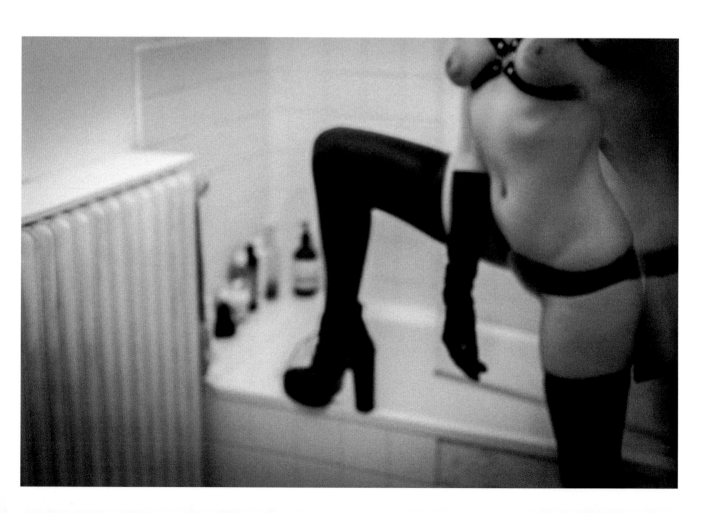

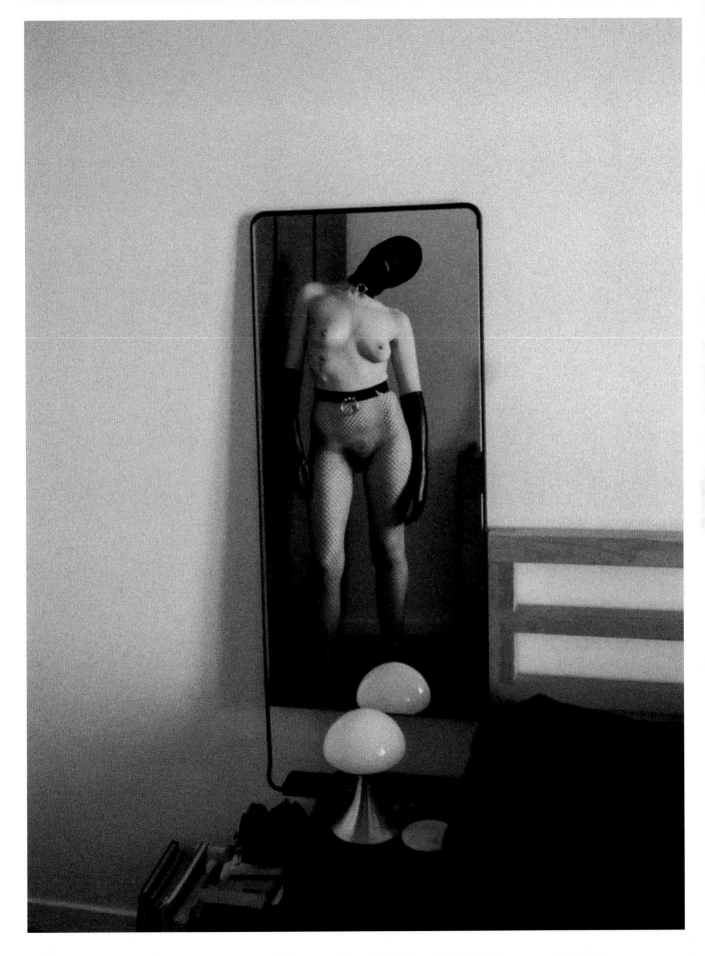

89

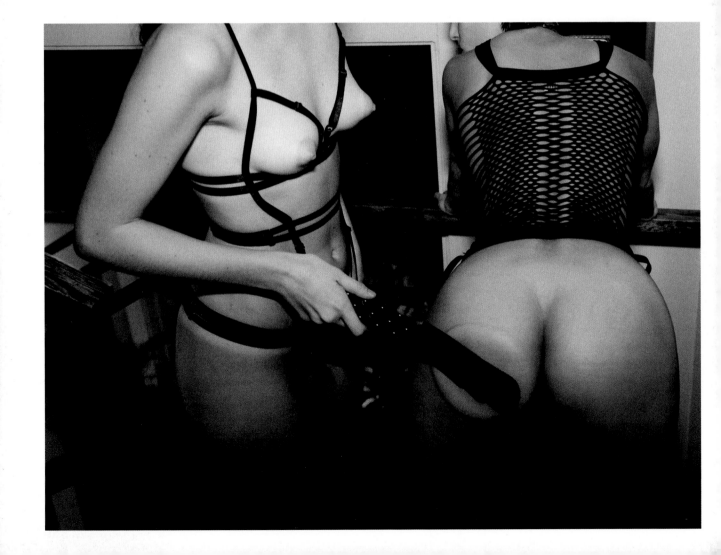

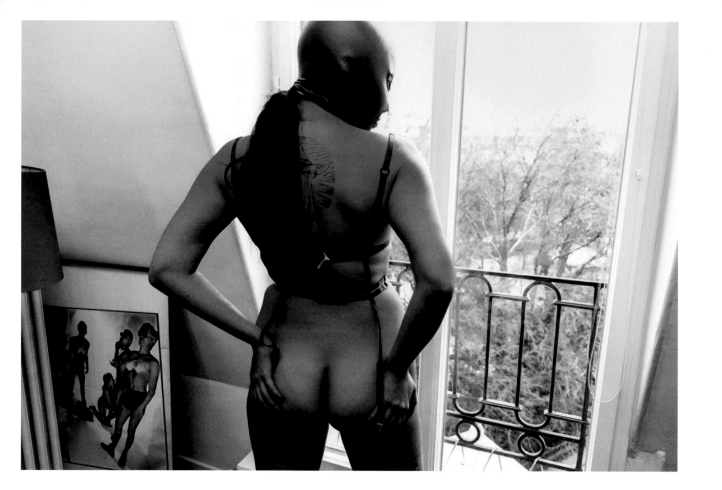

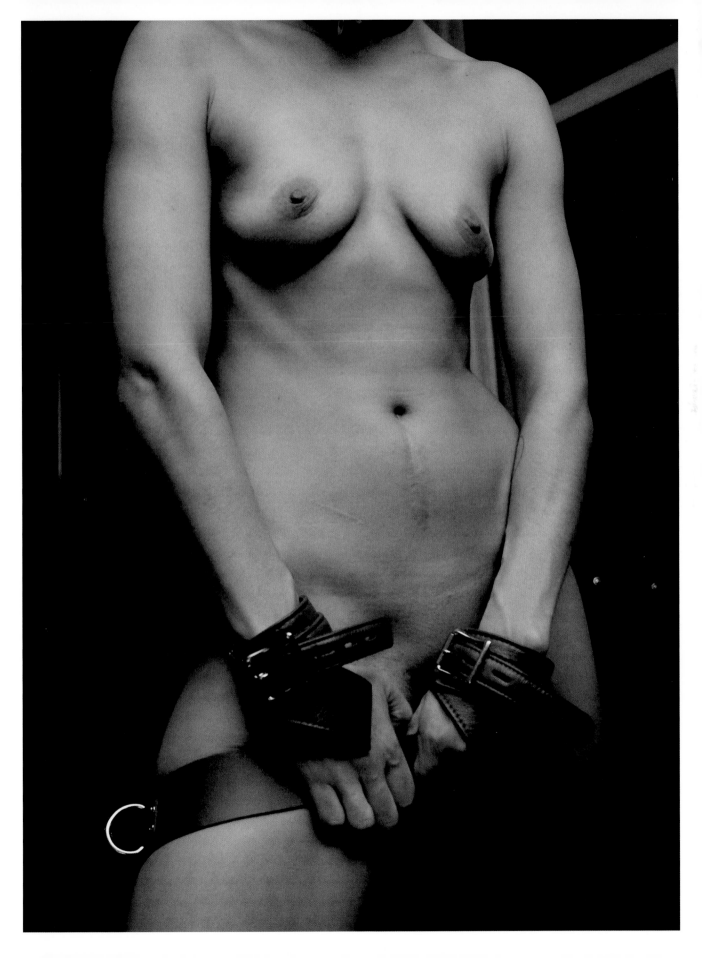

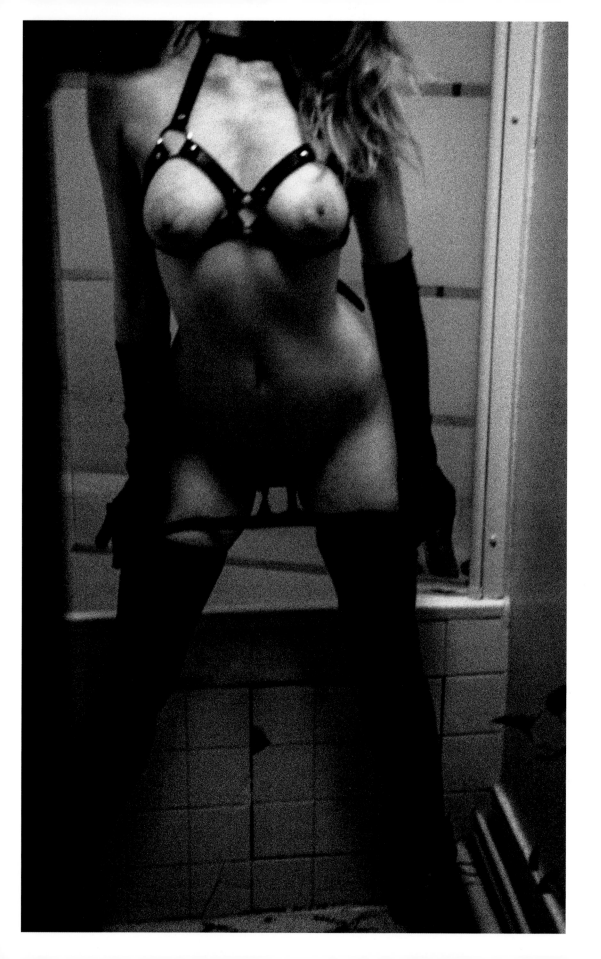

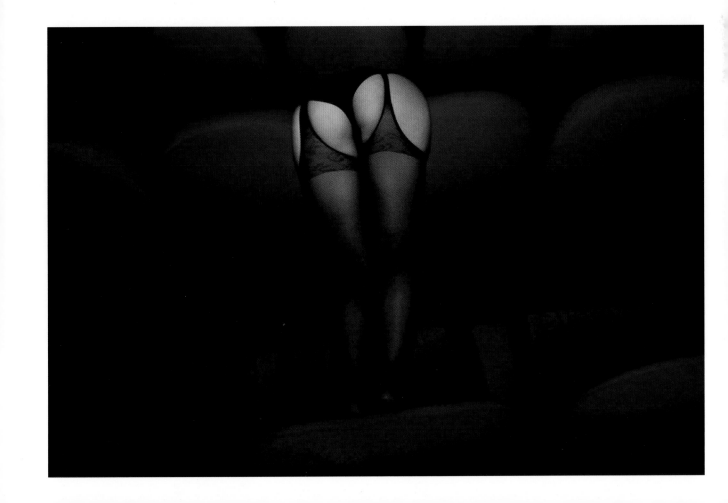

96

(inspired by "une sale histoire" of Jean Eustache)

1

My story is the kind of story that women will scorn to read. I should tell my readers now that the actions of the episode that follows are less important than the philosophy hidden inside of them. In fact, the study of the tale, in which I would say the hole is the most important character, is by far more interesting than the story itself. However, even though you may have concerns over certain details (I might add a touch of melodrama) I assure you that everything I will tell you now has really happened to me. The events took place in a Parisian café. The essence of the story should not be altered by details like this but I shall give you at least a minimum of context. I needed to work outside of my home and this café was big enough to let me enjoy the noise of a crowd while remaining isolated.

2

One morning, after placing my order with the waiter, I made my way towards the ramshackle staircase at the back and walked down to the smelly restrooms. I locked myself inside one of the toilet cubicles and quickly unbuttoned my dress. After I pushed away some abandoned pubic hair I placed a few pieces of paper against the cold ceramic and repulsively rested my naked thighs against it. Someone – I couldn't confirm the identity of that person yet from where I was seated – entered the restroom and, locking the door next to mine, started unzipping. They didn't sit down straight away. After a short silence, in which I recognised the concentration needed to generate enough pressure to push the urine through a narrow urethra, I realised that person was pissing standing up.

3

Everything, as we well know, happens first in the body and later in the mind. My belly started producing some extraordinary noises that I was ashamed of, a shame accentuated by the certainty now that the person in the unit next to mine was in fact a man. I listened to his piss hitting the water with a low reverberation in the white porcelain bowl. I listened to it stopping and starting again with a more brutal flow as if pissing itself – the act of pissing – was more important to hear for me than to perform. Two or three minutes passed and my neighbour, still unaware of his silent audience, came out of his compartment to wash his hands. I hadn't moved from my distinguished place and I felt suddenly empty – although my basin bore no visible account of body rejection.

4

Other than the embarrassment of being found in the opposite sex's restrooms, I felt relieved when I heard the man exit from where he came from. At last, I could concentrate on finishing what I had initially gotten here for. It was at about the same time, a little after I had activated the flush, that another person – I assumed a man – entered the same booth that the previous intruder had abandoned. I was no doubt being stupid to freeze immediately after I heard the sound of the door-lock and the man's trousers falling down around his feet, but I couldn't unburden myself from my new state of stupefaction. His pissing, which took about thirty seconds, was a gentle steady stream. To my surprise I found its smell not as unpleasant as the previous one.

5

I stood straight up on my feet with my dress still unbuttoned and resigned myself to wait silently for the path to clear up again. I aligned the point of my sandals with a row of tiles, the floor of my two-metre-square habitat looked like it hadn't been mopped for what seemed an eternity. My gaze fell unwillingly onto an unidentified dark substance roaming around a small puddle of suspicious milk. I gagged at the sight of a clod of hair wrapped

around what seemed to be the remnants of a worn-out plaster. The day was hot and even though I usually forget unpleasant things, the memory of my gummy thighs, as if I had dipped them in jam, is still quite vivid.

6

While I looked down to the floor I noticed a ray of light flashing across the varnished point of my toenails. I almost missed it, nervous that I was to look a second more at the filthy floor for fear of some kind of contamination. The light was so faint and barely noticeable at first. I couldn't identify its origin. Only after I bent forward and twisted my chest to align my eyes with the corner of the wall was I able to perceive – not without some unpleasant effort – a small gap, visible only from a certain angle, from which a timid light was flickering.

7

Once I decided to examine the nature of the gap – first its placement at the bottom of the wall, then its curious aim – there was no turning back. I soon contorted my body with a fold in my belly I didn't know was possible, placing my stare at the level of the hole with my cheek against the floor, and as soon as I managed to raise my butt high, in a position that resembled the Islamic prayer, I knew I was making my future as irreversible as my past. One could say I did not lack courage, most people would have given up a long time ago, but one could also say that I was intelligent and still open for learning. At this stage of the story it may be important to remind my readers that everything that followed I did in the hope to honour that last statement.

8

By some strange magical attraction the hole was forcing me to look into its centre. Like a bulls-eye to the other side of the world, it gave me a perfect insight into the next-door compartment – more precisely, the contours of the hole contained, no more, no less, the entirety of my next-door neighbour's sex. Suspended in a sunbeam, detached from the body it once belonged to, the male sex appeared

to me in its purest form. I felt overwhelmed by an electric joy. For the first time in my life I discovered that my physical comfort mattered less than the danger I felt in transgressing.

9

Within the week that followed I visited the café everyday, at first without thinking, denying my secret intention to look through the hole again. Walking down to the toilets I would stop before the giant mirror hanging in the staircase and admire the new smugness in my changed face. I smiled to think I was in charge of a very important mission. In the entire building lived thousands of men who would walk through the cubicle door unaware that at any moment my eye would capture them directly from the sex. The gratitude I felt was unexplained and I made no effort to understand it.

10

I kneeled on the dirty floor, my hair dipping into remnants of dubious water. I kneeled and I watched attentively the parade of penises going through the fissure of the wall with mute satisfaction. I listed my favourite ones, judging them by their size, their symmetry, their colour. I couldn't help but think that I was spoiled. I remembered as a teenager being at odds with the male organ. On rare occasions when I had felt adventurous, I had reached out a hand in the dark (while clenching the other) in view of encountering the opposite sex. With the tip of my fingers I had touched its softness with a vague sense of permission. Now I had a direct, unbroken, unchallenged, secret access to all men's penises in the world, and I sensed a powerful urge to see them all, to know and possess them all.

11

The first thing that drew my attention was the diversity of their appearance. I always imagined there was not a dick in the world that was not just like all the others, with the same old folds in the skin, the same two balls, the same sort of hair, but after weeks of observations I was forced to conclude that they were all in fact very different.

Amongst their multitudes there was always one that stood out as it appeared through the hole, perfect in every way. When that happened I would succumb to the violent urge of rubbing my clit against my hand until a great spurt of electricity would come out of it. Something felt terribly wrong about doing this with my face flattened against the cold floor, but I believe that element allowed my orgasms to be unrestrained. Like the desperate final defence of a wounded animal clinging to its last chance of survival at the bottom of a pit, it coloured them with a delicious bitter taste.

12

Here I find it worthy of note that while I had undoubtedly a wide range of dicks at my disposal outside of these toilets – being a fine-looking girl and men being generally easy captures – I had chosen to huddle up in a morass of shit to look at them from the vortex of a hole. The hole was tiny, and you know it, located at an impossibly low point. Hours of contortions generated horrible cramps, not to mention the humiliating walk back to my seat crippled with pain and my hair smelling of piss.

13

One day after hours of looking through the hole, as I walked in front of the bar where a row of middle-aged men were seated, I heard a voice say: "All this just for a hole". It seized me. Was it possible that my secret pleasure for raw and anonymous meat had leaked through the walls and the whole world had seen it? It felt as if my front-row ticket to the privileged theatre of masculinity had been stolen from me. The men looked at me quite calmly and assuredly and it dawned on me that my adventure with the hole was maybe not a concern for them, their depressed looks and greasy hair indicated that it may have actually been the opposite: I was facing my tribe. They all knew the hole and in an intellectual bond that only men knew existed, they shared the same addiction for it. I wasn't sure this new revelation was more of a concern than a relief but I welcomed it, content for a moment to have found a community I belonged to.

14

My dependency was horrendous while it lasted and worsened in the months that followed. Although I had never experienced the desire to imitate the opposite sex before (I always thought of myself as a feminist) I now resembled the repulsive men sitting at the bar with a precision that was uncanny. They didn't complain that I was a woman. Our similar habits and the nature of my addiction had limited the feminine characteristics of my appearance, which facilitated my integration. Every day I drank and sat with them, negotiating my turn to visit the hole. I understood my obligation to accept my fate as one has to accept the universe. I considered the discovery of the hole as a gift, a miracle that I never hoped for, so I accepted even its most inconvenient conditions.

15

At the time, I was seeing a man who knew nothing about my infidelities. Coinciding with my new activity, his sex had gradually stopped interesting me. It felt, in comparison to the male sexes I admired everyday, domesticated, too easy to grasp, available. The members that paraded before my eye in the toilet felt much more exciting, captivating scene-stealers, as if the dissociation of the man's sex from the man's body was the key to reveal god's most hidden work of art. Thousands and thousands of masterpieces waiting in line for my delight, sucking all my attention like a passionate photographer through the lens of her camera. It was the space that separated me from them that created the attraction, and knowing that the violation was perpetrated without the acquiescence of their owners.

16

I always wanted to unmask the faces that my favourite dicks belonged to. I would walk up the stairs following the anonymous man hoping for some life-changing revelation, but I was always disappointed. As soon as I would see his face, to my grand sadness, all excitements would go away. There was something about the unknown that was obviously part of the arousal for me. As soon as the

sex had a face, that the face had a voice, that the voice had a name, that the name had a job, it all lost its interest to me. I was trapped inside my own personal peep show and the eye of the hole was the only connection left to my carnal emotions.

17

Those are the facts. I am not lying to you. The hole took over my life. There was no place it was not. I am not a great analyser – it took me months before I became aware of the total implications – but I gradually discovered that the journey I had set out for was much more ambitious than I initially imagined. It was not just about a dozen middle-aged perverts and one single woman squandering their money on disgusting espressos, taking turns at a Parisian bar for the love of a crack in a toilet wall. The hole had existed long before the world itself had begun and it would continue to exist long after we were gone. The hole had been there long before the wall, long before the toilets had been built, even before the plans of the café took shape inside the architect's head, long before the city itself – none of those transient things mattered. What mattered was that the hole permanently and secretly existed, that it was the axis around which the whole universe and ourselves turned.

18

All these things I know full well are very hard to talk about. Most of the time I am unable to summon the courage to discuss them. I once tried to confess my habits to a group of female friends. I tried to make it short, omitting certain parts as though I didn't wish to lose their memory by saying them; my choices of words were ordinary, they didn't present a fair description of my internal struggle. The women's eyes looked away as I spoke, as if I was speaking aloud a blasphemy. "Have you got nothing to say?" I finally asked after I finished my story. "I have" said the bravest one after a short silence. "Please tell me what you think," I said. "I dare not," she replied. Eventually she spoke her mind. It was a single sentence. I never shared my story again.

I had predicted the end, but it is one thing to predict the future and another when it finally happens. The café closed down and the city condemned the whole block to demolition. I decided to walk by the site the day after its destruction. Even though nothing was left of it I was certain that the hole had remained alive underneath, like an eye into the past, still glowing and magnificent. I arrived and I did not close my eyes in front of the immensity of the cavity, my curiosity getting the better of my fear. Workmen were busy shouting and drilling in the empty space where the café used to stand. My eyes searched for the hole inside the fresh crater, it could be anywhere in between the mess of tools and machinery. I felt uninvited, intruding into an abominable chaos, unable to find anything, until it dawned on me that the empty void of monstrous anatomy was in fact the extension of the hole. Like a prophecy accomplished, the hole had turned into a bigger hole. I walked back home relieved and happy.

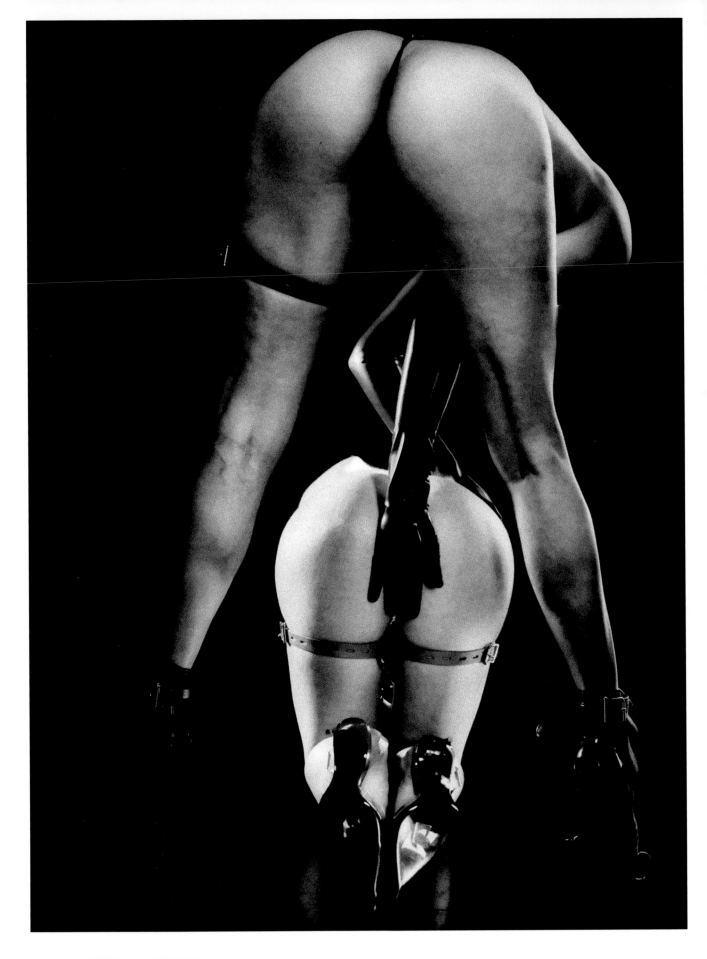

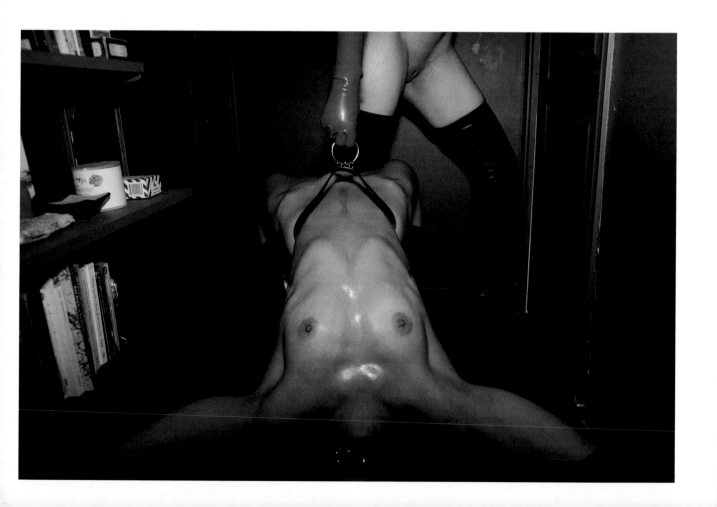

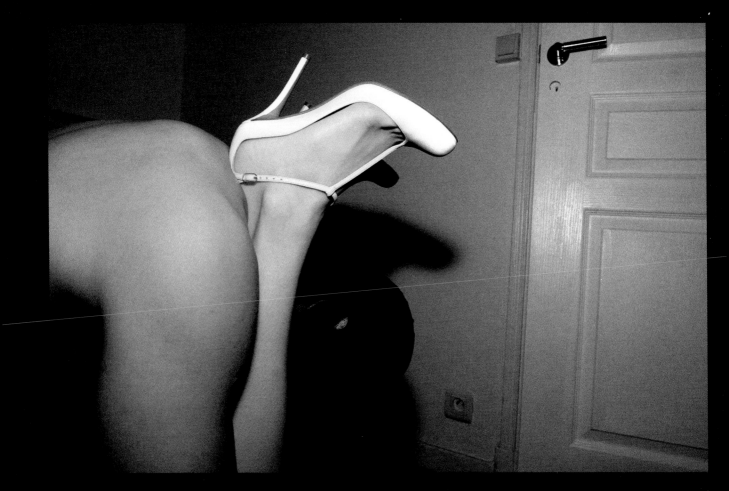

107

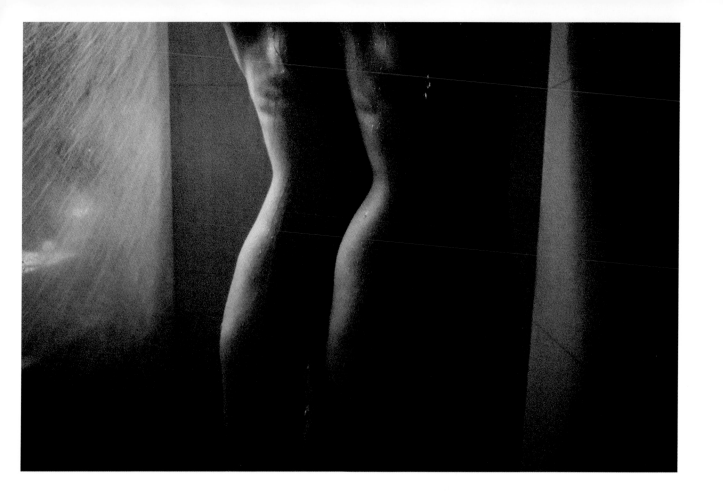

108

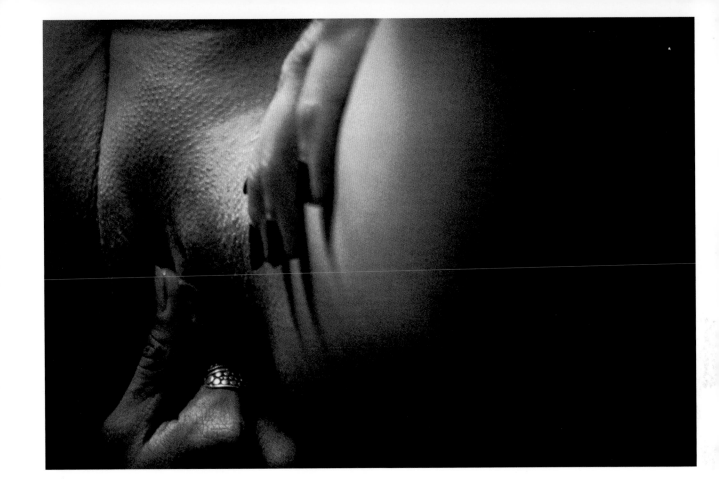

109

111

113

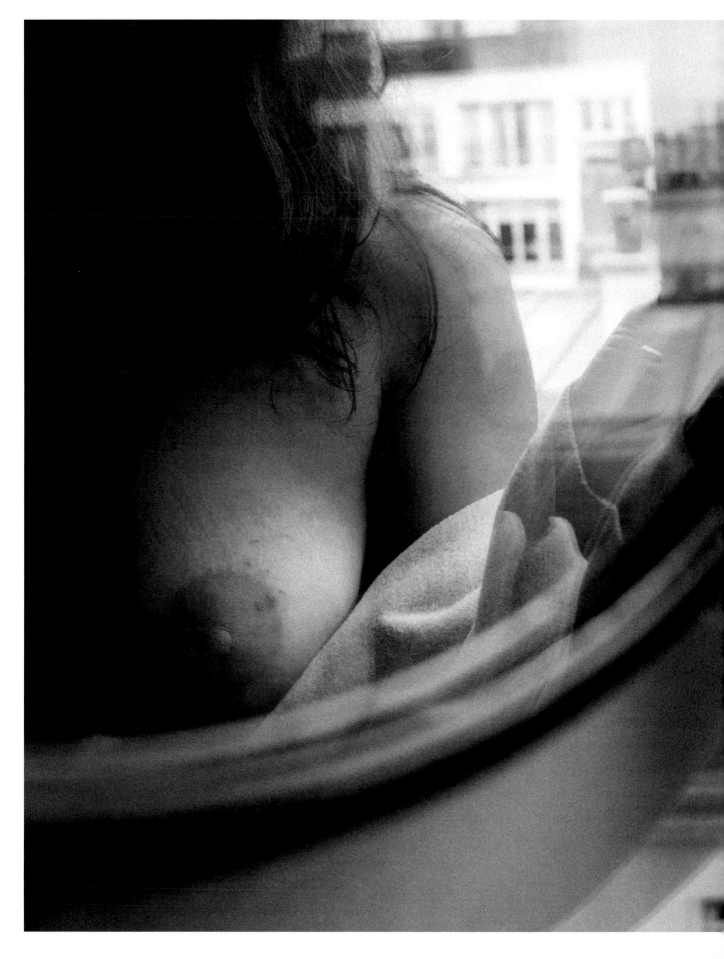

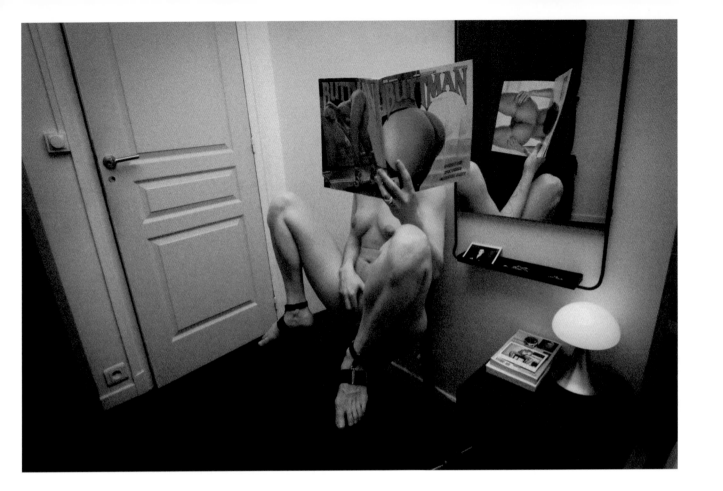

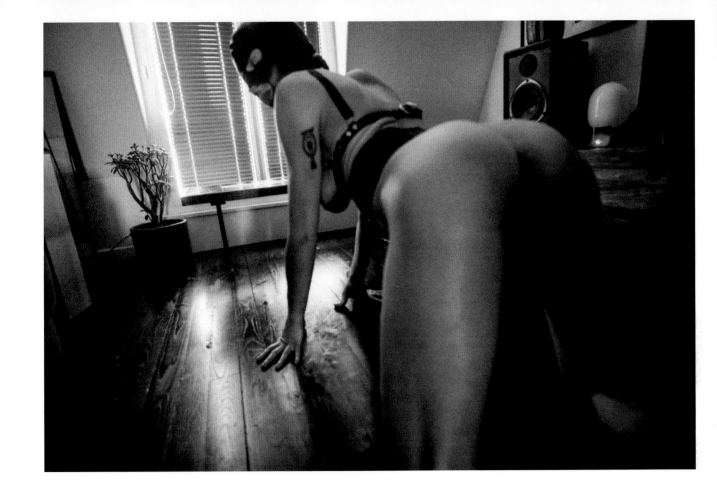

117

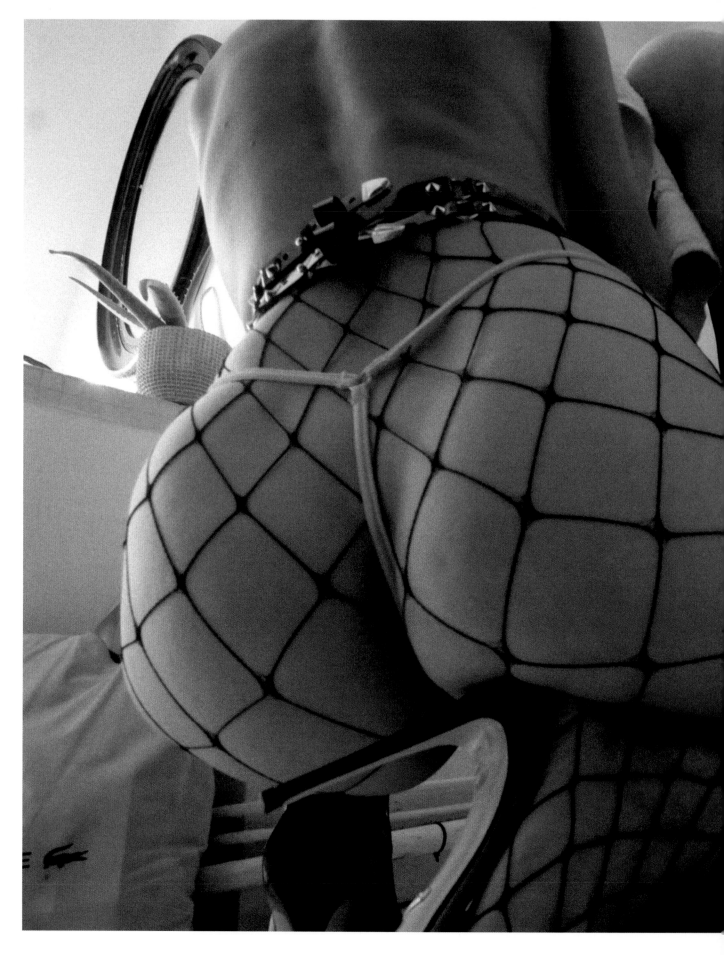

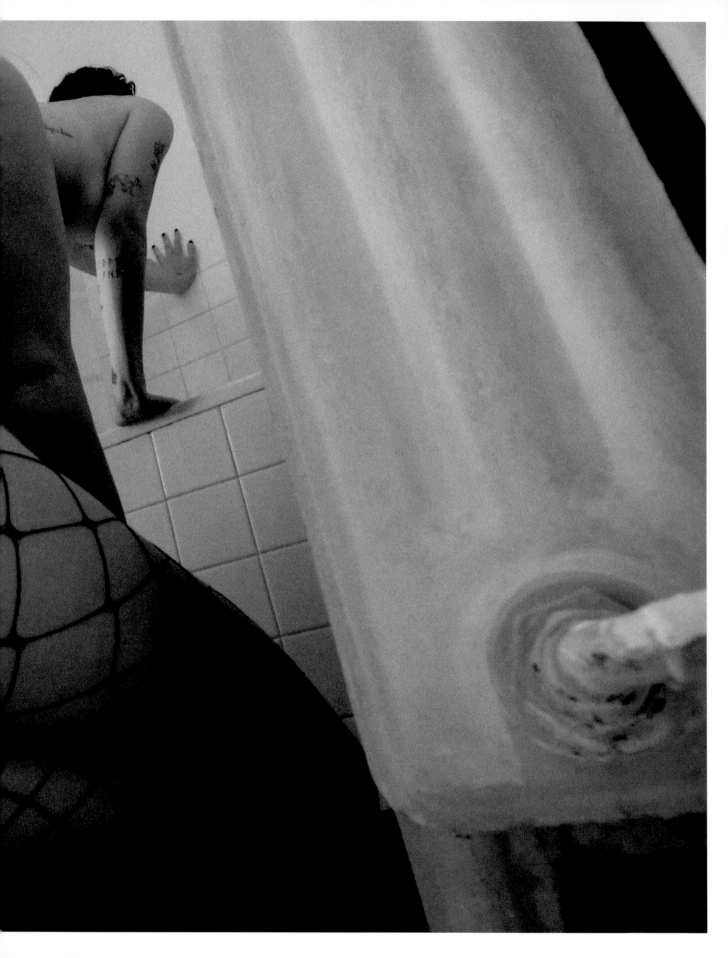

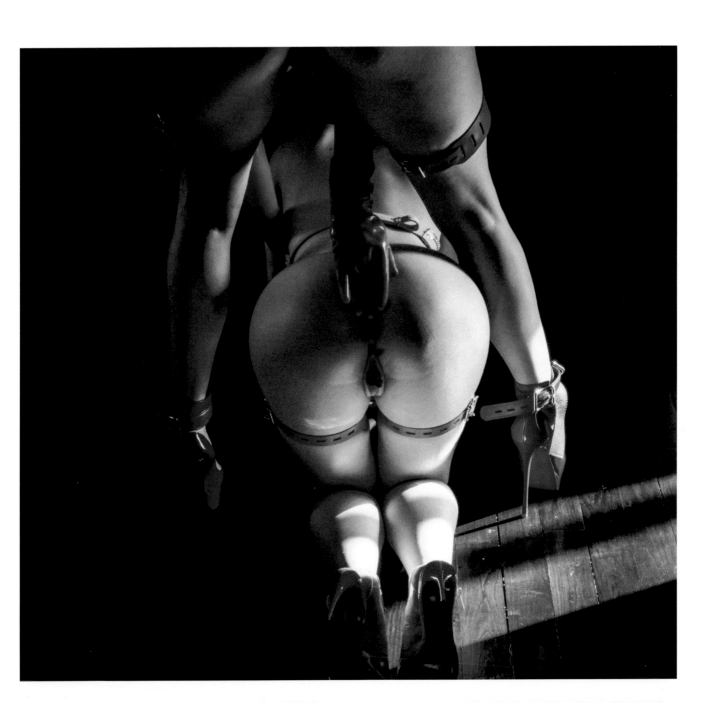

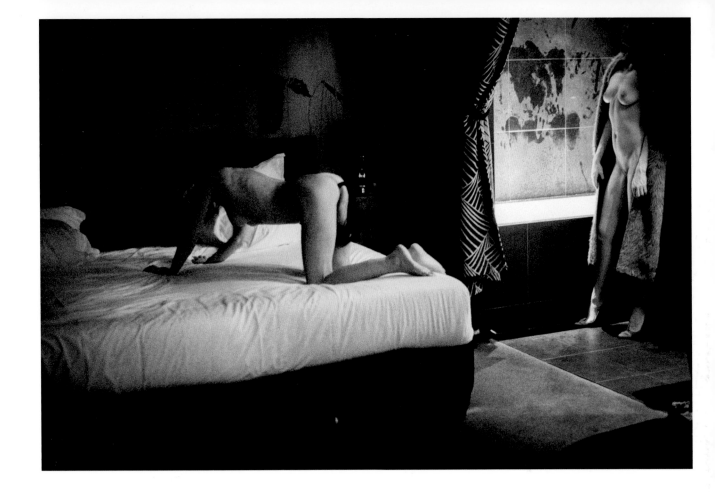

121

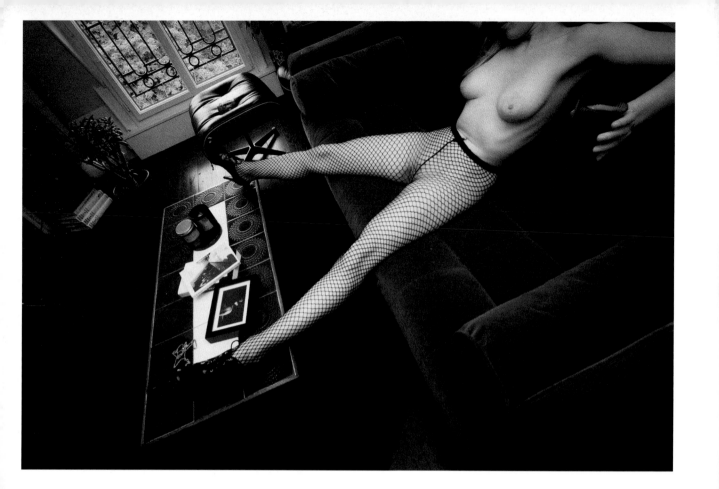

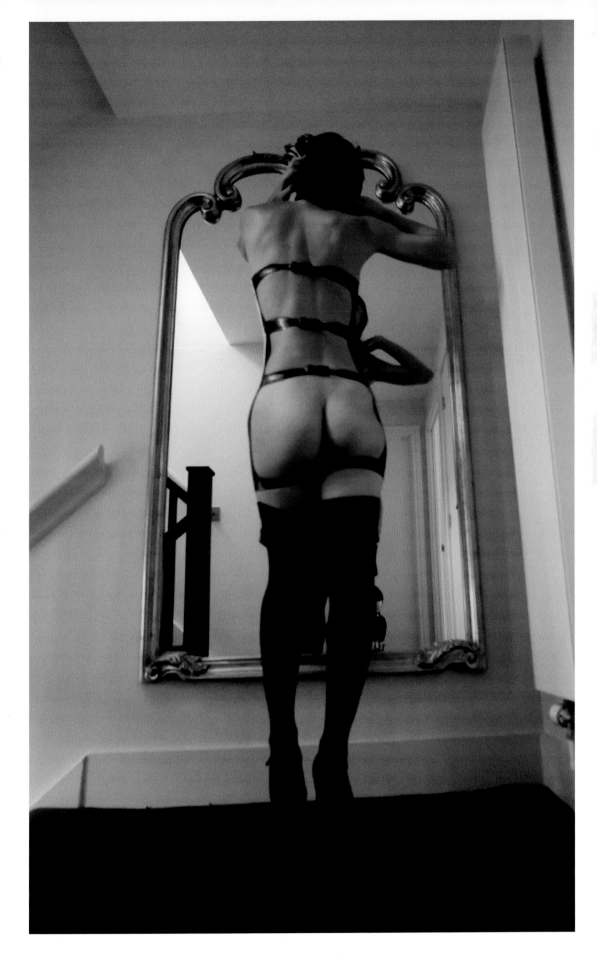

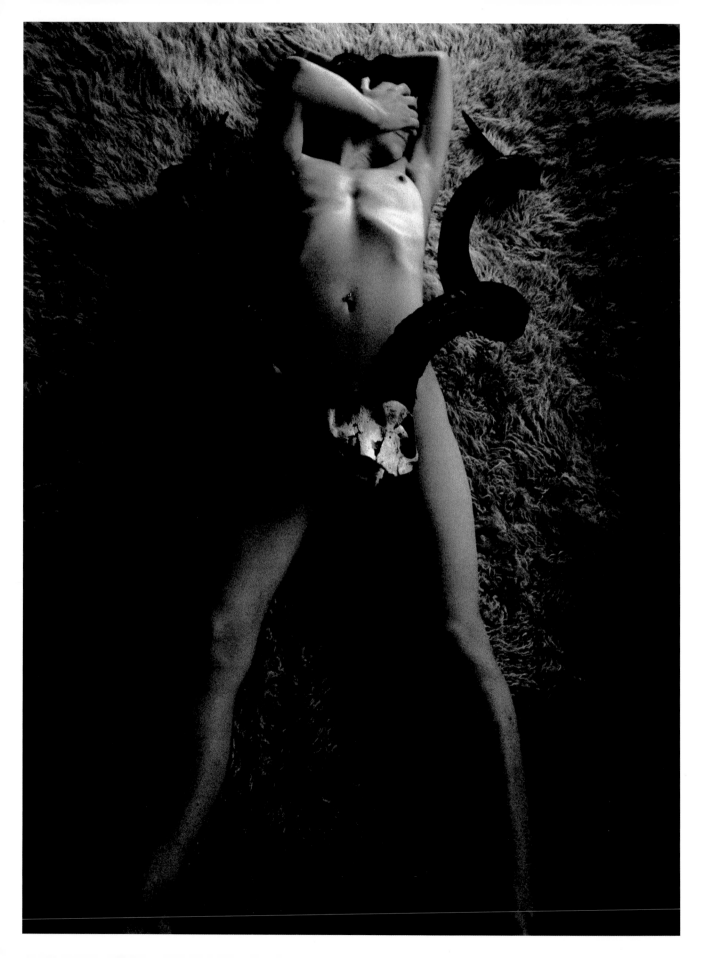

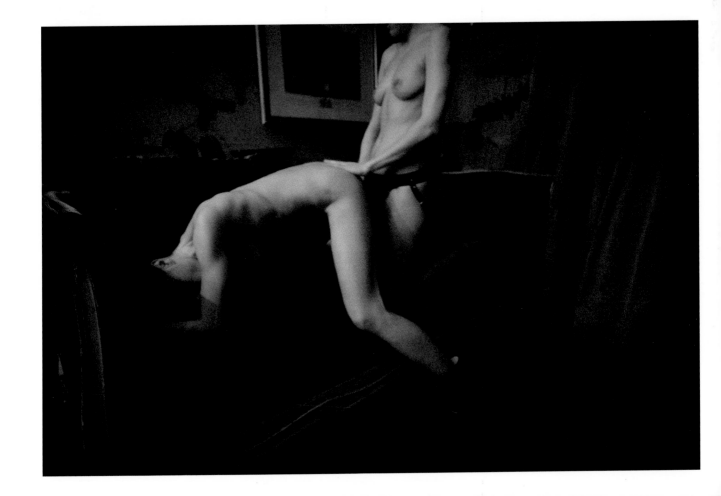

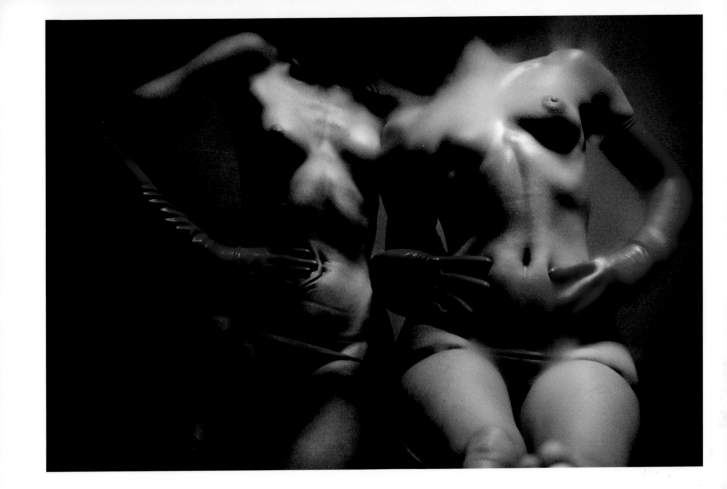

129

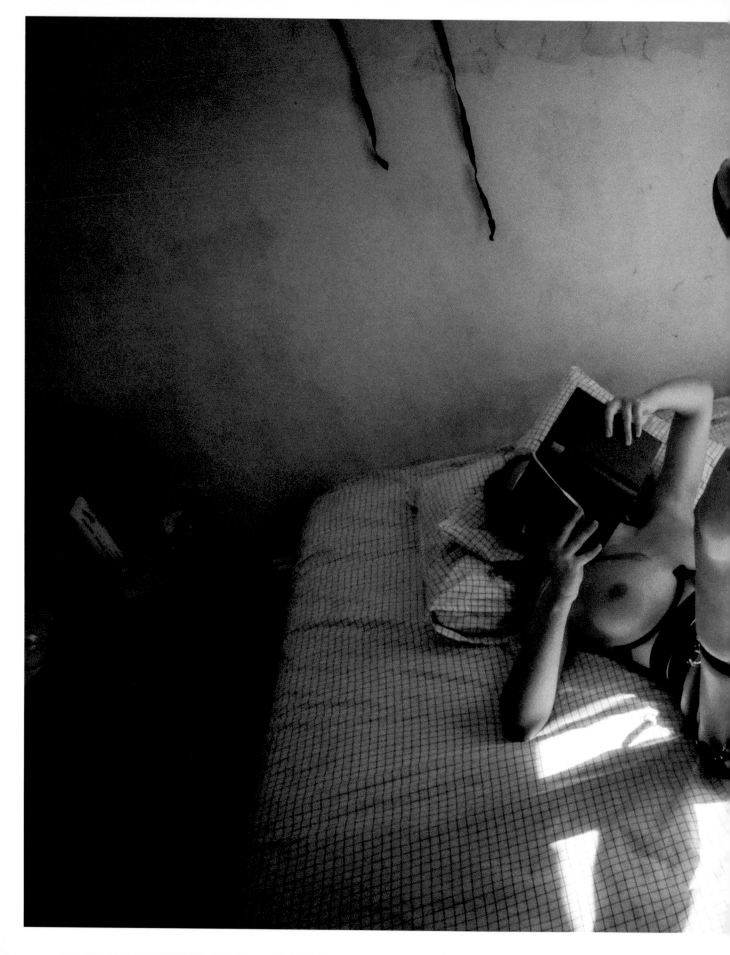

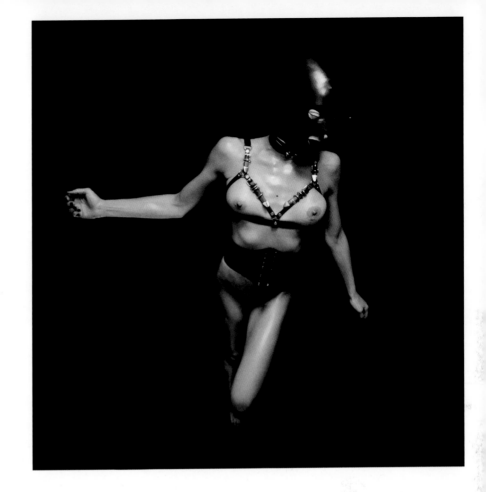

135

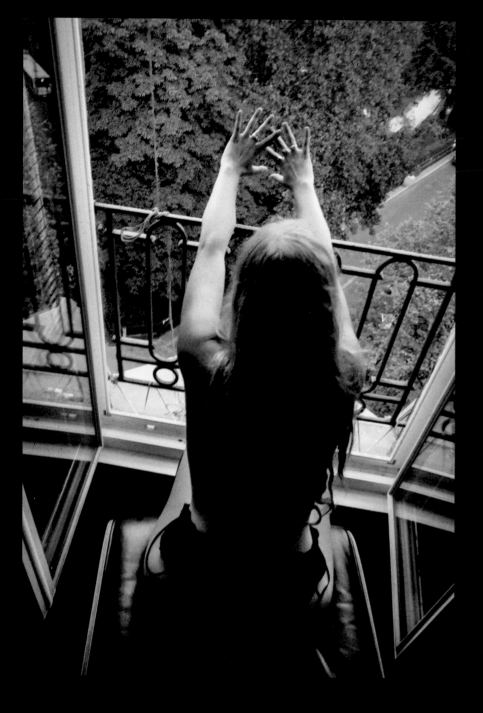

4. The Millionaire

1

I have found enough to feel at home in this existence. I have found money, love, independence and the right amount of solitude. Try to understand why – one should not over-judge other people's behaviour – my privileged position on earth has helped me to learn a great deal about the human condition. Most people think that men like me have no morality and indulge in false promises to get what they want, neglecting the appalling poverty of populations while living in 'Million Dollar Streets'. They conclude that me and them are different, that I am not human, in fact they want me to be above all imperfections, they want me to be super-human. Of course it's nonsense. Whoever we are, we are made of the same mistakes, the same anger, the same greed. We cannot escape our flawed humanity. "To err is humane" I believe is the ancient saying.

2

Death, of course, unites us like nothing else. Unlike animals, we are sentient beings living in time on a journey towards our ending. We have to accept that reality in our consciousness. To live is to accept the inevitable triumph of death, existence is a constant fading, still it would be a shame to complain.

3

My point is that with a bit of imagination any life can be turned into a fantasy. One can vary one's pleasures, break the dull rain for the sky to blossom with marvellous colours. One of my most distinct experiences in that respect is a yellow telephone in my study that I had installed during a rainy summer after the most awful thing happened to my romantic life: my wife moved into

my house. At the time, what did I know about love? Not much, but parallel to her intrusion I had noticed a change in our passionate exchange. Our love-making still inevitably ignited each other, but deep inside there was always something that remained undissolved. I was left with nothing but torment.

4

I ceased to sleep normally. Moaning like a dog who barks in his dream, I would agitate my legs in bed as if running before freezing into a breath-holding position. Awoken by my own screams, I would extract myself violently from my troubled dormancy, my soul choking, while laying supine trying to rationalise my fear. The panics of my nights got me accustomed to staying awake until daybreak, sometimes not sleeping again until the next evening, hoping that exhaustion would keep my sleep under control so that in bed the next night, I wouldn't awake in a rush of adrenaline thinking that I was mortal.

5

I kept the yellow telephone locked inside my mural desk downstairs, its golden key hooked on a chain around my neck. The phone would never ring as ringing was not its purpose. Unconnected to the main line of the house but to a separate line built specifically for it, it arose many suspicions in my young wife.

6

My marriage was burdened by the intrusion of this new colourful object. Symbolically, the phone connected me to an exterior world from which my wife couldn't afford to be excluded. She accused me of selfishness and demanded that I give her a final truthful answer about the meaning of this phone. She ordered the heart-to-heart conversation that lovers owe to each other, but despite her insistence in asking me the same question numerous times, the answer she desired was never revealed to her. In return, she only heard my silence through and through. Her frustration grew considerably.

7

I got the idea of the yellow telephone one morning after I spent one of my sleepless nights downstairs reasoning everything through. The continuity of my thoughts led me to see the shape of a yellow telephone that I would pick up during my many night-time distresses. I immediately sorted the practical details of my new idea and my butler had the object installed the next day. The telephone was to work this way: I would pick up the receiver to say one word ("tonight") and thus trigger a series of events designed to defeat death and the monotony of life.

8

The night was dense. The helicopter flew above the pavilion's rooftops on the north of the city in the direction of the mountains. At home I would fear the darkness of the night with a giant perplexity. Here I cherished it, the only moment I could see but not be seen. Towards the horizon the giant silky bed of the sea was shining with the absence of boats, and the presence of the giant moon scattering its silver light on everything. I remembered my bed and the sudden taste of death's certainty, which I felt so many times while lying in it, but I smiled thinking of the supreme terror that I was about to experience and, I was sure, was about to annihilate every particle of this anxiety.

9

The helicopter left me on the side of the mountain in a deserted patch of grass surrounded by high trees. The machine flew away rapidly, its flapping sound gradually disappearing and with it the last sign of civilisation. I immediately started running towards the forest and trudging through high bushes as far as I could, I tore my clothes off and threw them up in the air until nothing remained on my body but my socks and boots. At that exact moment the night had reached its summit of darkness and I rolled down into a bed of humid moss like a rabbit into a hole. Then I waited, for what seemed hours, feeling cold and fully alert and alone in the humid soil. I grew gradually disaquainted with myself, a feeling akin

to happiness and relief. Like a snake that hides to get rid of a layer of skin, I was certain that I would leave something of myself in this hole.

10

The helicopter flew above my head again and landed in the same spot where it had previously abandoned me. I heard a few men's voices but they soon wore off, dividing through different paths inside the forest. During this paralysed but lucid moment of separation, I felt my body in a totally different way and that sensation of estrangedness got me excited. At the sound of each of their footsteps I could feel my member hardening. Covered by dirt and lacerated by branches, my body convulsed in the contradiction of its desires, afraid and eager to be found. No trace was left of the old terror of my inevitable death that I once felt in my bed. The blood in my body was rushing in my veins to signify that prime existence was beating the life out of my heart. I had never felt so painfully alive.

11

A few moments in existence offer the gift of the present time. The present is pure, it cannot be boxed and is inevitably fleeting, we regret its loss while being condemned to reminisce about the past or make plans for the future. I thought of the moment when one of those men would eventually find me in my hidden rabbit hole and would do what he wants with me, for such were the rules. The present would be more present than ever before. Eventually he would be joined by the rest of the group, who would do whatever they want with me too, until the sound of the helicopter would signify the end of the game and they would finally leave me alone, beaten on the cold earth, remembering my humanity only by the warmth of my human tears.

12

What would you feel if you saw a rich man like me curled up in a dirt hole of a remote woodland encircled by the sperm of men who have reduced his body to nothing? Let me tell you what you'd feel: joy, utter satisfying joy. The

satisfaction that for once justice has been done and your interests have been served. You'd take a deep breath and sit on the greatest sense of achievement you'd ever get to own, pushing down any sense of guilt you'd feel rising inside your chest. Because the version of the world you believe in would be happening right in front of your eyes. 'At least for now' you would think, 'I allow myself to enjoy this moment'. And I understand you, because I have felt it too, the power of standing above. I offer you my degrading pain, my vulnerable body, so you can understand that in the end you and I are part of the same species.

13

With my eyes still cast down, I tried to concentrate on listening and define the limits of the sounds surrounding me. At first, everything seemed to merge together and it was hard to know where the mountain stopped and the men begun. When their footsteps grew more distinct I felt my neck swell and my back tense as a response, a faint grunt slipping through my closed lips. I heard the sound of a man who started whistling, as if calling an animal to his feet, and the hissing melody absorbed all the other sounds, its music fencing me in. I remained captive to its magnetic power until the man's presence felt closer and closer and he finally stood a few metres from me. When he ceased to whistle, the silence felt just as impenetrable. For a moment I hold my breath considering what I ought to do. Looking at the man felt impossible. I heard him slowly fish out his cigarette case. I smelled the smoke a few seconds later and heard him blow it out with a great contagious calm. My heart resumed its beating while an erection grew more intensely inside my pants with each breath.

14

I don't think he had a plan, neither did I, but he stayed in this spot for a very long time. I finally took a chance to try to see him from inside my prison. He was not looking my way, letting his attention dissolve into his cigarette, twirling his lighter in the fingers of his free hand. I felt a special attraction to the sleek blackness of his silhouette

vanishing into the night. I contemplated his neck and the strong angle of his jaw, the delicateness of his wrist from which hung a silver chain and on which the moonlight constantly reflected. I contemplated the muscles that soon would break all of me, inside and out. Ah, to look at death and not be seen by it! The man was staring at the horizon with a feline precision and I desired nothing more than to plunge under his blue gaze like falling into the black ink of the sea.

15

After I made a detailed study of the man, I felt bereft of fear and realised boredom had taken its place. My mind was suddenly seized with the horrible thought of tomorrow, Monday morning, when it will be time to get up. Something had to be done. My legs started to ache and I urgently needed to reach a more comfortable position. I began moving cautiously and soon experienced the familiar pleasant yearn to be found. I didn't understand why I so poignantly wanted to be found by him, but I ached to take a look at his face when he would hear the sound of branches under my boots, realising his main prize was getting away. As I jumped out of my hole, fear took its rightful place again at the centre of my plexus. I went on far ahead as fast as I could but had no courage to look back, feeling dizzy from my brusque breakaway. The sound of his heavy footsteps behind me and the bitter whiff of cigarette smoke encouraged me.

16

Three, four, six men joined the hunt. The echoes of their pace growing faster on either side as I ran to my ending. That long chase into the night excited me, made me drunk. I inhaled the thick air of the damp night from the top of my lungs, each step an adjournment of my inevitable defeat. Finally, feeling trapped and out of breath, I stopped in a small clearing where they soon encircled me. Caught by the moonlight my penis stood erect like a spectre through a bed of emerald leaves, standing maybe too proud and defiant for my victimhood. Slowly the men came near. The rapture that took a hold of my body at

that instant shook me from head to toe, a supreme stroke able to change a man's entire life. I saw the advancement of their shadows intermingling at their feet, one more step and they would be a breath away from me.

17

Before me stood a tall handsome man with threatening grace, staring at me with his two shining eyes. He caught my penis with one hand as if I was not just a man but a machine he had to ignite. The rest of the group echoed his gesture with the same mechanical charm, grabbing random parts of my body. One of them suddenly muttered "found you" while swinging his hips very slightly towards me as if there was no need to hurry now. I tried to imagine the pain awaiting me but the pain we imagine is never the pain we end up having, in fact the anticipation always hurts more than the act. Minutes passed and the fear that pain would come merged into the fear that it would not come. With an air of assumed humiliation my gaze dropped down to the row of penises in front of me. I reached to touch one, knowing the man who was holding my sex would now slap me.

18

Most of the time I didn't understand what was happening. It was a strange vision, those limbs fluttering under the moon. It started with a quick slap after another, then kicks. I was pushed from arms to arms, like a doll, with a laughable and grotesque passivity. How could I be excited when my body was debilitated by pain? All week I had longed for this kind of abandonment. Once my body completely surrendered to it, I didn't suffer anymore. Each lapse between each blow were capsules of pure happiness. By narrowing the window of comfort I was giving myself all the better chances to grab pleasure even more perfectly. I fell on the ground where I rocked myself in tears and orgasms.

19

Bruises – a red one, a yellow one, a green one – mapped the surface of my skin as I wrapped myself in a blanket

inside the helicopter that flew me back home. I enjoyed the wordless silence of my journey through the end of the night. I had worked far too hard and endured far too much to not appreciate the peace that followed. I was rushing home with lassitude, finally ready to compose myself to sleep. All this time my wife had been in our bed and I was filled with unutterable bliss at the thought of being with her soon. Once I lay down by her side, I immediately felt the warmth of her skin radiating from her, it was like aspirin to me. I let her calm respiration oxygenate my dream as I fell asleep almost instantly.

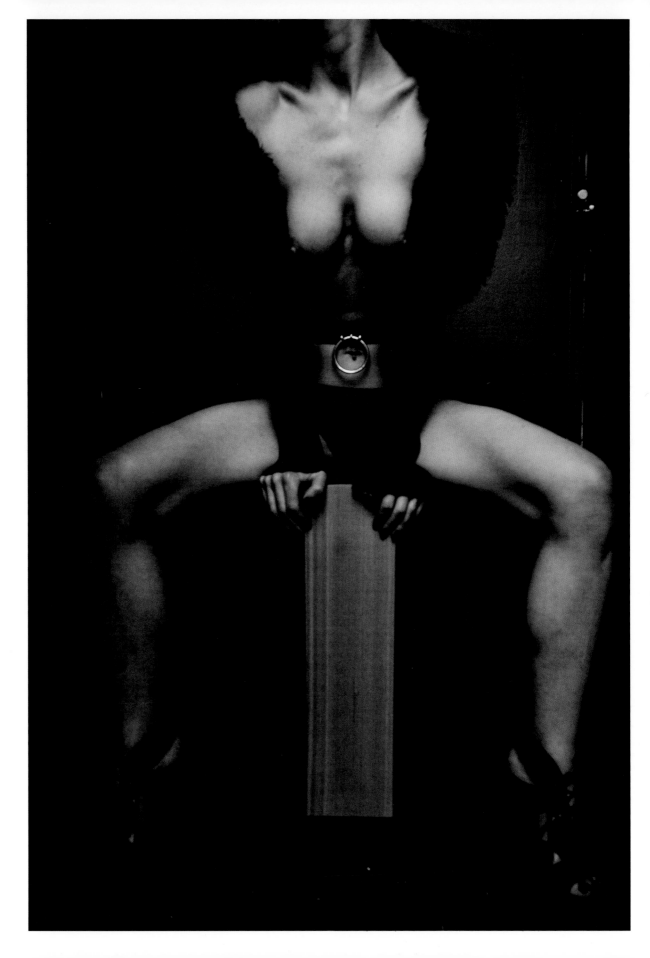

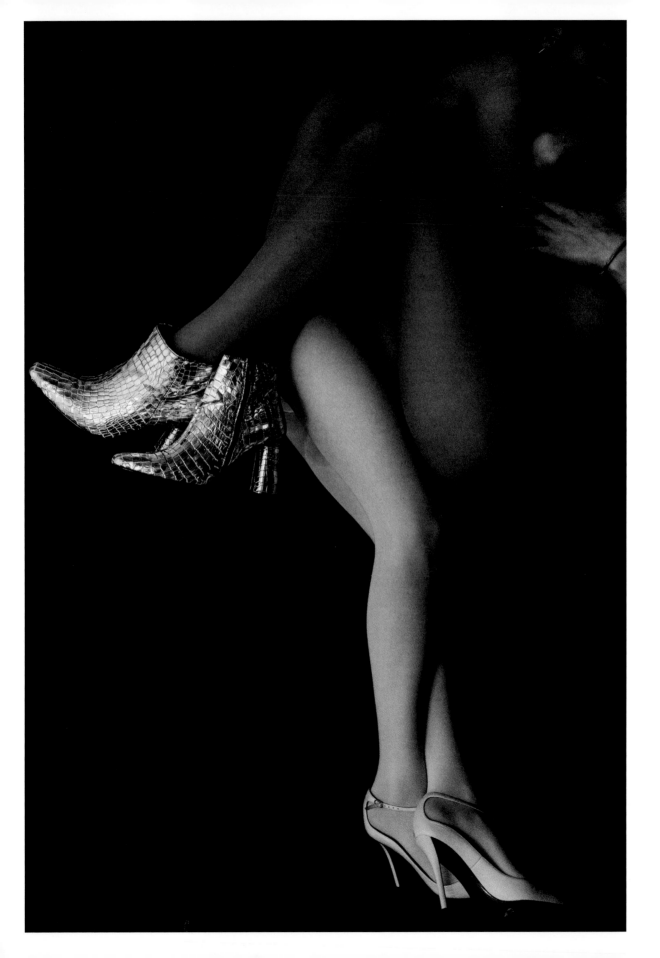

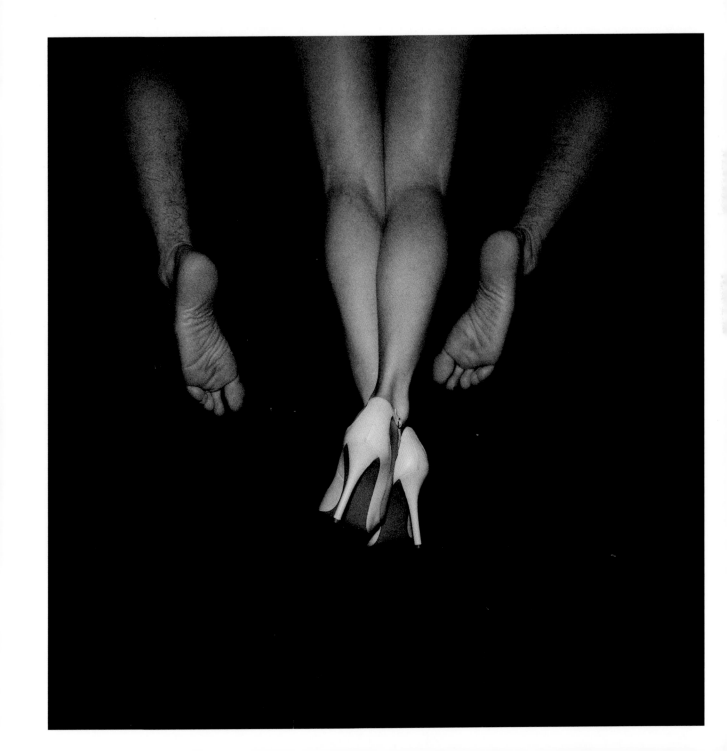

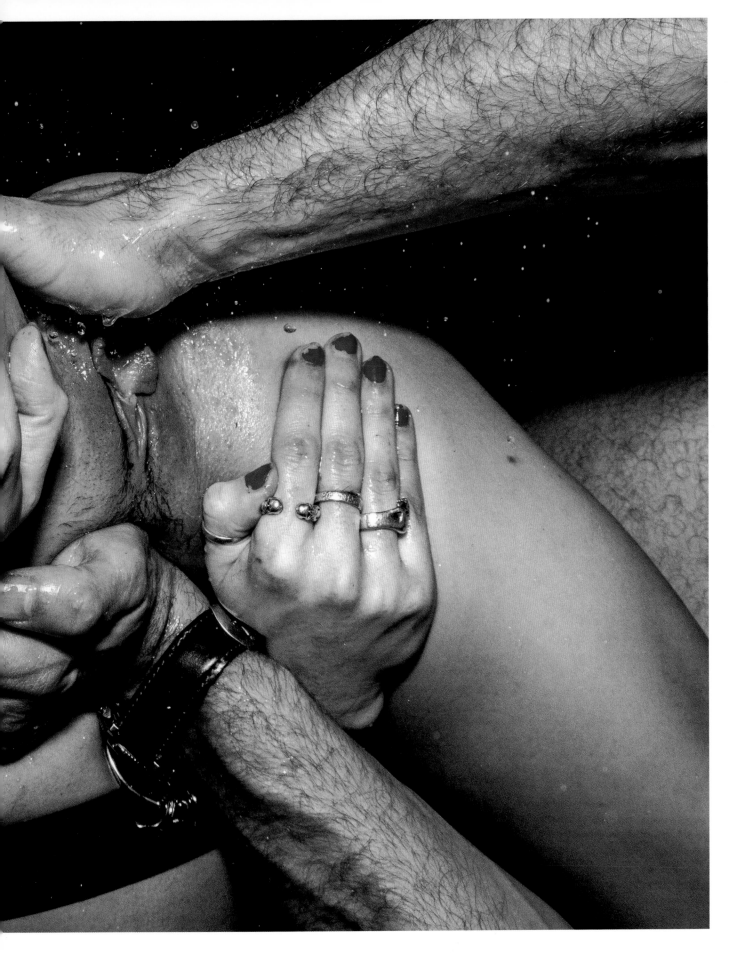

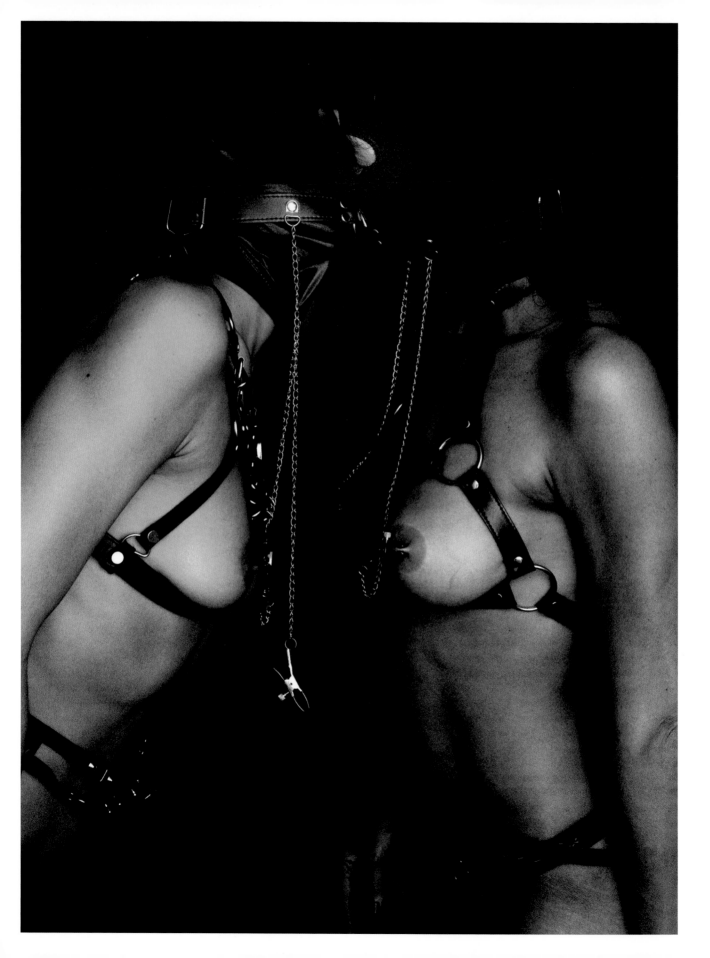

151

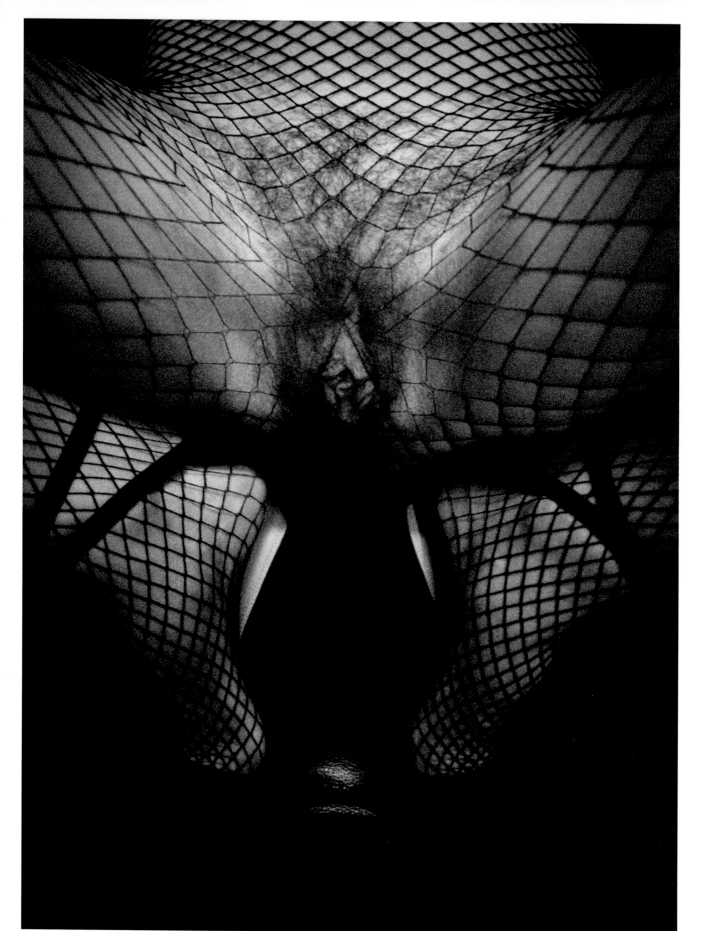

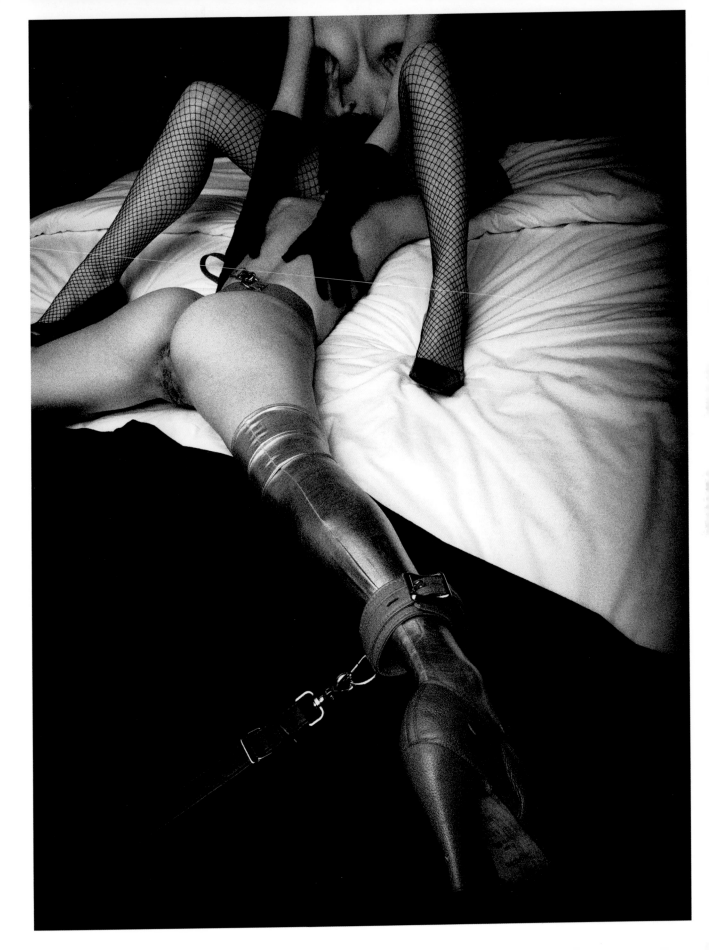

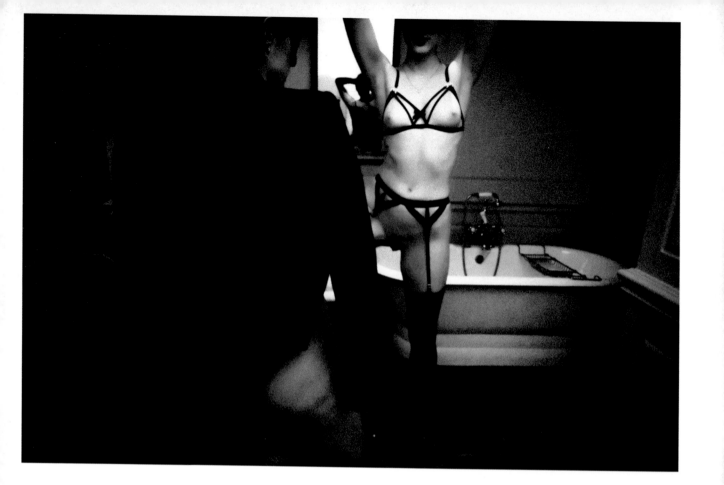

154

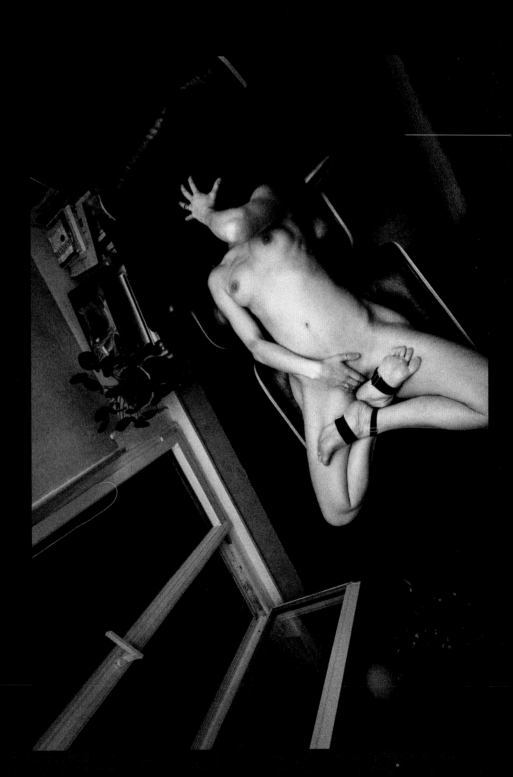

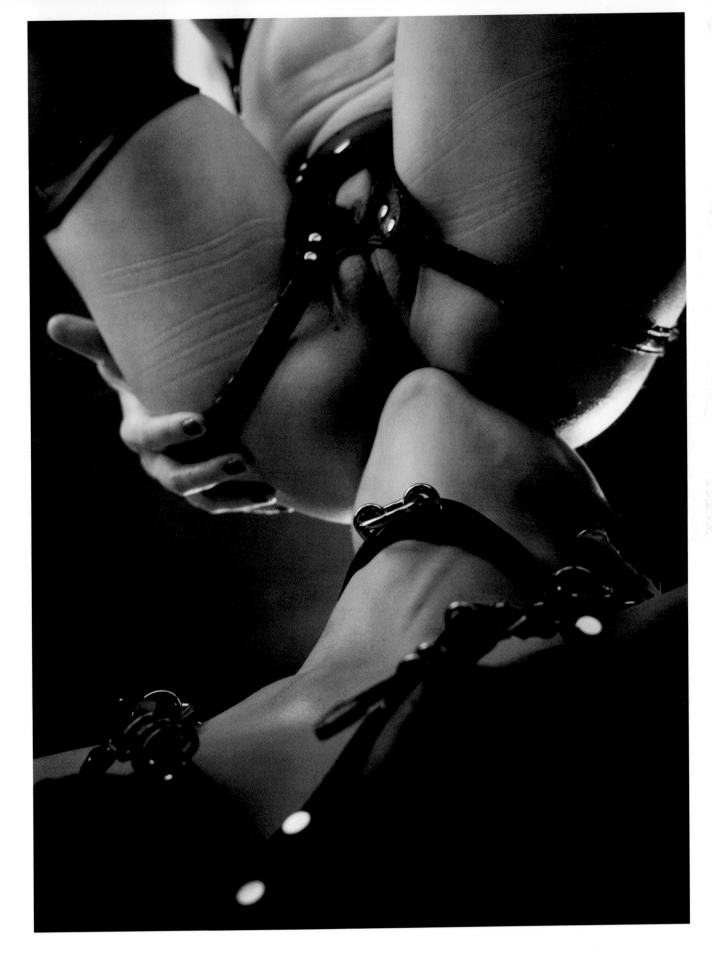

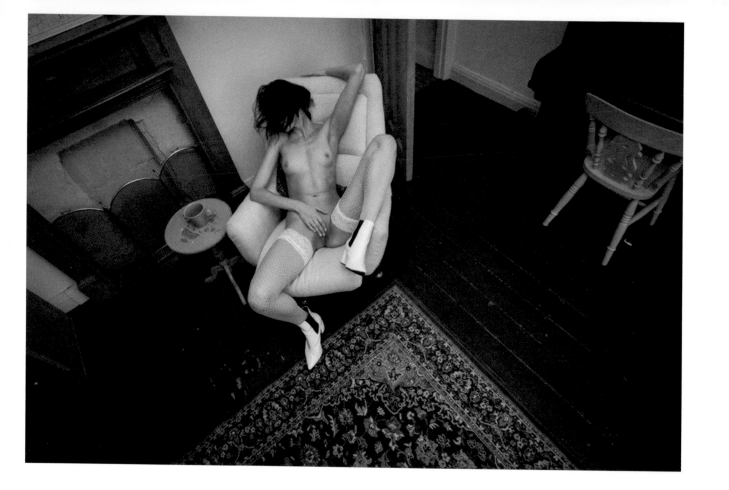

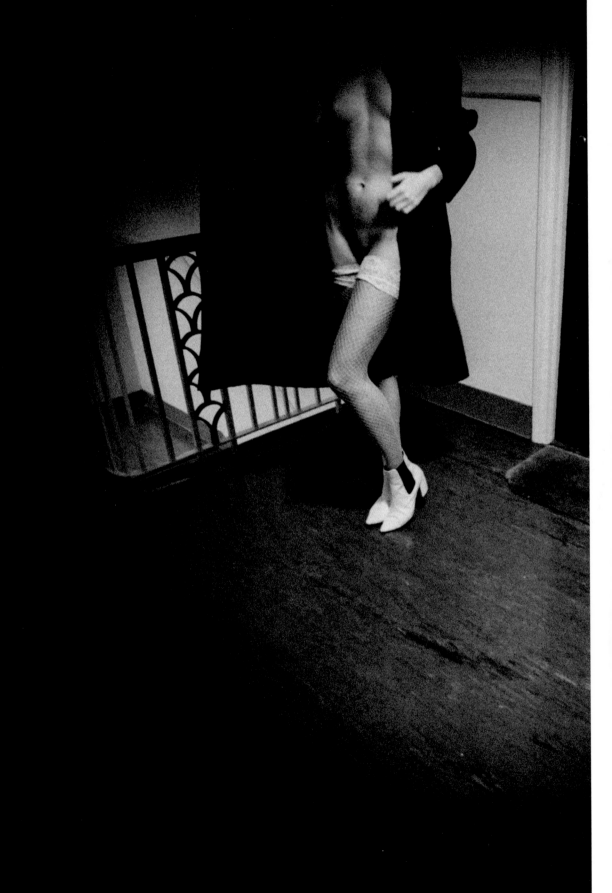

163

165

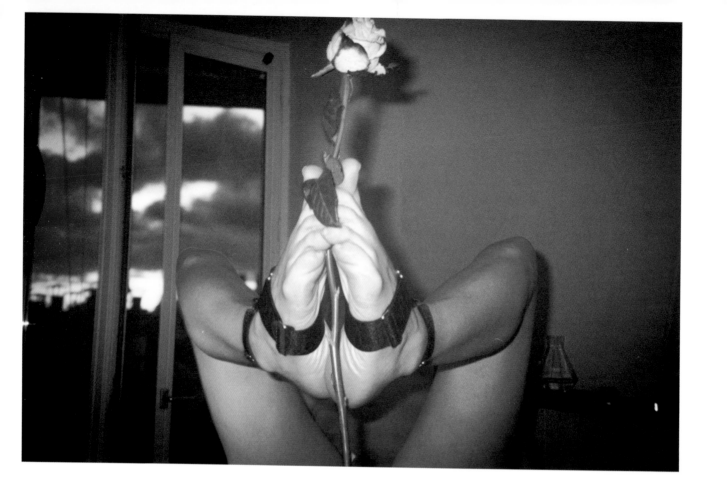

170

171

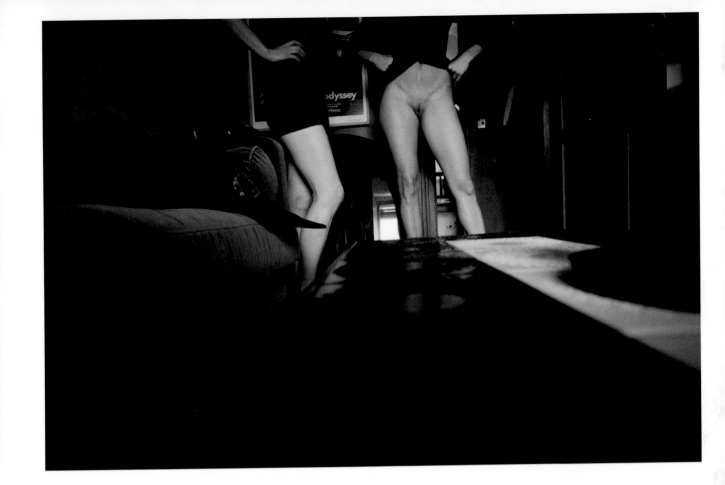

173

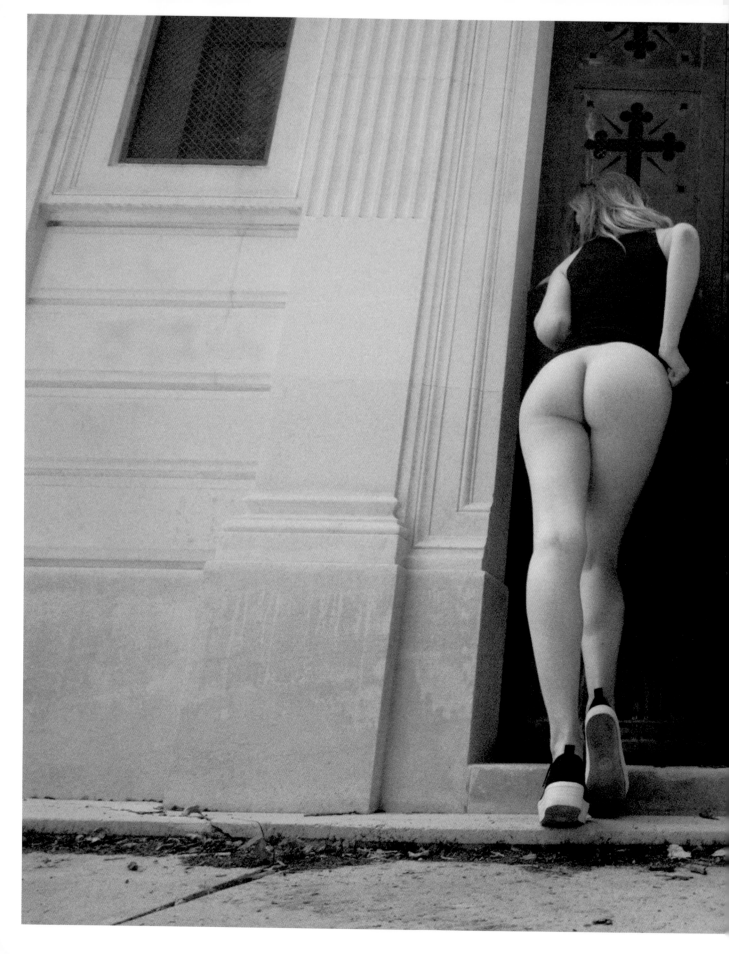

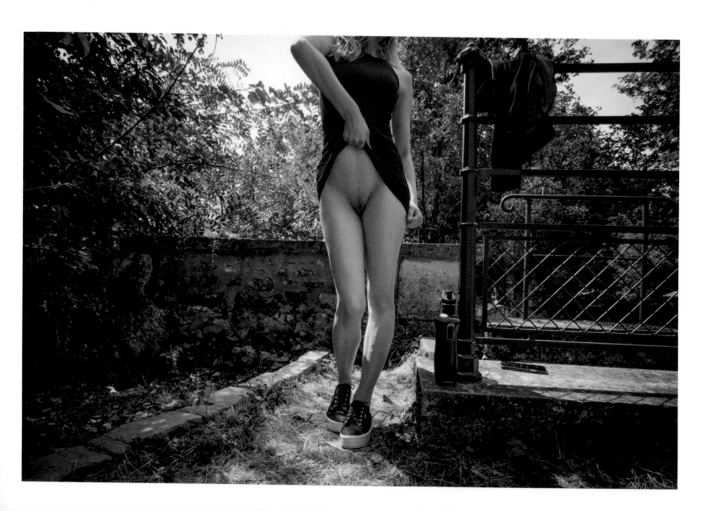

1

When they said they were going to tie me up to a tree in the forest, I didn't believe them. When they affirmed their authority by spitting before my feet, I didn't dare ignore them but I still didn't believe them. I cannot explain such faith, today it would be impossible to recreate it. The gods who constantly inspired my beliefs as a child, who made me see my existence as an orderly labyrinth at whose centre lay a beautiful pond that I knew one day I could reach, must have died a long time ago.

2

The event took place when I was a little boy. Subsequent events should have distorted the memory of that first day – yet I seem to remember nothing else so clearly. The loss of memory for everything anterior to that event is also the most significant symptom of my condition: one single moment from which the rest of my story was written, a black hole that constantly draws myself to its centre and from which I can never escape. The adult I have become interprets the kids' rejection as a chaotic expression of their attraction to me, hatred and desire dangerously yoked together yet competing for survival. But in my young mind, although I knew their intentions to be impure, curiosity was lending me a naive temerity. I knew very well that every step towards the forest (I discovered afterwards that I was never forced to walk) would awaken endless waves of self-reproof, verging on self-pity, a sensation of sheer irrationality mixed with the certitude that the forest would become the first border I would cross with great intellectual horror towards my insanity. But nowhere else in the world had I felt so courageous and so happy, a sensation of great danger invading my core.

3

When I disentangled myself from those lascivious sensations I found that I was attached to the trunk of a tree whose thickness at the contact of my hands felt it had existed long before mankind, long before the universe itself. The thought crossed my mind that my new vegetal support would provide enough wood to construct a coffin for everyone of us, including the boy who had led his group of friends and myself to this dark place of the forest. None of us knew by then that for many years to come this moment would curse my troubled mind. For now this was the primitive tableau of bored little men mistaking cruelty for fun in the countryside. Behind my executioners were corridors of trees becoming monumental walls at the advancement of the night. I didn't recognise the architecture of the forest at first, its symmetries imperfectly rendered through the sensation of oppressiveness in my head (with blood rushing to my eyes). I realised I had no balance, or a balance new to my body. I felt airy but close to the ground. I saw upside-down leaves, upside-down moss and upside-down tinder, an upside-down ladybird came flying towards my nose (to this day I still wonder if those memories are faithful recollections of events that truly happened or mental warped residuals created by the many nightmares that followed). I saw the boy pull out of his pocket a hurried knife, he used it to sharpen a wooden stick he was using as a walking pole. He was paying less and less attention to me as though the game was starting to irritate him, or maybe he was feeling hungry and remembered his mother's apple pie waiting on the kitchen table. He rubbed the tip of his wood clean with his palm and forearm and suggested to walk back home with the others. The little crowd left and I found myself alone hanging upside-down from the tree.

4

The forest, though a few steps from me, seemed incredibly out of reach. Motionless, I perceived the first dusky light of night and soon heard the beast-like sounds coming from the jagged shadows of the woods. In my line of horizon, I saw the heavens in the sky above offering

the theatrical proof of a complex universe. I prayed to the gods to save me that night. They were gods created by my imagination, cruel tyrants of immense perversity fighting battles unknown to man in the largest spaces between the stars at the top of the highest trees. They were ironic symbols of my pathetic inescapable obedience to the ropes. From that vivid picture I wondered if the universe had a memory, if all my anxiety and desolation could be transmitted from where I stood erected on the top of my head. Suddenly something like joy shifted the course of the evening. A gentle rain fell down and I saw the trees offering themselves to water with reverential awe, as if satisfying a need lost and forsaken for centuries. It was not just joy – but calm – a calm that I felt too (this you will not believe) from the lower part of my body, which in my current situation was facing up. The water was the gods whispering – not to my ear but to my crotch – and with the songs of the frogs who ran out to welcome it, I felt it fall onto my pubic area. Soon the accumulation of water totally wet the fabric of my trousers and the liquid slid down underneath my shorts to my penis, down slowly to the part in between my bum cheeks, through my belly too, my torso and gently to my neck. The water was cold, caressing my skin, and I held my silence through their delight as if the strong arm of Nature had come down to give me my first hand-job.

<div align="center">5</div>

After what seemed an infinitely long span of time and particles of water had taught me all they knew about their centuries of living, I felt a warm presence in between my legs – I was certain of it – that gave me the sensation of being split in half. In my self-absorption and because of the intensity of the pain, and the insensitivity of my limbs as a consequence of my position, I scarcely perceived the physical world around me anymore. I hadn't noticed the silhouette who had walked up towards my upside-down body and was now standing in front of it. I found that the warmth between my legs originated from the mouth of this stranger, held wide open in front of my phallus in an effort to bite through my jeans. This part of the story may

seem unreal because it's a known fact that the perception of a man is strongly altered after long hours exposed to an upside-down position. I will admit to that. As the years advance they are no longer memories, they are body reminiscences. The anonymous biter opened my zipper and licked the head of my erect penis. I wiggled violently with a short animal scream – shocked by the electricity of the touch – until I reached the absolute plenitude of everything and fell out of consciousness until daybreak. In the morning, I found myself wet and free from the ropes, alone and curled up at the bottom of the tree.

<div align="center">6</div>

Here my story grows more strange and complicated. Soon I realised there was a life before the forest and a life after the forest. I survived ordinary days of terror only I knew existed. I kept forgetting about it but the emotions kept returning. One afternoon a group of girls persuaded me to do a handstand in the schoolyard. When I did, I started to wet myself uncontrollably all over my blue jeans and felt the liquid stream down over my face and enter the inside of my nostrils. I saw the girls bounce away laughing through the blur of yellow liquid covering my eyes. I finished my day at the back of the class with wet clothes and the smell of piss. One night at a friend's pyjama party, the lack of beds meant I had to sleep top to tail with a girl. I felt a guilt-filled desire moving very fast inside my body which totally disappeared once I turned the opposite way. Later as a teenager I had to apply ambiguous methods to convince the girls to touch me upside-down, realising that was the only way my body was responding. Most of them refused and walked away, one of them let me put my legs up around her head. All these experiences never brought me complete satisfaction, often bordering on humiliation, until years later I met the man with the glossy hair. Not only did he agree to tie me up naked to a beam in his house, my head not touching the floor, but he added a vulgar detail, he asked me to resist. With great joy I would wriggle like a worm on a fishing hook and beg him to let me go. My arms were tied up behind my back to make my escape impossible. He would stretch time and

play with me, calling me names, spitting, slapping, until he would pull his hard penis out and stuff it inside my mouth. At that instant I always knew I was tasting the proof of my own destiny, I had been robbed of my true nature all along, and this was my story, no one else's.

<div align="center">7</div>

Here I was. His balls on my chin, ravaged by a desire that profaned the laws of nature, defying gravity, perhaps re-writing the occult manual on bad behaviour. Day after day, from jubilation to jubilation, I came back to him and felt reborn. After our first encounter he made me promise to never tell a soul, for my own safety, he said. To me it was impossible to believe that this was an act that someone could frown upon. It felt so complete, universal, touching me on every level, undertaken not by one particular man but perhaps by the whole of humanity. Once suspended, fear would grip my heart, the position always creating a sense of physical terror like the sight of a crucifix turned upside-down, with blood rushing intensely to my forehead. Through hours of trance and ecstasy, enlightened by my reversed point of view, I learnt new ways of appreciating the human condition. I learnt that things below are the same as things above, that the hungry man is connected to the satiated man, that the lying man is bound to the honest man, that every man is in fact two men joined by their inverted actions, so that when one is awake, the other is asleep. I never found a rebellious word in me to forfeit my ordeal, in fact during the act itself we barely spoke. To omit those words only strengthened the effects of the sessions. In the eyes of the gods I used to pray to as a kid, I was convinced that him and I were two opposites of the same being and he was helping me to mark my stain into the world with the stamp of my incurable perversity. There was never a rehearsal prior to the execution, always the real act, from which I emerged exhausted. Then came the ritual of washing my body, and the floor, to prevent the abominable act from sullying the next day.

8

Springtime came and I met a girl of divine intelligence. Her eyes were like marbles the colour of cypress trees. Her figure was that of statues found in the Roman temples of Antiquity, built on a single muscle arching from head to toe, an idol of fortitude and innocence. It was the absence of artifice on her face that struck me as beautiful, and the cup of her bum cheeks never fully seen under her short dresses. I enjoyed her company. With her I felt I was someone else, someone new, and our conversations were a distraction from my traumatic self-centred obsessions, it never crossed my mind to spoil them with the dark story of my past forest incident. At that point in my life I could think of myself as a happy man. I joyfully cruised through the weeks that preceded the fatal moment of the sexual act, the day I had to face the inevitable encounter of our complex human bodies. Back then, I hadn't been touched by anyone since the man with the glossy hair. I was wounded, so gravely wounded I should have been on the edge of my life, but in the abyssal depth of my suffering I had lost my capacity for pain and I hung on to the girl with the marble eyes like one hangs desperately to a single lifebuoy in the middle of the ocean. During the last days of June, she grabbed the side of my t-shirt and pushed me inside her cold bedroom. The blinds were shut and I remember the freshness of her sheets in contact with my hands, I wanted to lose myself in their folds, plunge my head and rub my face into them until I could find enough peace to fall asleep. But such a craving for comfort was not allowed, the moment had come, she wanted to have sex.

9

The first thing I felt was a sinking inside my stomach, and like the deserter who's about to flee the army, a strong desire for this moment to go away. When she pulled my t-shirt from my chest I realised my wish was probably pointless and I might as well do the things that were about to happen. She kissed me and her gesture felt unbalanced, inspiring pathological fear in me. Her face close to my face felt like a betrayal to the natural order of

the sacred universe. I tried to make my actions like any other but they seemed interminable, vulgar, and all my struggles to perform correctly in vain. I convinced myself that the second steps would be easier than the first, but when she placed her sex above my sex and I felt her pubic hair brushing against my pubic hair, her hungry eyes close to mine, her legs parallel to mine, her body identically resting on top of my body, and the fear that there might be no mitigation to this position, I leaped out of bed and ran to other side of the room. The absence of obstacles, the perfect juxtaposition of our two symmetrical bodies, awakened so much nervousness. I was suddenly alarmed by the feeling of performing the same act that men and women had performed for centuries before me, an act motivated by nature and procreation. My body was quivering to the feeling of conforming to the norm, conforming to gravity, to their god, agreeing to everyone and everything but myself. She walked towards me slowly. My escape had inspired a soupçon of tenderness in her eyes. "There is grief in you" she said "you must turn it into strength". She helped me to sit by the bedside. I couldn't tell if she was able to understand. At this point I was a miserable wretch facing his miserable inadequacy, and my tyrannical thinking reminded me that it wasn't time yet for me to rest.

10

It is difficult to recount with some degree of reality the events that followed. In that time, nothing seemed to happen consecutively. I had thought a great deal about my failure with the girl of marble eyes, the event embarrassed me, but more importantly I had to renounce the hope of living one day a normal life. I wondered over and over if the discomfort I felt was genuine or fabricated. The thing is, I thought, I am unique. Until a man lives his life he cannot know for sure who he truly is or what will make him stand apart from the regular man. So I learnt to feel a certain contentment in my defeat. Besides, I had found a place where I could express my upside-down personality.

11

At night, in a special performance imagined by me, I would invert myself and strip in front of a small crowd in a notorious club in the south of the city. Exceptional and shocking, my show soon became the favourite sexual attraction of the curious and the horny. It felt as if everything beforehand had lead me to this moment, to the stage, dominating a herd of libidinous young stallions. By a single act of public naked suspension I would transform hours of self-devaluation into overrated self-esteem, I breathed an emotion that resembled acceptance, I was acquitting myself from the burdens of my past, and it felt like the battle was won. Their lust awakened by my display, members of the audience would come to me one by one to touch my inverted body and spit filthy names on me. Soon the whole place would reverberate to the echoes of flesh upon flesh, leaving me disoriented, hanging alone surrounded by an orgy of disorganised human bodies, waiting for someone at the peak of their excitement to dare at last swallow my extraordinarily long hard-on to the balls, which always had the amazing effect of transporting myself beyond the realms of this world. Such was the magical spell when I was rubbed out by strangers. Sadly the feeling never lasted outside the simulacrum of the performance, I was still the miserable wretch I used to be, but I welcomed the gift, even ephemeral, of art. Every man on earth longs for plenitude, including me, but during my moments of doubts I comforted myself by thinking that maybe a life is not given to us to be happy, maybe what the fountainhead of all philosophy is teaching us is to welcome the complexity of poetical living.

12

The first few weeks after I started suspending myself onstage my popularity grew quickly until there was no one ignorant of my name: The Inverted Man. One day an older woman came to talk to me after my performance asking why I was inverting myself. "I find it less difficult to believe in reversed realities," I said. She nodded in approbation but seemed preoccupied by a more pressing question. "He who wanders about the world sees many

things", she said, "he who sees it upside-down, what story could he tell?" The woman was resting on the bar clumsily – as if she didn't belong – she looked like someone who worked all her life with big responsibilities but to whom bad circumstances had recently foiled an ultimate plan. "Daring men might wander through it but only one could come back unchanged". She moved her hands slowly around her glass of water, drawing small circles on the wooden platform while looking profoundly to its bottom as if trying to capture the general process of human failure. "And who is that?" I asked curious about this woman's unfamiliar intonations. She raised her gaze to see me and with a twinkle in her eye she said "Isn't it you?"

13

The motivation that pushed me that evening to share my story with a complete stranger was very clear. It appeared to me that the woman was a symbol, the symbol of the blank page, and that in order to rewrite my story I had to meet that woman and tell her everything, and just when I had stopped thinking of the past suddenly the past was rushing back with an ease I was surrendering to without any authority. Some parts of my speech even brought tears to my eyes, but they were tears of relief. In exterior I was giving all the signs of submission but inside I was in control. The pain wasn't controlling me, I was using the pain, like I was using the woman as my blank page. For so long I had been afraid that if I named my struggle it would be reduced to the rank of ridiculous caprice. It didn't matter anymore. The woman listened to me in silence with a patience I had never seen in anyone else before.

14

She came back to the club many times until our bond grew into a friendship that suited equally my need for recognition and my need for independence. What motivated the regularity of her visits wasn't known to me. I thought it was most certainly not a charitable exercise on her part, she never once offered a remark that indicated a trace of pity. I just assumed her loneliness at home was

too much to bear so she would come hang out with me. It was deeply relaxing to converse with someone genuinely unaffected by arrogance, money or youth. It had made my contempt for the world weaker and I noticed the early signs of attachment. One evening in the middle of an animated discussion about what we had called our 'Inverted Philosophy' she said something that gave me a great deal to think about. "I can cure you" she said. If we had been playing poker at that moment I would have called her bluff, but the facileness with which she had pronounced the phrase made me immediately return to seriousness. "What did you just say?" My voice suddenly sounding louder. "I can cure you," she repeated as if putting a suit of hearts on the table. "What do you mean you can cure me? I don't need to be cured, I have the stage!" I pointed at the back of the room to base my argument on concrete evidence. She smiled. "You're right. But I have been listening to you for months now, and I know I can cure you, in fact, I can guarantee full recovery". She seemed possessed, almost happy. I reflected that there is no feeling less disappointing and mediocre than that of a friend's betrayal. I sensed the attraction of rage but I wanted to escape its orbit as much as possible. "Why are you so interested in my recovery, are you a doctor?" I said with a tone of reproach. To which she replied: "All your life you have lived under the perception that you couldn't be any other way. Wouldn't you want to change if you knew you could?"

15

Some conversations have the unbearable propensity of creating an endless feedback inside your head. For me it was insomnia. I felt like a tiger trapped in the vestige of my former self. I wasn't angry at the woman for what she had said, I was angry because she showed me a more refined version of myself that I knew I could never stop thinking about. I longed for my past ignorance when I believed nothing could ever save me. Now I was a madman sweating at night about the new man I might become. It was hard to imagine who that person would be. At that point in my life, my upside-down performance was the highest

of all my pleasures and imagining a life without such a thrill was life-threatening. When I exposed my reasoning to her, she said she could not guarantee to save the pleasures I experienced as an inverted man after the transformation. "I thought you would be thrilled to lose them anyway to be honest, you could have new pleasures, a normal life, meet someone, have children." Her eye twinkled as if she had pronounced the magical phrase. I thought while looking at the woman's face that I wasn't looking at her face anymore, I was thinking of something more engaging, more miraculous than generations of parents moving forward with the same hope written across their face, I was thinking of an empire that I knew existed but which I had abandoned, an empire that possessed more humility, engendered more diversity across the centuries than anything I ever knew. With a kind of vertigo I came to the realisation that the forest and the stage were the same thing, that they had been my home all along and that at every second of my existence I had felt their presence stirring inside my blood resulting in every second of my happiness. I thought of myself again in my first night with the gods as a kid, what magic was in the air and how I felt lifted from the dust. In the forest I knew change. All I had to do was come back to it.

16

Time in the forest seemed slower. Although delimited by the line of the trees the sky seemed infinite and bold as if the gods knew this was the night I was coming back. I could not contain myself. I walked the same path I once walked with the herd of dangerous kids. I felt again my discomfort which back then I enjoyed as my first adventure. I was led by the desire to live the memory again, and with ropes I attached myself upside-down to the old tree. Once inverted I waited all night for something to happen, anything, but nothing came. I was dry and bored, my dick flaccid like a mushroom on a dead tree. I walked back home disillusioned. A few days later the older woman came to my apartment, she knocked repeatedly on my front door until I opened it for her. I hadn't seen daylight for days and the sun was hiding her silhouette in a

halo of fire. "It is an inexplicable story, don't you think?" she said with a twinkle in her eye. "What is?" I said with impatience while covering my eyes. "That you and I met, that in the vastness of this universe you and I happened to be alive at the same time". Her posture against the sun reminded me of someone I knew very well but whose name I couldn't remember, and this reminiscence made me feel an unexpected kindness for her. With a gentle voice I said: "Listen. I won't change. Even if you say I can or should, I don't want to. I didn't choose the way I enjoy my body and I don't care if you say the long awaited day at last has arrived, I will turn it down, I don't want it. Madness can come threatening me in my own bed; I will still choose to ignore this normal life of yours that you insist on living, with all its mediocre highlights and dreams: I will think about other possible ways, I will think about it every day, even when my mind will turn into an absurd labyrinth of lust whose centre I can never find, I know what it is to battle, I have … the inverted ways. I told you my personal story, I thought it wasn't personal, that everybody could understand it, but you listened and were lead by a dangerous urge to possess. I don't want your solution, the solution is less interesting than the mystery, I just want to endure, enjoy life and eventually be dead, and in death be no one, like everybody else". My eyes had gotten used to the sunlight and I could now see the motions on the woman's face, her mouth trembled in the burst of a smile as if the twinkle in her eye had navigated south during my monologue. She held a long pause with a lack of tension in her shoulders that suggested a secret relief, she said "I accept" and walked away. As I watched her disappear into the blur of the late afternoon sun, I thought again that her silhouette was familiar. I watched her feet melt into the vapours of the heated pavement until they joined together completely and formed what I believed to be, the shape of a head.

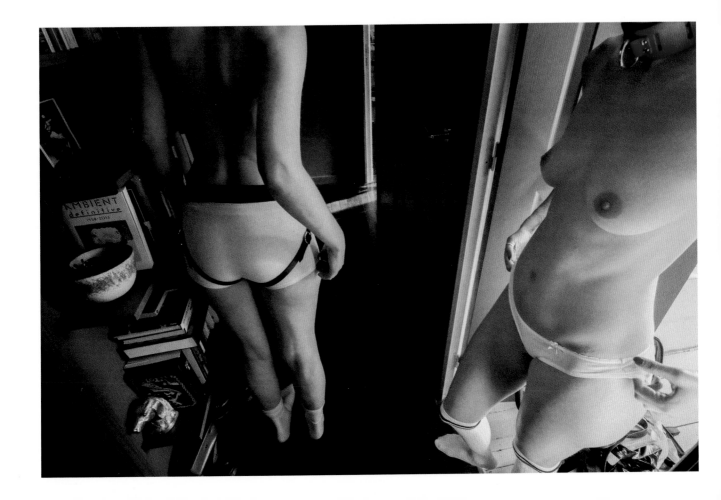

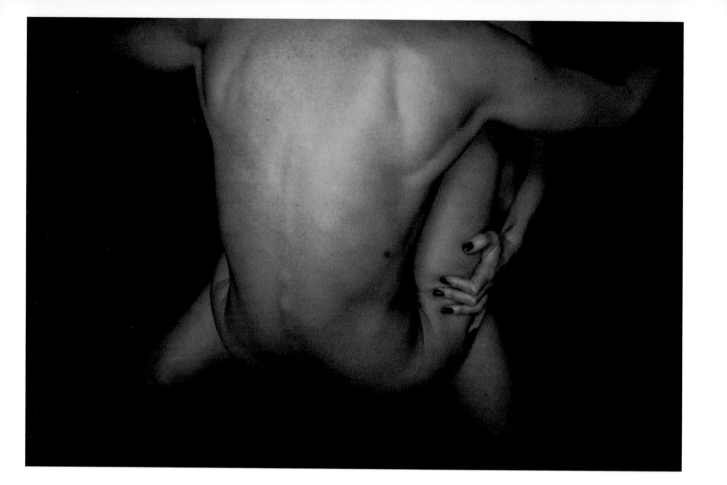

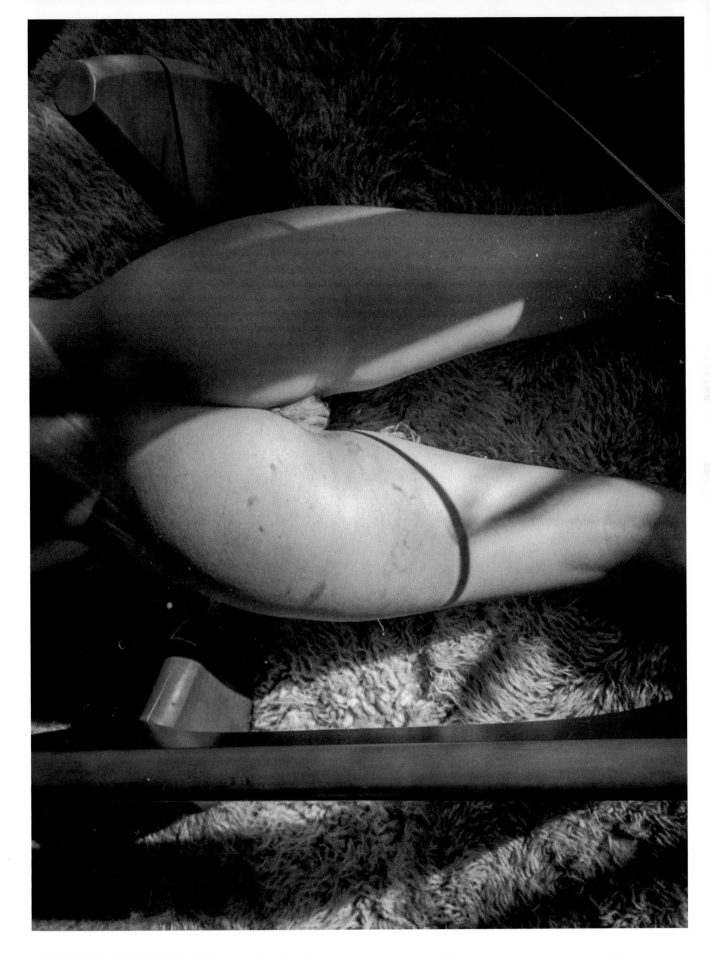

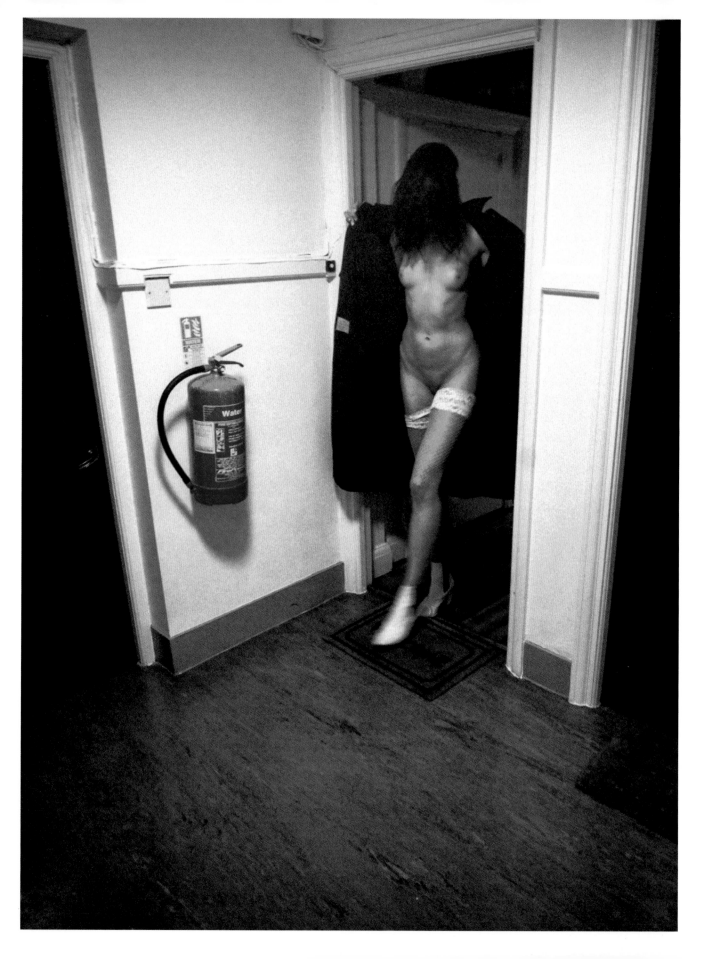

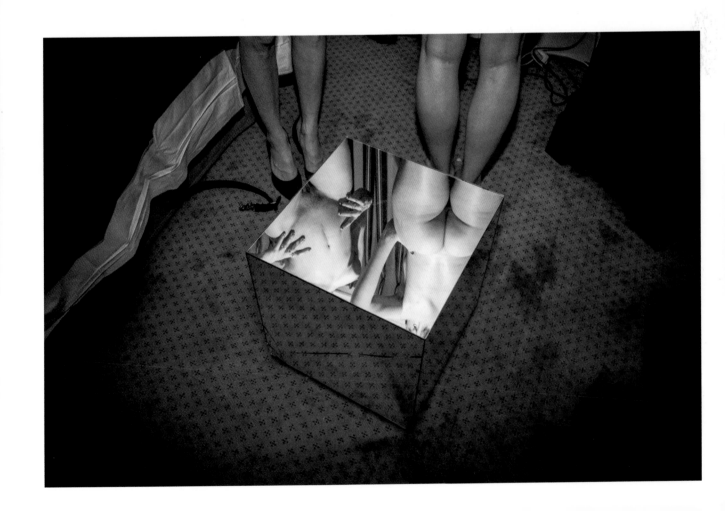

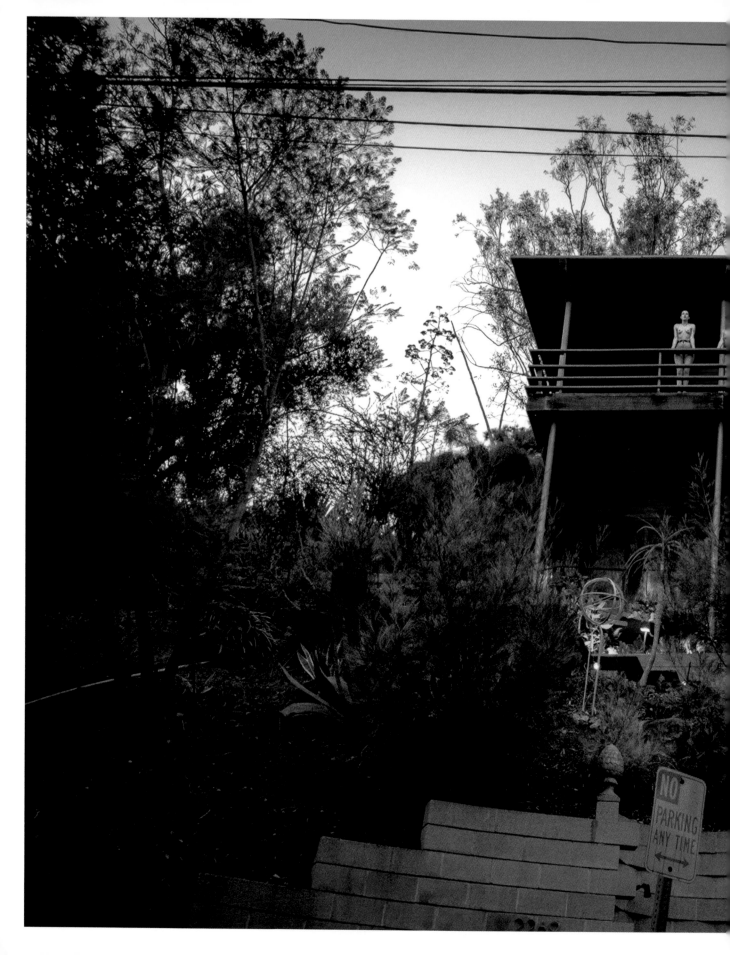

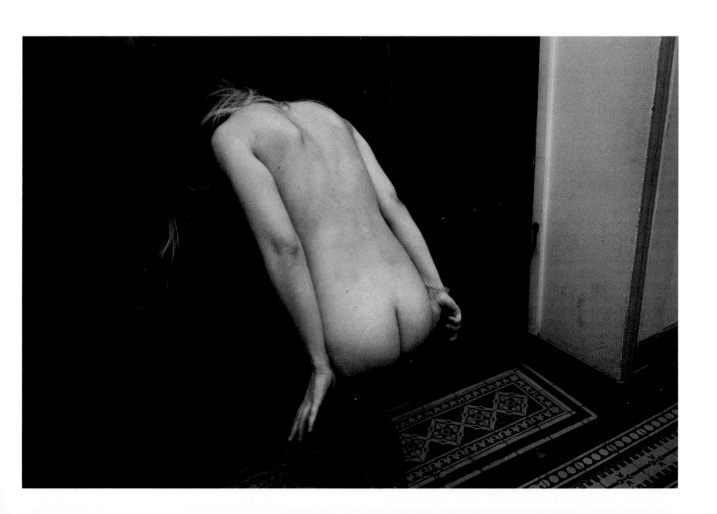

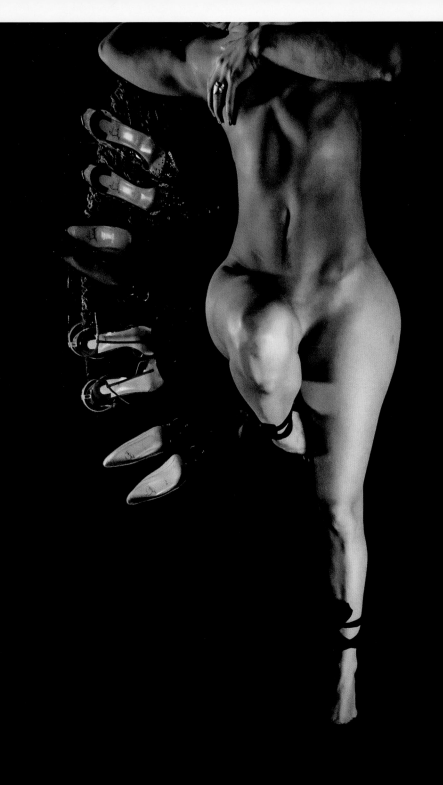

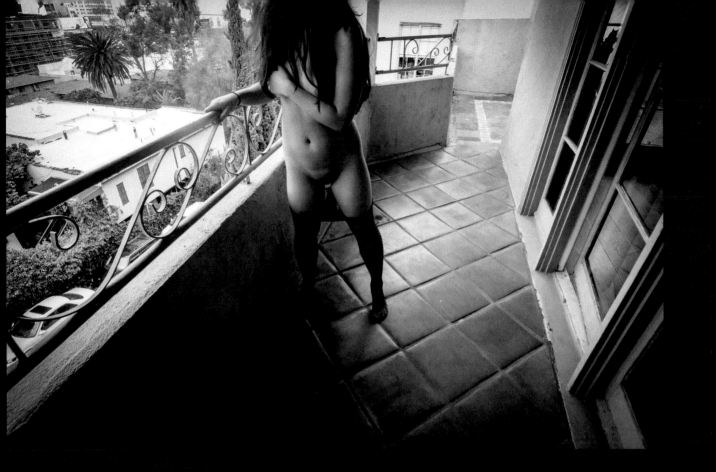

199

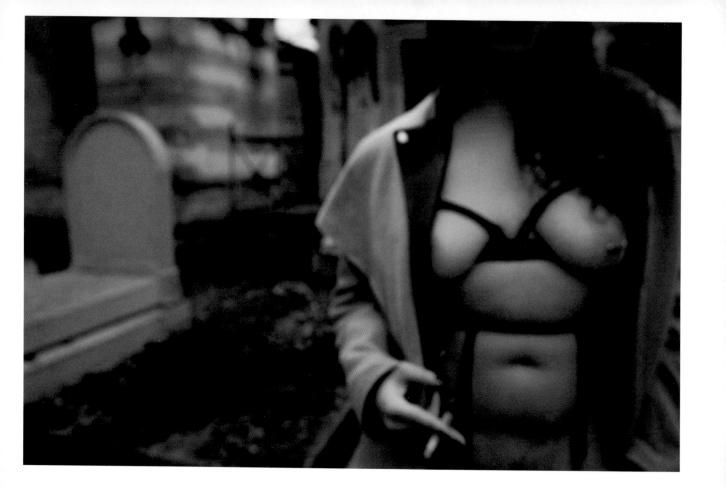

200

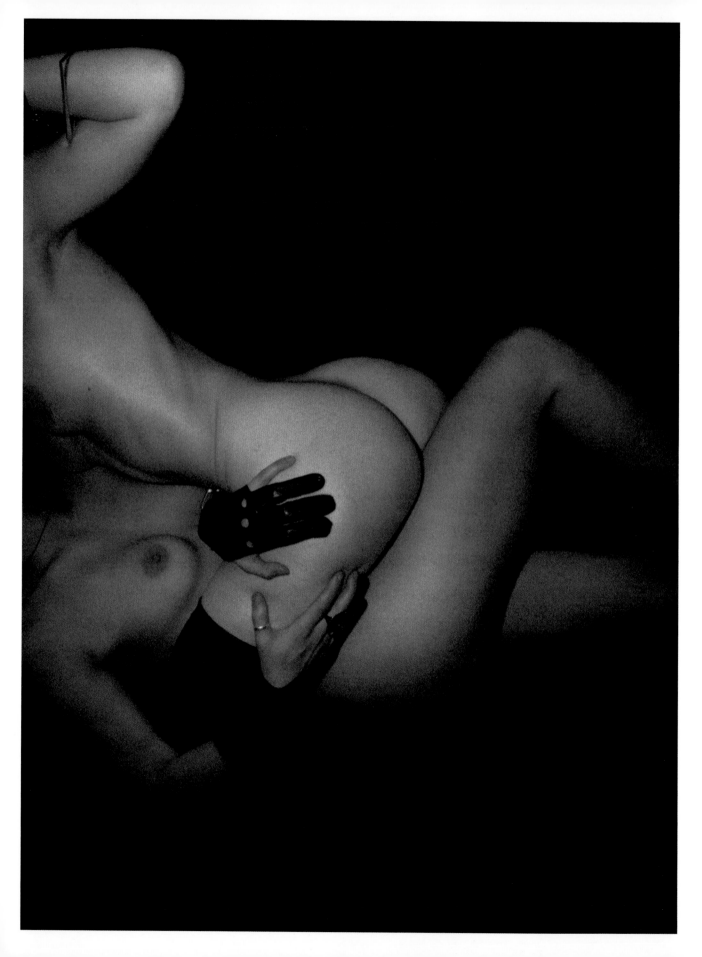

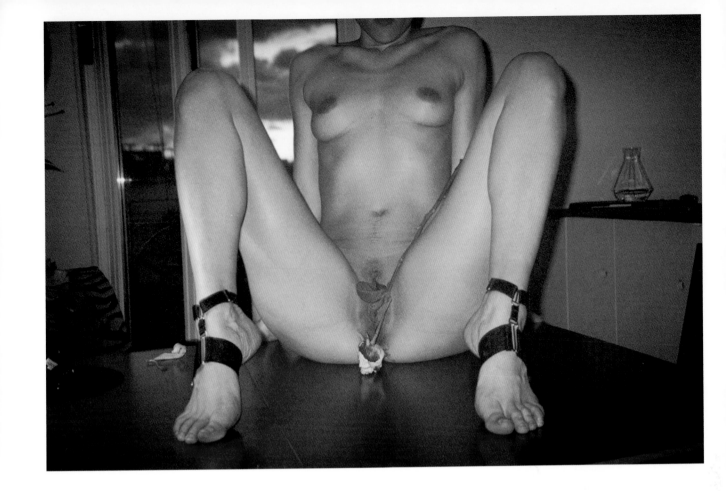

203

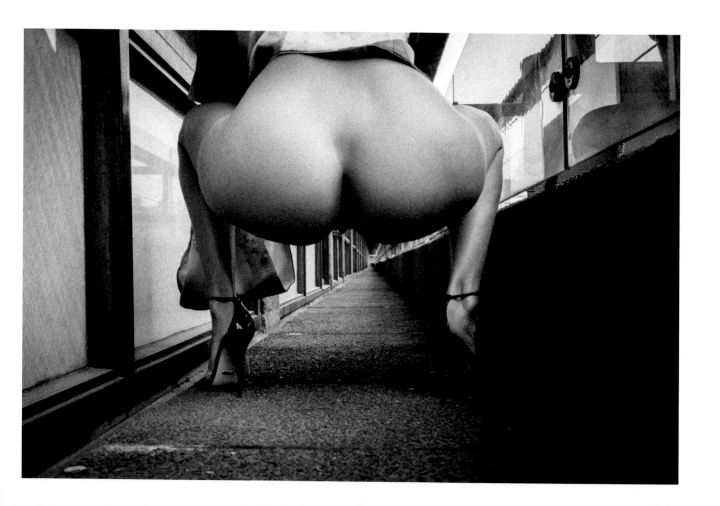

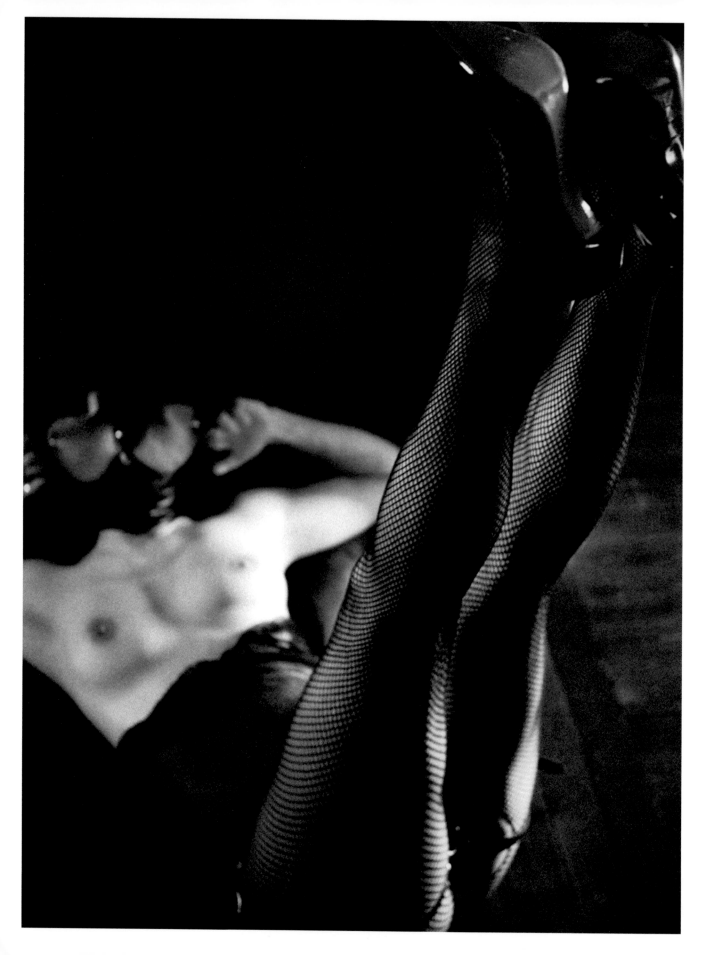

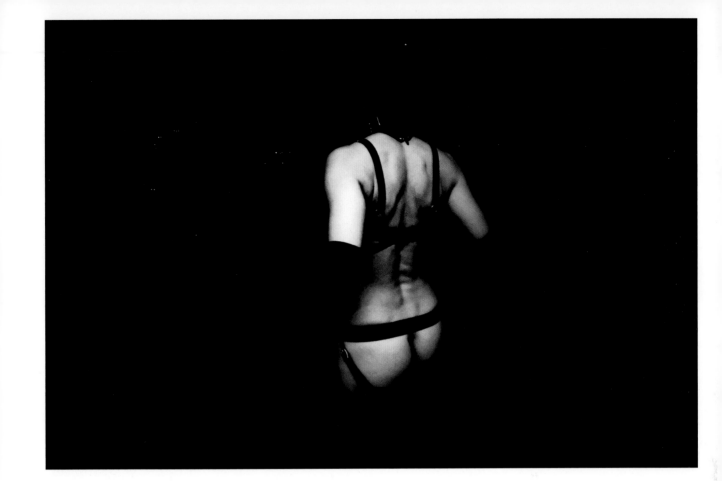

207

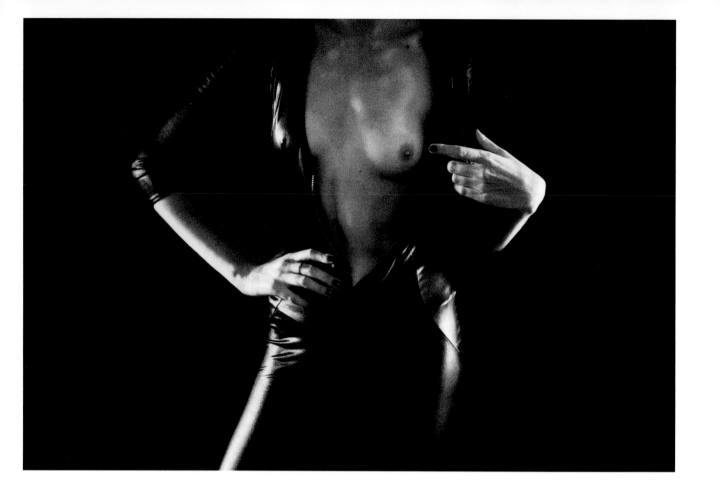

208

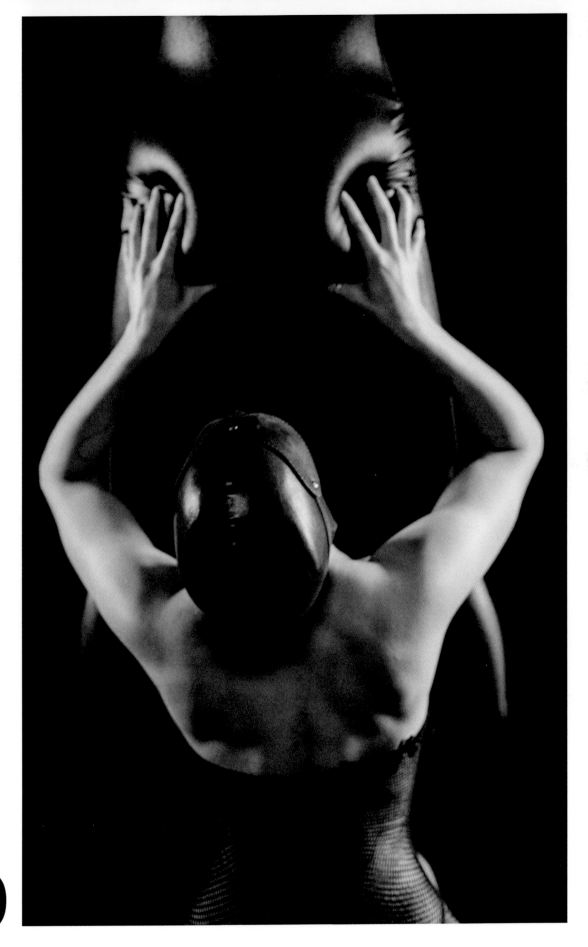

209

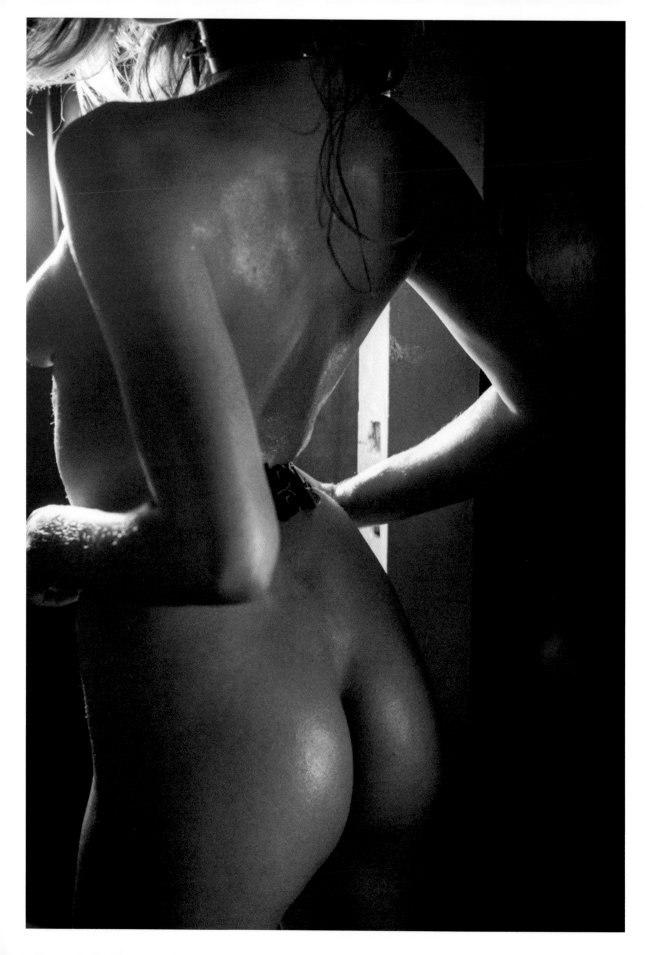

211

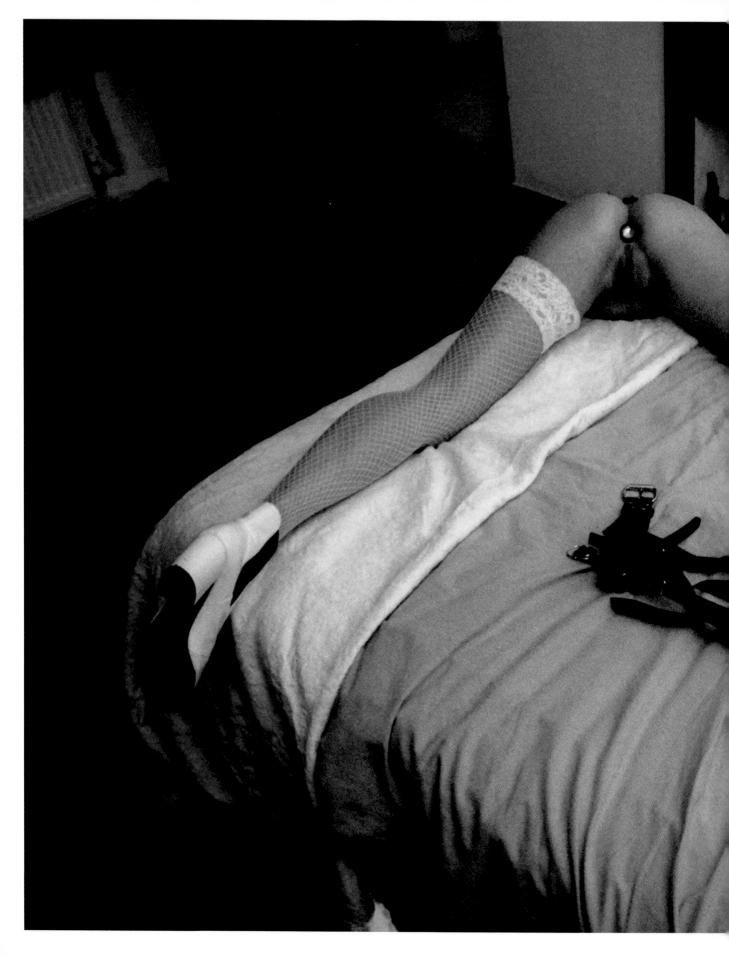

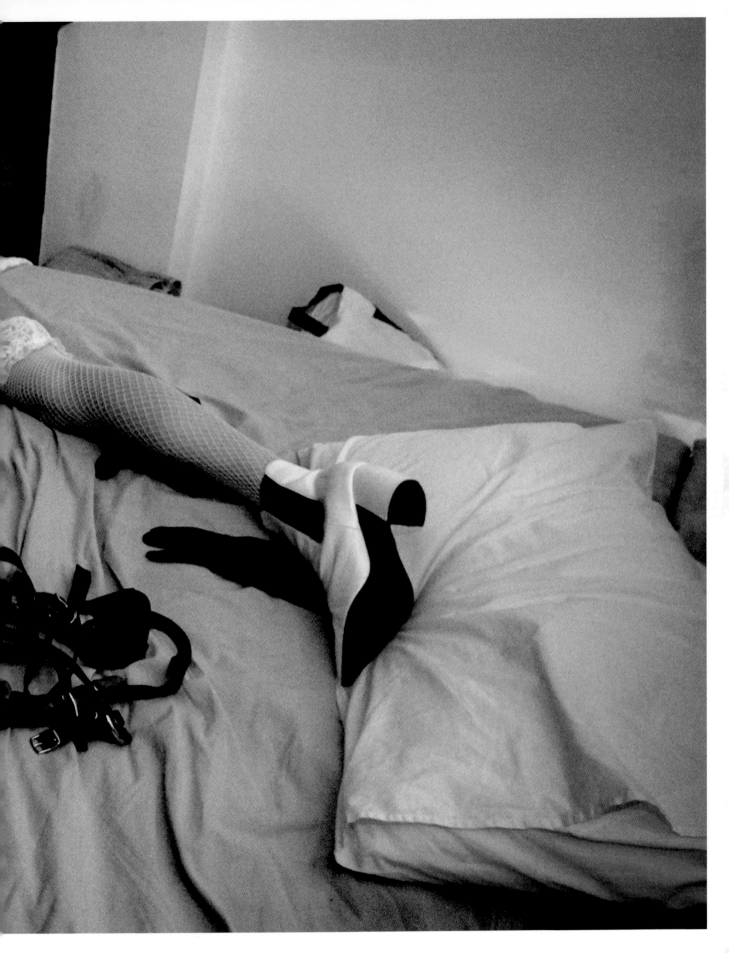

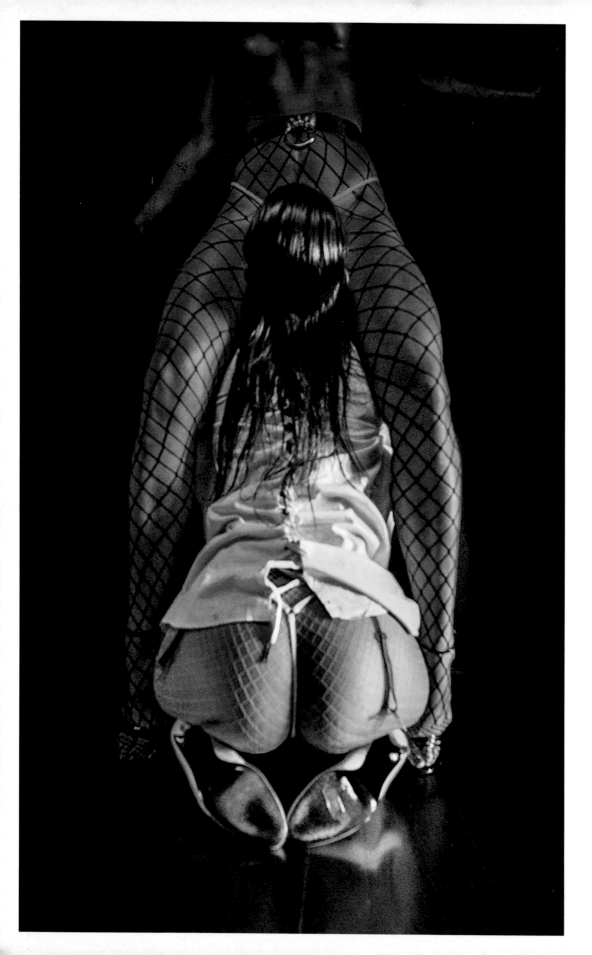

214

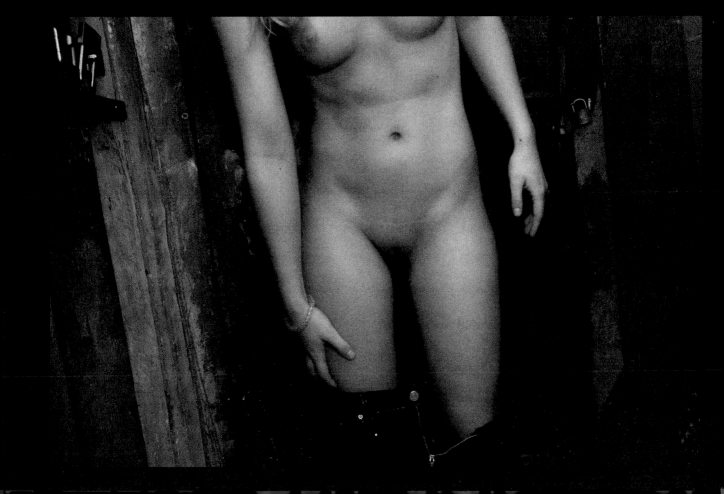

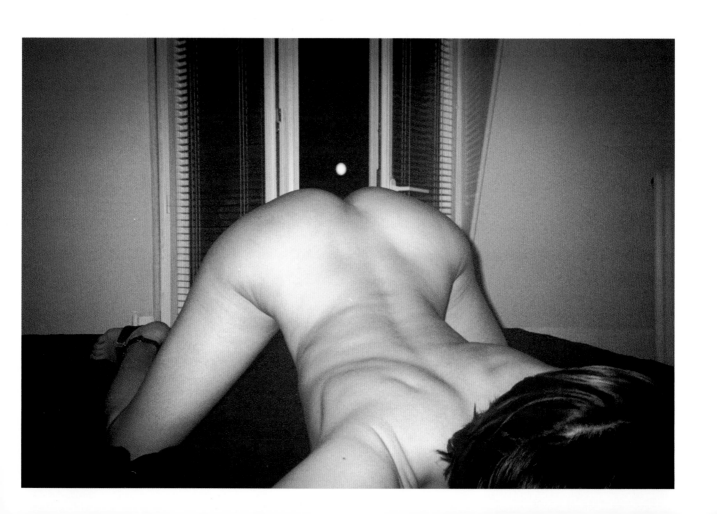

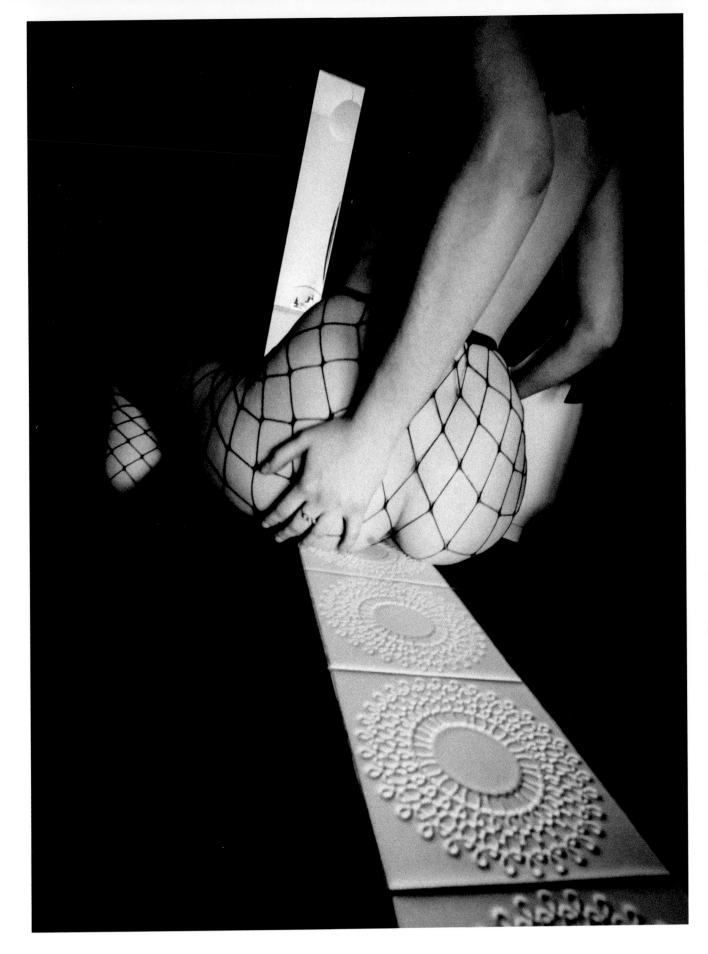

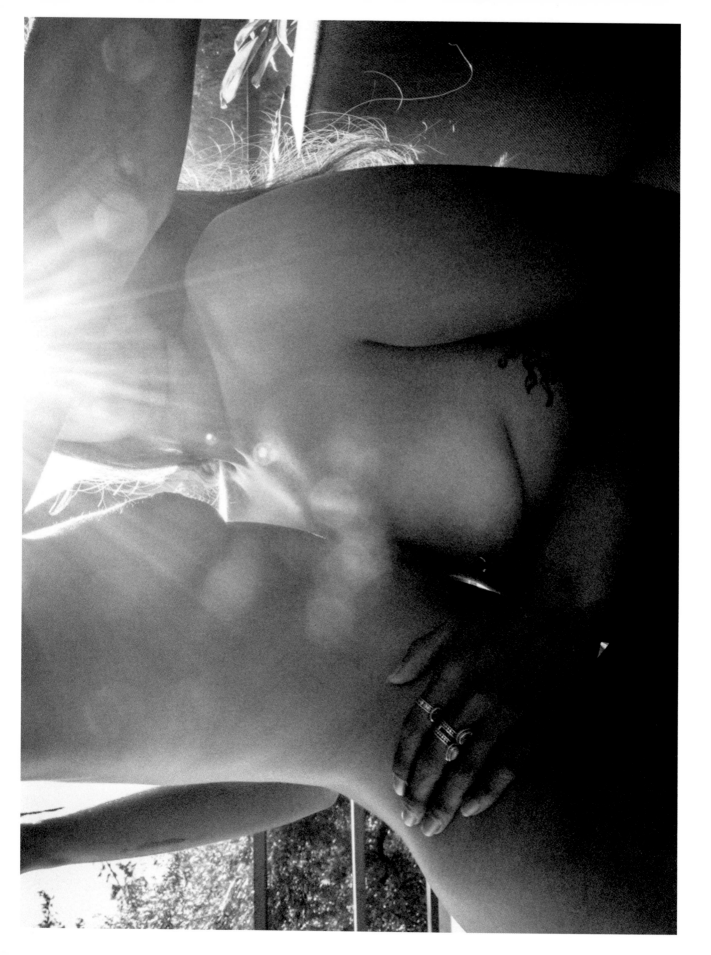

1

It was the year of my thirteenth birthday when I was plunged into a frenzy of prurience. I woke up one morning with a splash of milk on my belly which tasted salty and unusual, after what the world ceased to be the simple playground I had always known.

2

My penis had doubled in size during my sleep and it didn't come back to its normal appearance until I rubbed it up and down over approximately four hours. Forced to pass out after such an unprecedented effort, feeling close to drunkenness, I woke up only to start off again, unable to explain why, probably thinking the next ejaculation would leave me satisfied. But it continued to swell agonisingly, even when I opened my eyes trying to hook my gaze on some boring phenomenon. Like blowing on an incandescent ember, nothing I could do would put a stop to it.

3

Although I was absolutely in the right then, the events that followed now make me feel very sorry that I wasn't naturally endowed with a stronger will to stop myself. At that early stage the probabilities of success in taking control of my sexual life would have been much higher than they turned out to be after that. As years went by, my appetite for sex became astonishingly insatiable.

4

I understood very early on that my penis was bigger than average. The first time I had the chance to observe it erected properly on its base of black hair, I gave it a proper long look of recognition. I had an instinct that

its head, the colour of peach and of perfect dimensions, would be ideally scaled to pressure all the right points inside a woman's vagina.

5

Growing up, sex was all I thought about and was probably the one thing I became really good at – and I could be at it for hours. As soon as I finished with someone, I planned to see another. Talent? I suppose I could admit modestly to a certain talent, but doing what I loved was probably the highest of all the truths I was telling myself about myself. Above all, I believed I was born to please. I was a gift to all the women of this world.

6

We are all humans, the same blood runs in all our veins, but to me women were different. In fact, not one woman I slept with turned out to be like another. Using my sex as my guide, I discovered with humility the wide variety of women's nether parts. What a moist, happy and plashing world! So secret, alive and emotional. There was nothing more I loved in this world than penetration. I could live in that blindness forever.

7

Sex and hunger are known to be regulated through the same brain chemical, so that having sex is by consequence directly connected to our eating habits. By satisfying one appetite centre, you are supposed to satisfy the other, but mine never seemed to reach satiety. After hours of love-making I was often taken by a poignant hunger. It was as if sex, instead of fulfilling my desire for food, was expanding it.

8

Sometimes my cravings were so strong I had to find something urgently to calm the spasms. I would come flowing over food wordlessly, master a succession of rapid scooping motions until I would neutralise the stir of panic inside my stomach. In peace for an hour or two, my tormented guts set aflame, I would try to relax and preserve

the last trace of independence and dignity I had left, until the urge returned and I had to start over again.

9

In appearance I was still the same charming guy, my hunger was remarkable for causing the sharpest pain without leaving any external marks, but in those moments I often became strangely insolent and savage, a contrast to my usual sensitive and calm nature. Weeks passed and the feeling of hunger became more and more unnatural, arriving sooner after sex, sometimes seconds after orgasms. I didn't know anymore what came first, my desire for sex or my appetite for food? Erections kept coming, but I felt my libido bonding to hunger as to a whole new system of evil.

10

One evening in bed with a beautiful woman, in the midst of the most blissful post-ejaculation drift, I heard a scream pierce my ears that felt ominous and horribly fateful. The level of the sound felt just as loud as impenetrable and I saw her body sitting on top of me in the dark going through inexplicable contortions, as if suddenly unrelated to normal human life. I touched the warmth and stickiness of blood running over my belly and witnessed the horror of the woman's face as it externalised the pain, raising her arm in all her nakedness and absurdity, terrified at the sight of bitten flesh. I felt suddenly nauseous and tried to sit up, tortured by my effort to recollect my actions. Did I bite her arm while ejaculating and not remember?

11

Walking up the dark streets that night thinking of what I had done, I sensed the notion of facing my actions equally torturing and liberating, unable to tell which feeling was winning the battle in my mind. Halfway through my journey, my stomach was penetrated again by a sharp pain of unprecedented force which froze my steps and folded me in half. This was far more terrifying than anything that had happened before. My body was affected

and I understood there was no salvation for me. This was not going to happen only once.

12

It was at that instant that I felt my connection with the world snap. I understood that I had changed and felt separated from a world now devoid of meaning. I was on my own, the rest of the world turned against me, and for the first time I doubted that I was standing on the right side of the fence. For years I went on thinking I knew myself, that me and people like me were worthy and righteous, intrinsically good, or at least trying to be. I believed the world split in two halves, and the other half was where bad people lived. But little did I know about evil, that bad things only exist in as much as they exist dormant within ourselves.

13

I went on struggling with what I had done, what had motivated my action, but I couldn't find the source, nor the guilt. I felt astonished by the memory of the sudden pang of human blood on my tongue and concluded that I was possessed. I couldn't explain to myself why at the peak of my orgasm blood had become the perfect love-potion, ejecting my sperm in the most satisfying way, but in my heart I knew I couldn't condemn it. Thinking about it all made me sick. I had one desire left: not to go insane.

14

How can one maintain rigid control over oneself? The events of that night reshaped into my mind gradually as I got on with my life, but the more they came back the more they seemed unreal, as if from a bad dream. I smiled thinking of the insufferable shame I had felt. This is fantasy, I thought, pure fantasy. Driven by god knows what intention – perhaps not so much by desire as I pretended – I prepared myself to go out and meet someone to have sex. I could perfectly well have taken a proper break considering the torments of my last encounter, and sort myself out, then there would have been nothing of what happened next, but I wouldn't be telling this story if that

was the case, would I? In fact there wouldn't have been any story to tell at all.

15

I remember the provincial house and the silence of the rooms that signified the absence of husband and children. I remember the expression of supreme happiness, not the banal kind, that I tried to communicate with my heavy panting, like an imbecile who thinks he's picking up precious stones in the trash can of stupidity. That was obviously a weak solution to ward off evil and my optimistic demeanour underwent a slight change when I found myself (after hours of playtime) penetrating her whilst standing up against the wall in her living room. I could smell the perfume of her skin in the alcove of her neck and with each penetration, as my pleasure prolonged towards orgasm, grew my craving to suck on the heavy flow of blood swimming down her veins.

16

She must have felt the insistence of my teeth nibbling on her skin because she soon whispered in a breathy voice that it was ok, that she enjoyed the pain. With her permission I was able to relax. I started sucking on her skin as if to taste her juice first, then applying more pressure with my two canines I felt the outside membrane of her neck crack, a gentle snap followed almost immediately by a heavy flow of blood which, coupled with the shock of the next penetration, began to send me outside of my own consciousness. She tasted delicious like candy and I sunk my teeth deeper and deeper with an ease that surprised me until finally a whole chunk of flesh fell into my mouth. I pushed my sex vigorously inside her and ejaculated violently while eating the entire piece.

17

When I came back from my blissful confusion and my heart resumed beating with a more regular rhythm, I immediately wanted to communicate the immense gratitude I felt towards the woman who not only had accepted me but had accepted my most secret perversion. Standing

in between my body and the wall, her body felt as heavy as a sandbag and I quickly realised that she had lost consciousness. In panic, I laid her down carefully on the carpet and repeated her name hoping to bring her back. I checked her breath underneath her nose to feel the air that she exhaled then, without thinking, I let my hand wander towards the wounded neck, still flooded with blood. I touched the damaged crevasse the size of two fingers and the contact immediately stirred up the liquid remaining at the root of my sex.

18

How can one know for sure what's good or bad? How can one know he's looking at the world from the side of righteousness? My thoughts seemed to have taken a turn into confusion. What if instead of being wrong, I was righting a wrong? Unable to get a definite read on my moral compass, I took a hold of my penis with my free hand and started masturbating, the desire too painfully strong to resist, while gently touching the pulp of her meat. Unable to push it back, I started sniffing the open wound like an animal at a fresh kill, and after a second of hesitation, looking at her blind face, I took another bite, a very small one, enough not to make a difference. This felt immediately good and I took another one while stroking my cock harder and harder. She didn't move or wake up and I carried on like this for a while unable to stop myself.

19

I woke up hours later to the dead silence of the house and it took me a minute to remember where I was. The night had bathed the room with all its blackness and gave it a miasma of evil. I sat up to inspect my surrounding with a close attention. I touched my body as if to make sure it was all there. Her body next to mine had kept its position, both of us covered with dry blood and scum. I noticed a difference in skin tone between us and as I got closer I remarked the absence of rhythm underneath her chest. A quick touch at her wrist pointed me to the right conclusion: she was no longer passed-out but had succumbed to her wound.

20

With ever so slight a note of appeal, maybe the same way people get a vicarious pleasure out of becoming scared when they watch a horror movie, I looked at the circles diverging from the fantastic dark red centre of her wound. I inspected the messy lines and cuts above the brilliant whiteness of the bone as if that was the only opening left into her beauty. This long sequence of observation came to an abrupt end when I felt a stab of emotion followed by a rush of shame as I shockingly remembered that I was human – a fact that had escaped my psyche to only return now. I rushed home, passing my usual eating places without stopping, my mind plunged into chaos, harassed at every step by stomach cramps and writhing memories.

21

For days I didn't go out. I didn't eat. I didn't have sex. It was torture. Since I was a teenager I had never experienced abstinence for more than a few hours and I was now drowning in hallucinations. I lay in bed all day crying with feverish repetition, famished and delirious, never parting with the image of her death, like forever walking through that person's soul. The test of hunger, sexual and physical, enhanced the smell of human flesh, a distinctive whiff unmistakable under perfume and cream. My tears had salted the surface of my forearm and, midway between madness and survival, I took a frank and frightened bite off myself. The coarse texture of my epidermis didn't appeal at first but this bite was a scientific experiment. How much would I have to hurt myself before I could start feeling something real?

22

Several weeks passed and I managed to survive on a diet of self-eating and tears. I am sorry to say that not content with this ingenious solution I also coupled my meals with masturbation, which in the end provided everything I needed for a meaningful life. It felt as if I could go on forever. I won't launch upon a complete description of the state of my physical appearance at that point, all of which would be difficult to understand, and impossible to

attest, but let's just say it was barbaric, rather precarious and highly unhygienic.

23

Strangely enough, those were not the causes of my death. I actually never died. I carried on eating myself until I ate myself up completely and disappeared, never to be seen again. It didn't hurt to disintegrate, it felt rather refreshing, like a long descent into a lower level. If I'm able to tell you my story now it is because I still exist, somewhere in between worlds. I have survived, fated to wander forever, searching for new flesh to bite.

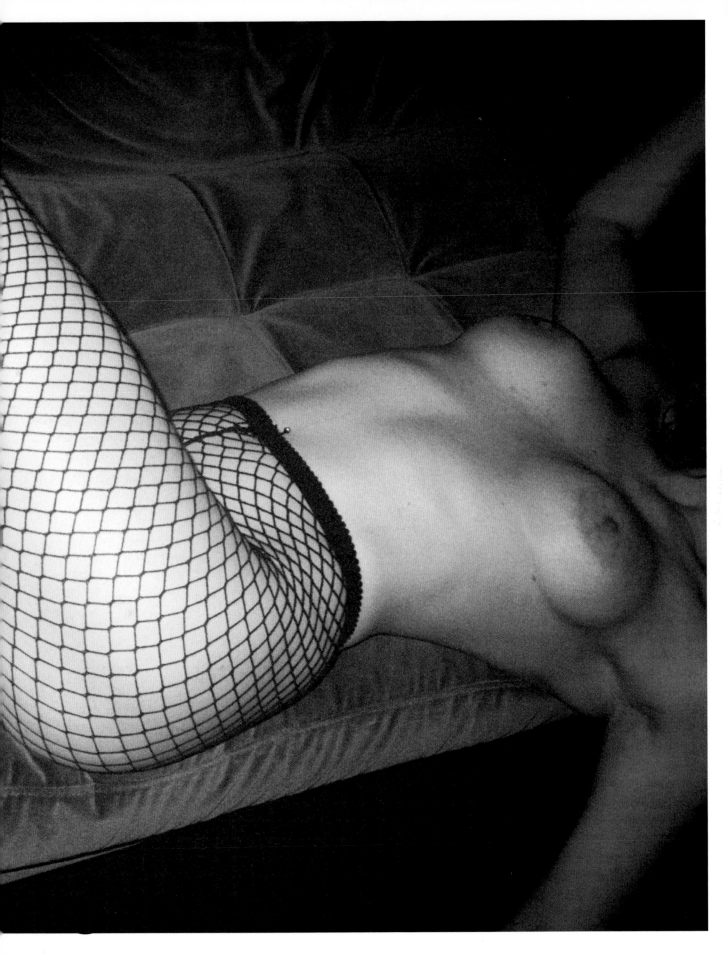

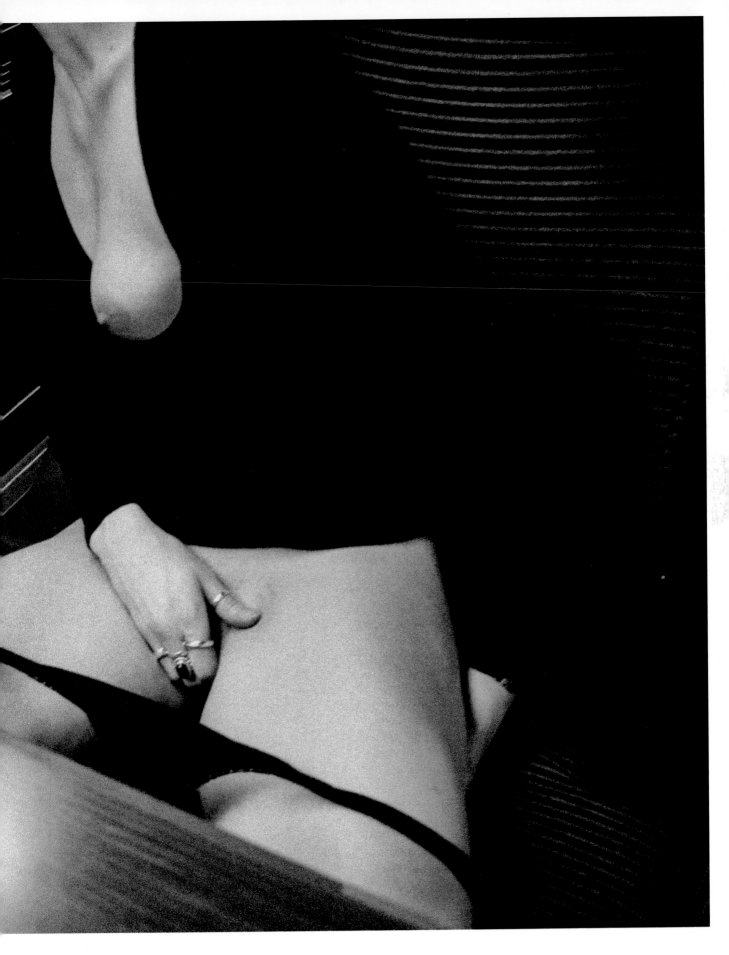

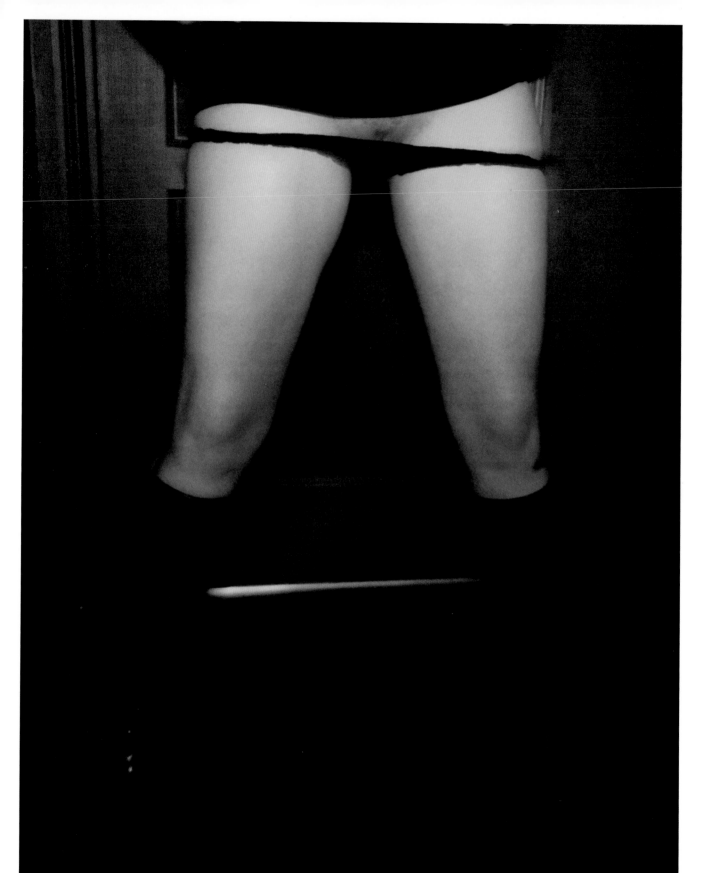

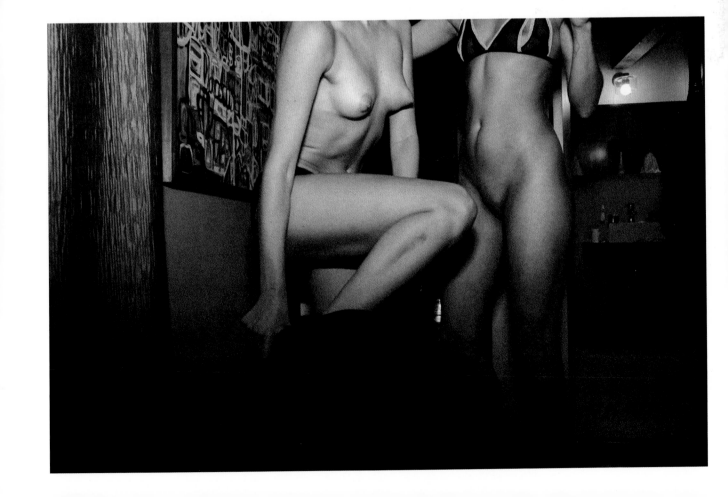

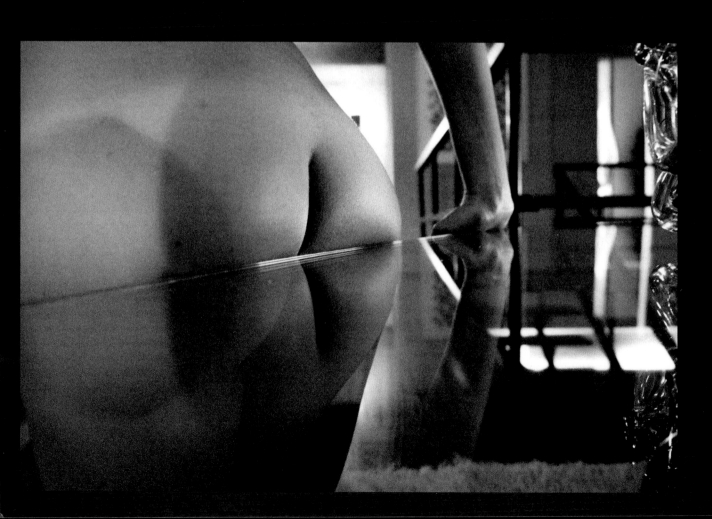

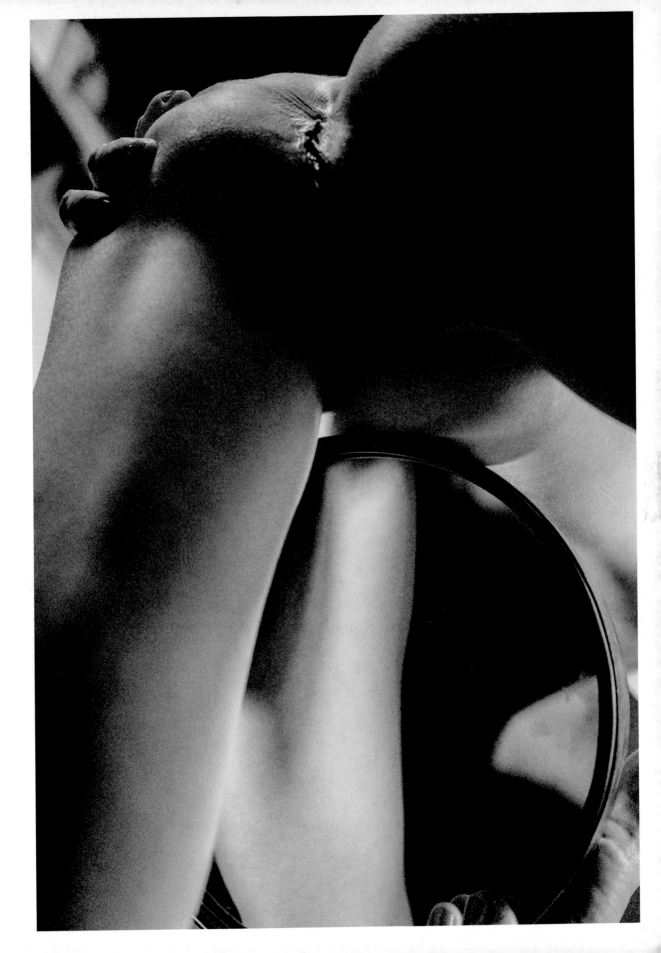

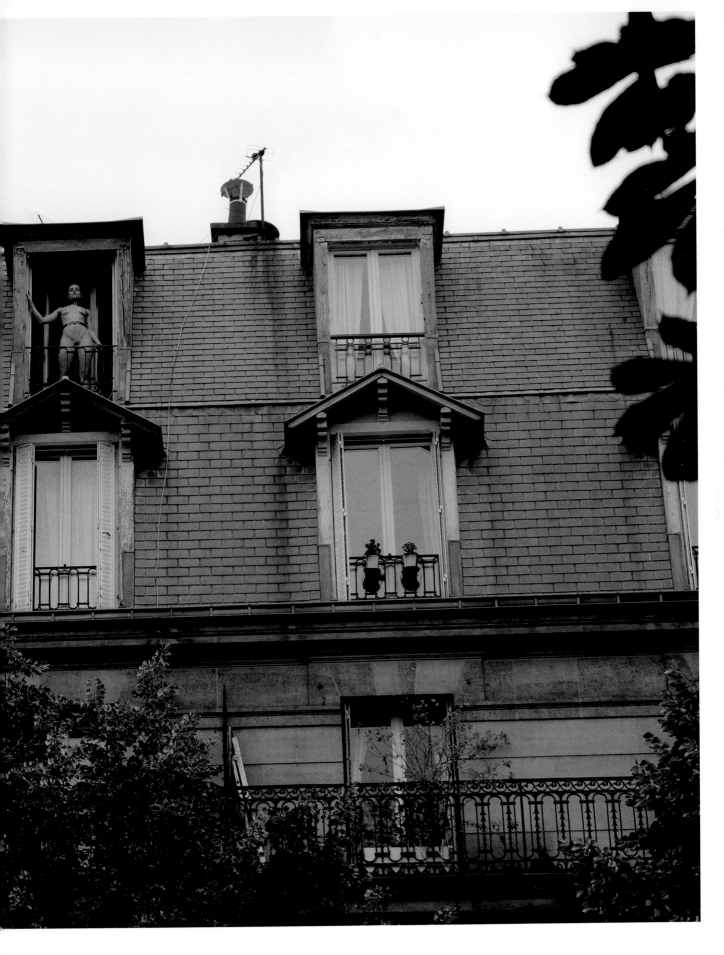

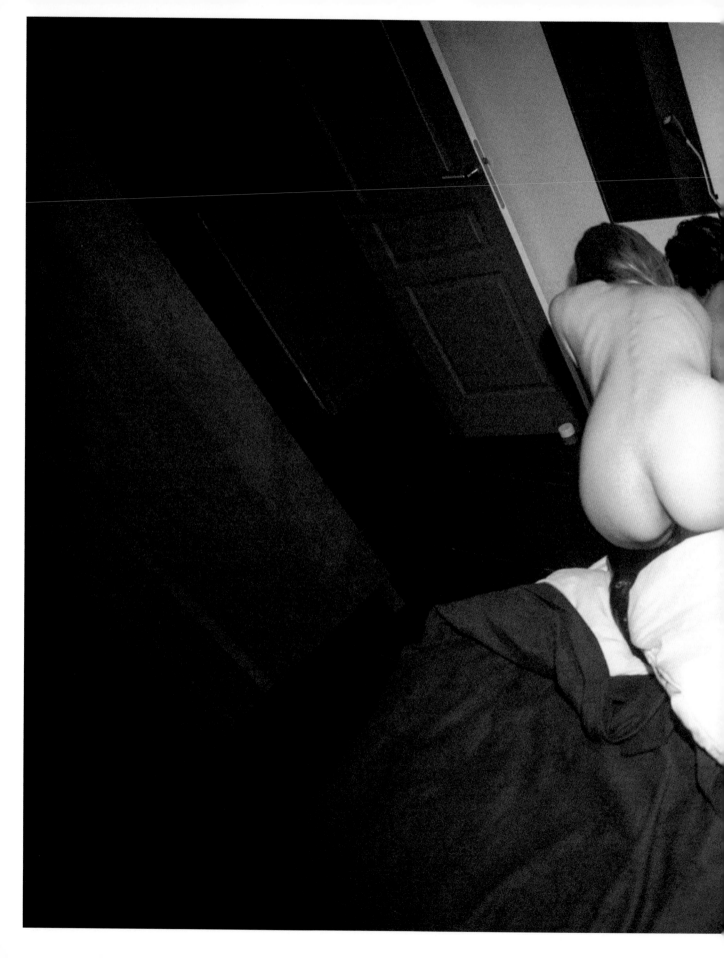

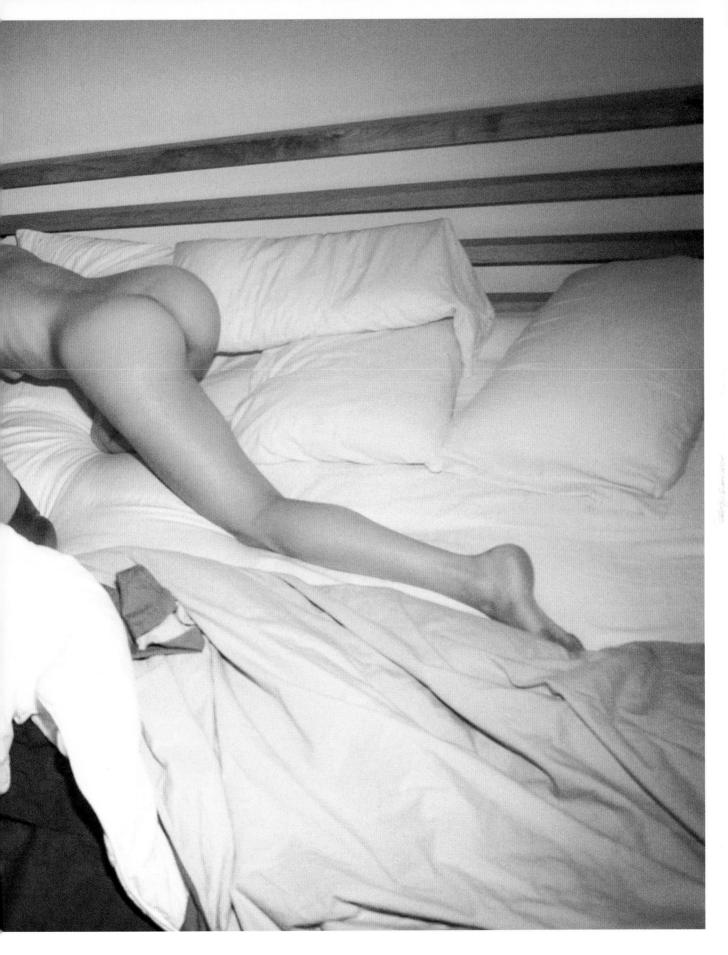

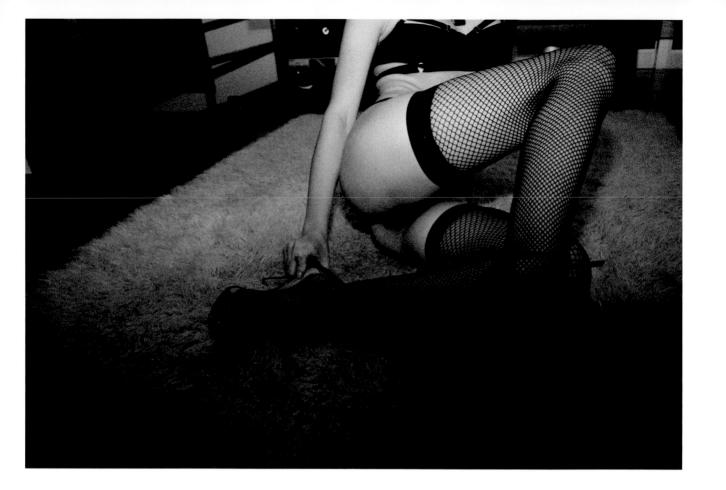

242

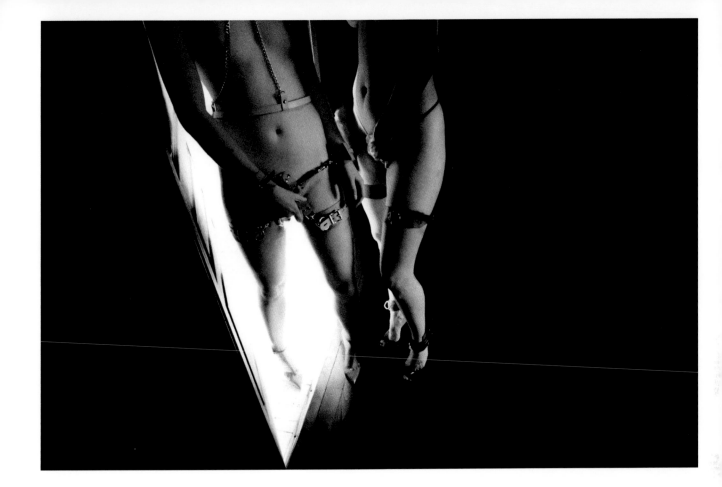

243

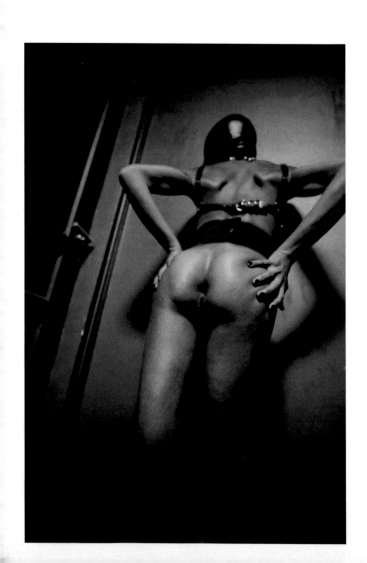

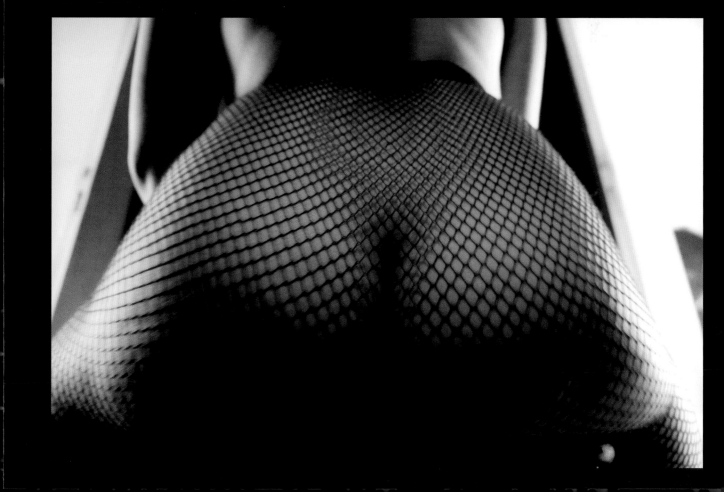

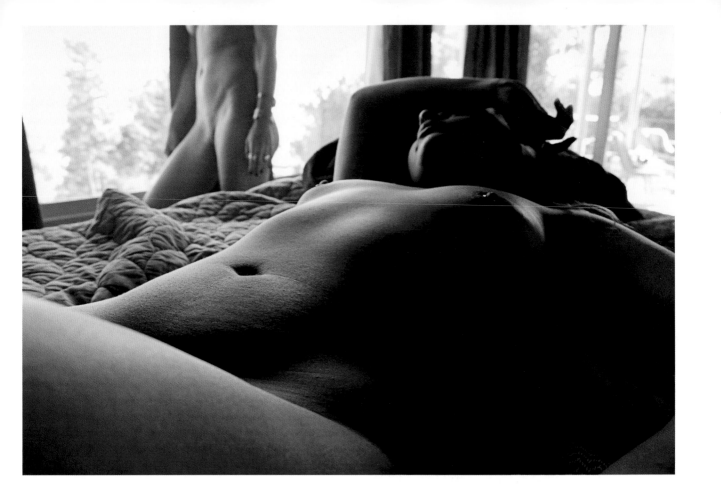

248

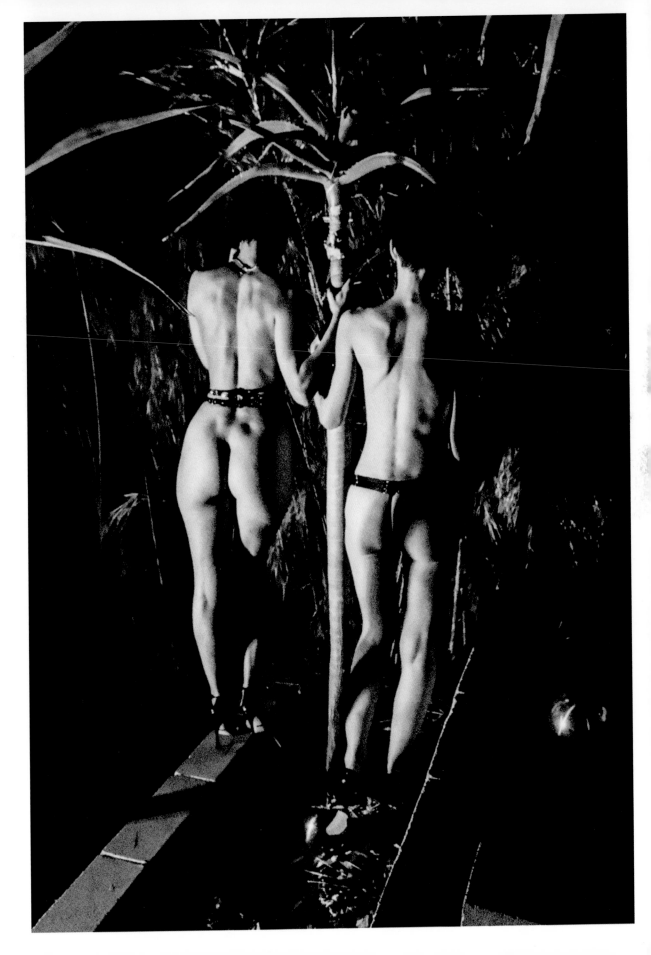

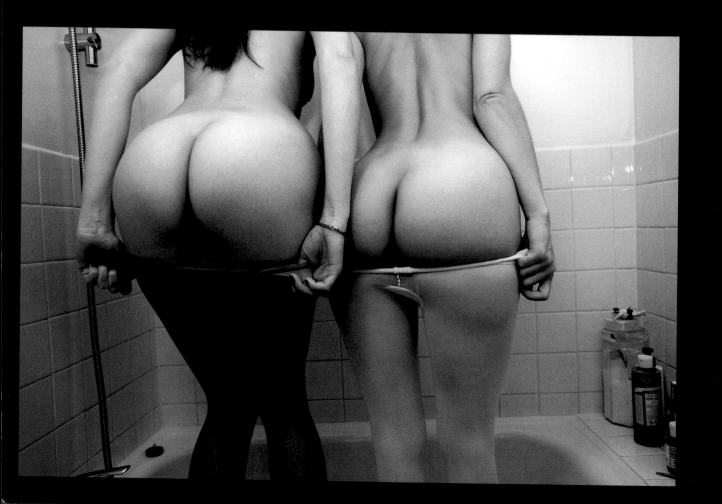

1

Until I came to terms with the gravity of the fact I imagined my husband's death as an accident, a pause in the passage of the breath in and out of his sleeping body. It seemed that the image of his invisible spirit hovered around his corpse, only perceptible by my imagination. Understand me, there was still a body after he was gone but a body that radiated life and energy even hours after he was no more – as if it was impossible to have a body without a life living inside of it – and what was once life was now the present mystery of a disappearance. His intellect had vanished and yet I couldn't detach it from his physique.

2

At the morgue, the vulgar matter-of-factness of his body, docile like a soldier waiting in line for his next command, did not agree with how I remembered him living his life. The corpse in front of me represented everything that was empty, impotent, void and sick. Thankfully the forces who killed him had omitted to take away his beauty and I cried at the remembrance of our past together. Only my memory of him could sustain the illusion that his new state of paralysis wasn't going to be permanent.

3

That night in bed I thought about incarnation awhile, his spirit wandering deeper and deeper into life, forever magnified. But those who die, I thought to myself, never return to themselves, neither love nor desire have ever succeeded in pulling a word out of a cadaver, not even the most infamous wizardry or dark magic can bring the soul back. Unable to sleep, I left my house and walked to

the morgue. I had to climb its barbwire fence at midnight or be submerged by the supernatural beliefs I had just acquired. I had to break the glass of the front window and introduce myself to the cold dead-house, be that mad scientist who refuses to alloy death with separation and needs to toss one more time the most iniquitous question that mankind has asked since the beginning of time. My suffering was running like sweat out of my pores from the delirious illusion, the struggle to consent to the existence of a void, to the suction of the so-called nothingness that we supposedly belong to, where his mind was now wandering, allegedly.

4

He lay supine on a metal table with astonishing stillness as if cut from the ruins of a white porcelain statue. The light was dramatic but surprised me in making his body disgorge reality, almost too real, as if it still belonged to this world. As I got closer I couldn't refrain from touching his chest and I rested my head against his heart, now dead to the world. I no longer wished to believe in these mad illusions but an atavistic force was tempting me to kiss his body, to make him mine one more time. I climbed over the table to sit on his hips, I touched his face and let my tears fall onto his closed eyes. If I refused the brutality of his death, I knew I had to accept what it had imposed on me: the mystery of his cadaverous attraction.

5

Maybe my childhood fantasy of inanimate objects becoming alive was the motivation that explains my sudden erotic appetite for his useless body, or maybe his death was too surreal not to arouse the desire to examine it more closely. I grabbed his testicles to estimate their weight and was surprised to find their cold dryness in my hand, their fluids still bagged inside as if waiting to impregnate me. Sitting on top, the softness of his skin impressed me and I started rubbing my inner thighs against it. Swimming in the infinitesimal details of each tremor, I started humping my husband's flesh with the uninhibitedness of a dog humping its owner's leg. I yelped

like a small animal in the absence of his kin, a dramati-
sation that pulled my magnetic body in a kind of immea-
surable search for infinity.

6

When I came back I was faced again with the silence of
the room and the inertia of his body. I was alone, alone
in the world, and the sooner I admitted it the less likely I
was to plunge into an abyssal sub-level of insanity. There
was nowhere I could meet his consciousness again even
in the ultimate act of erotic love. We are alone, I thought,
alone in our flesh and bones, there is no trespassing possi-
ble between the bodies of two enamoured beings no mat-
ter how deep goes the root of their love. Like a sort of
unconsolable widow I stared at my husband's eyes hoping
to see them open after my love-making, but they were
insolently closed and that realisation made me feel colder
than before.

7

By a tilt of the hip, I suddenly felt a presence underneath
my thighs, like a wooden stick pushing against my pubic
bone. I concluded that my effort had created a miracle
in the swelling of my husband's sex – who having heard
my prayers was obviously responding with the only part
of his body he was still able to operate. I am neither a
madwoman nor a liar and these facts really happened.
From the limbo of death where he was, my husband was
undoubtedly communicating his joy and approving my
coming back, urging me to mix our juices in one last mor-
bid emulsion. I grabbed a small plastic container from the
nearest shelf and collected the miraculous sperm, hypno-
tised by the thought of the dark immensity from which
it had erupted, as quickly as liquid soap from a dispenser.

8

Back at home I stared until dawn at the plastic cup laying
on the table in front of me. The first rays of sunlight hit the
recipient and turned its colour fluorescent grey. A strange
development which compelled me to welcome the occult
into the room, inviting me to do what it said. Silently, I

parted my legs and introduced a few drops inside of me. I could hear the chants of priests and gurus rejuvenating ancestral melodies and it felt like falling into a cosmic bath of obscenity. I was renouncing to the familiar world, in complicity with witches and poets, I was initiating a new kind of post-mortem erotic transmission. When it was all over, I froze the rest of the sperm in my freezer.

9

As I walked down the aisle to the open casket of my dead husband on the day of his funeral, I rested my hand on my belly and smiled. I was ready to let him go. I knew I could never force him back into life but I found consolation in knowing that a part of him was now inside me. At last I was able detach him from the dark limbo where my imagination had imprisoned him, drifting above the ruins of humanity in a kind of eternal state. My only hope: that his memory came back to him. But there was no way for me to settle that.

10

The entire church was packed with women. My husband always thrived around female attention. Not that he was abusing of their kindness, he was never man enough for such impoliteness, but women always felt safe in his company and kept coming back. It has been said, considering I was his wife, that such a turnout should have drawn me toward horrible pain. But I must kill this theory in its infancy because such a pain didn't exist for me. Those allusions belong to a sick society whose only chance for survival is the perpetuation of its own sickness.

11

When I looked around the church and noticed hundreds of these women sitting uncomfortably in narrow pews, I realised (I was now certain of it) that their soft presence was bringing me closer to him. The smell of their perfume was the incarnation of his soft dissolute lifestyle in which women had always been the most respectable company. I couldn't help but think how he would have rejoiced in such a display of femininity, all the women he

enjoyed in his life attending the last celebration of his life, their intrusion into the church conjuring up his spirit as clear as holy water.

12

Besides, it would have been incredibly dishonest and utterly hypocritical of me to feel any sort of resentment. Someday I will tell why – I will have to credit certain vital revelations in order to clarify this feeling – but now is not a time for me to indulge such personal stories. Let's just say that to the present day my entire love life has been based on the fulfilment of primitive justice, in short, of organised freedom between my desires and my husband's desires, pushing against the larval unprogressiveness of modern society.

13

After the ceremony, against all expectations I invited every woman present in the church to join me in my house. Anyone who dares see in this invitation an insult to the conformity of marriage is only at the mercy of their own corrupted mind – a mind that is erotomaniac and yet cultivates year in, year out the ignoble sexuality of scoundrels, never reaching satisfaction, disdaining the expression of those it wants to break. What I did is simply called providing sisters with a shelter on a funeral day. I fed them, I spoke to them, I sat them in my husband's favourite chair, until our collective conscience rose as one and formed with our laughter a protective dome against the tentacular oppression of the world.

14

A woman with purplish lips who stood by the chimney with a drink in both hands as if afraid to be alone was arguing that the root of her grief originated from the fact that she could no longer touch him. "Because reality is far superior to memory and stories we tell ourselves", she said. I thought she was damned right. The light in the room was low, brooding, and I switched on a lamp while listening to her lament. Surging a few seconds after the flash my eyes saw a black watercolour stain inside the

bright lightbulb and it seemed a splendid augury of the emptiness where my husband was now resting. Such a blind spot was the incarnation of the widening schism between us, and why we could no longer touch him.

15

More women kept invoking their trauma, naming objects, people or places I had never heard before. I couldn't help but want to be their ally, to find the secret door to the departed beyond. I had never carried the faith that belongs to those who have given themselves to god, but I always carried the faith of those who have given themselves to man, for it is man and man alone who is left at the end of the day with the difficult task of amending his ways and be forgiven. I thought of the immensity of the hole where we had left him that day, I pictured his tombstone standing in the dwindling light of the evening and I searched with my mind the dark solitude of the earth for a way to bridge our two worlds back together.

16

That's when I remembered the frozen sperm. Certain of the genius of my sudden thinking, I ran out to fetch the pot and gathered all the women in one place to let them marvel at its magnificent content. Feeling exhilarated, the entire room was prepared to materialise the myth of our dead husband. Candles were lit, incense was burnt, curtains were shut, armchairs were moved to allow sitting on the floor. I drew a circle of moderate dimension with a paste of white flour and turned vinegar. The plastic pot was placed at its centre. The reflection of the candlelight against the white matter brought back its previous glory as it started to melt. It was as if, by a spell of heat and erotic smell, we were liberating a thought that had been frustrated for centuries.

17

It is during an act of orgy, or religious mass, that humanity meets its true ego. The soul is introduced into the body and during this moment of absolution and possession we are able to discover what we are and who we are.

That moment of exposure, when a new consciousness replaces the old, is of extreme tension and can be risky if not conducted with care. One has to commit to the occult alchemistic operations that take one back to nature and closer to oneself.

18

Soon, like pure heroines of the earth finding freedom in this pagan ceremony, every woman in the room gathered in groups of three and stripped down to claim their grief in a symphony of cries and moaning. Their body contortions were the physical blossoming of women who understand that their intelligence can no longer rule over their body, but their body has to rule over their intelligence. Truly demonic, united inside their trinitarian factions, they lured the world into their wombs. Together, they were the apocalypse.

19

But how senseless to try and describe such a tableau. No description can articulate the beauty of these women, their simple alignment with the natural order of life and death, the perfect composition of their limbs and the insurrection of their sex as they rose to their toes, allowing me to introduce drops of male liquid into them. The temerity of their abandon was so great that it annihilated any kind of judgment. Who could attack such disarming vulnerability, and above all, who could understand it? Like any act of creation it possessed a part of mystery. For what is creation but the stubborn and naive attempt to walk through a solid wall with the firm belief that passage will somehow be made possible?

20

Nine months later, ten children were forced into existence. From my husband's dead balls to the primitive guts of these women, I had created a new bloodline. I was the proud midwife of ten sexless children, society only had to reckon with their ghostly conceptions – Nature too would have to eventually take this into account. I still bless the day I found my husband's apples saturated with the cold

juice of life, down in the fridges of hell. I extracted his nectar just in time, the re-collection of Nature's dues, like a flower's scent is extracted to make perfume. It seems so easy written like that. Well, why don't you go ahead and try it? And tell me whether or not you would do it differently under the same circumstances.

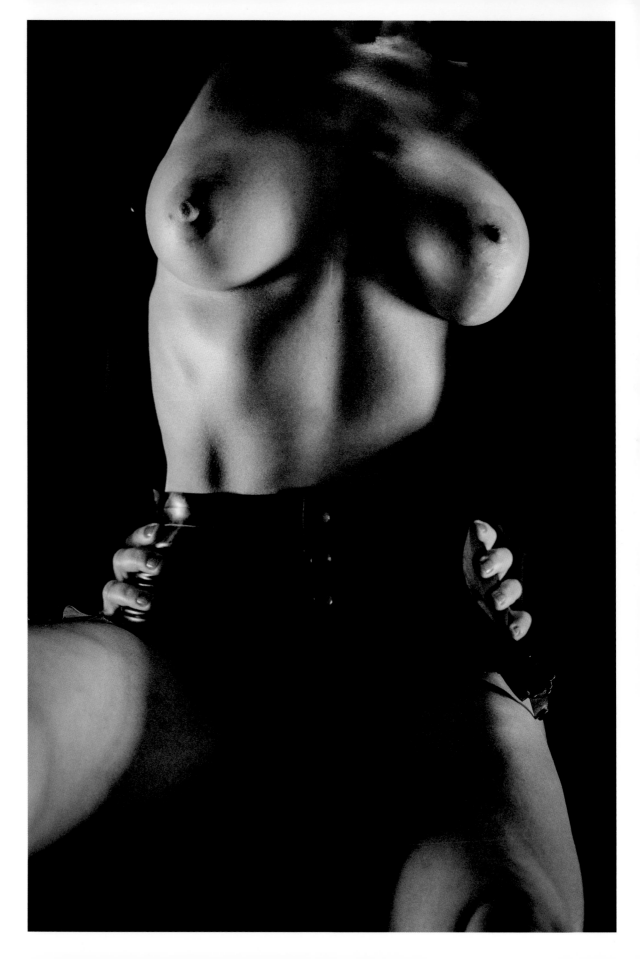

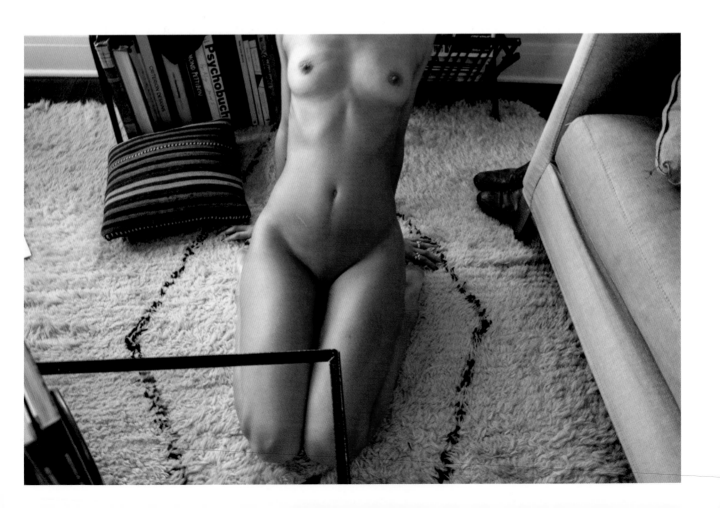

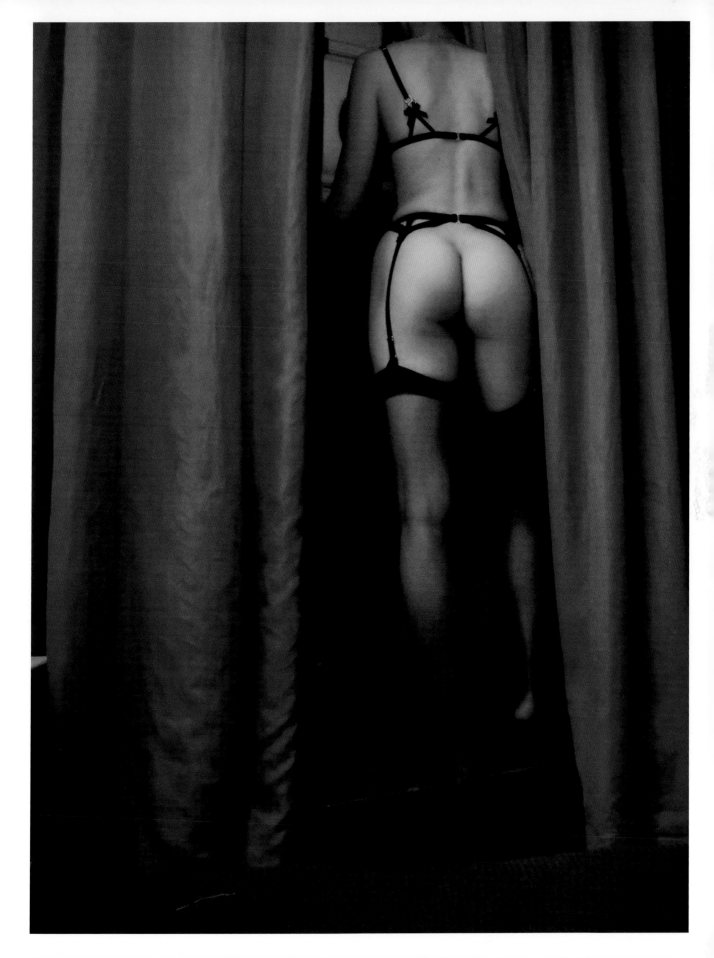

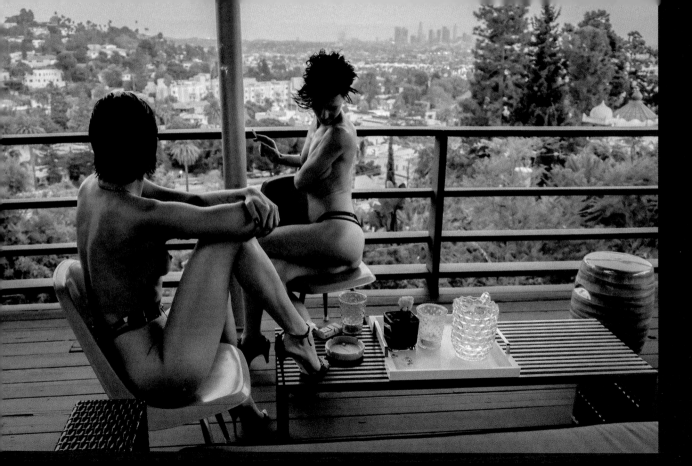

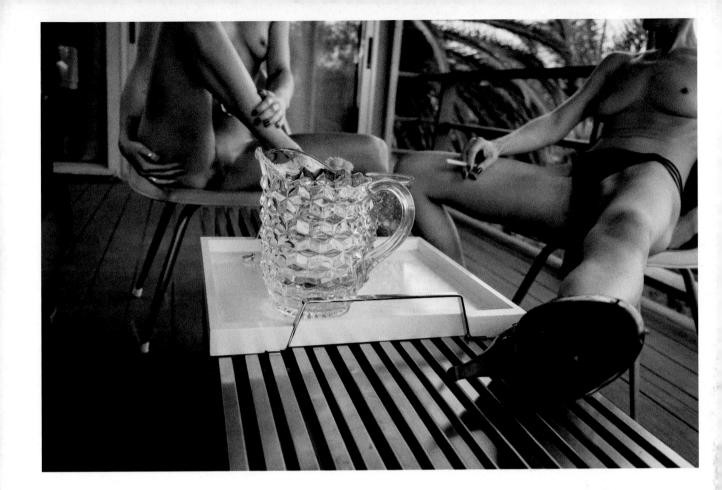

263

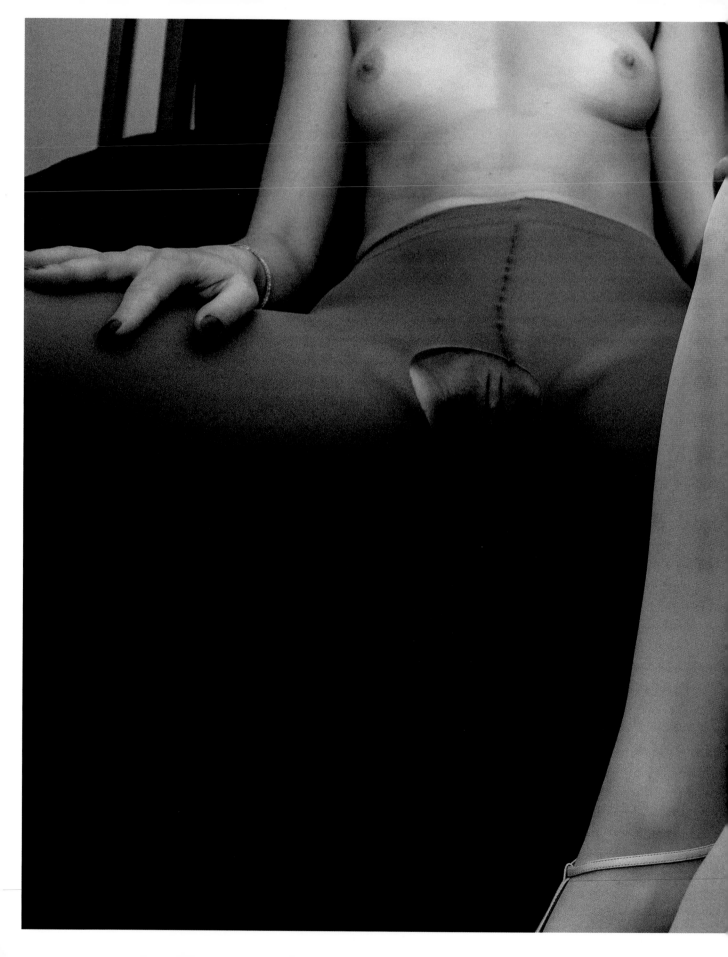

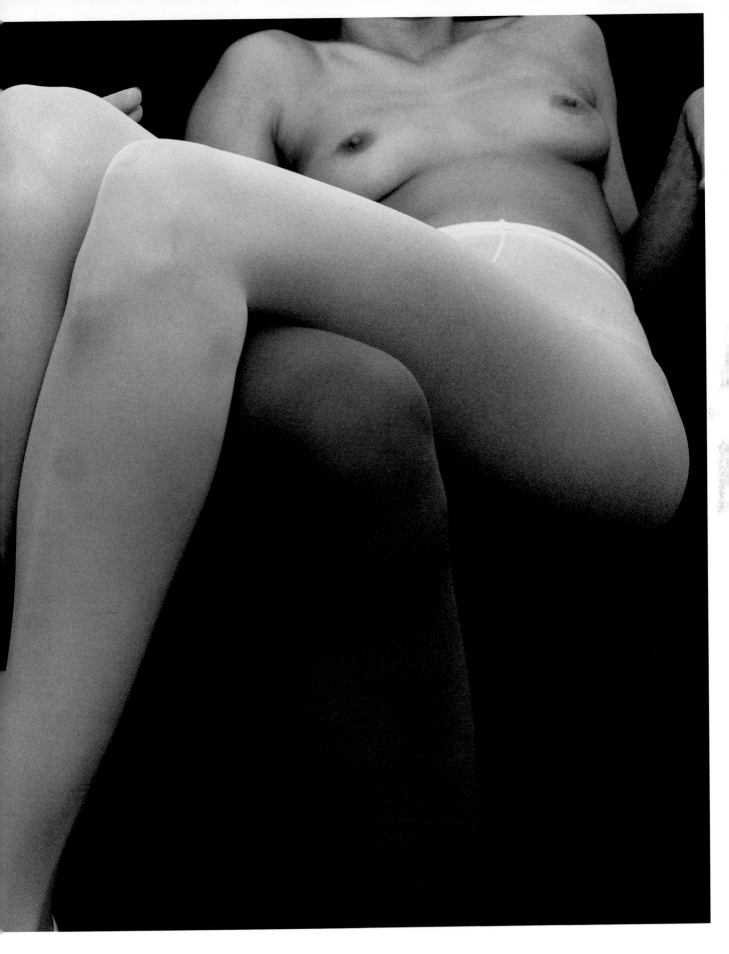

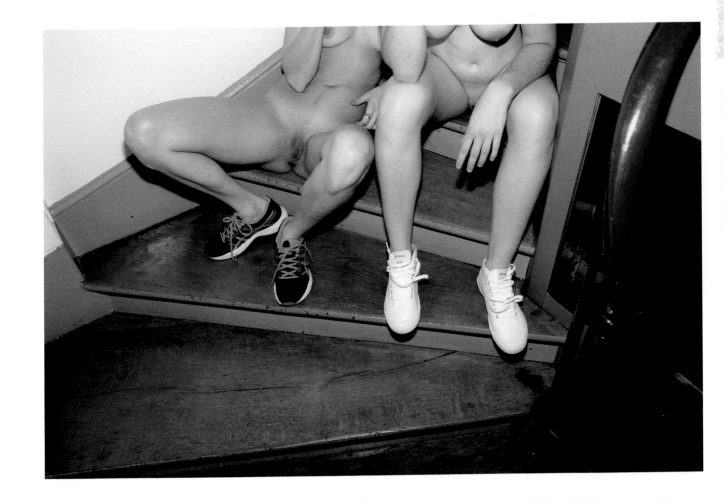

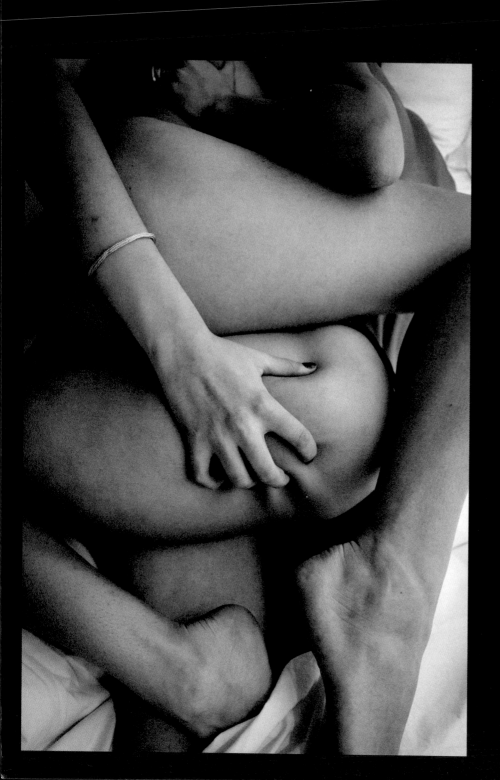

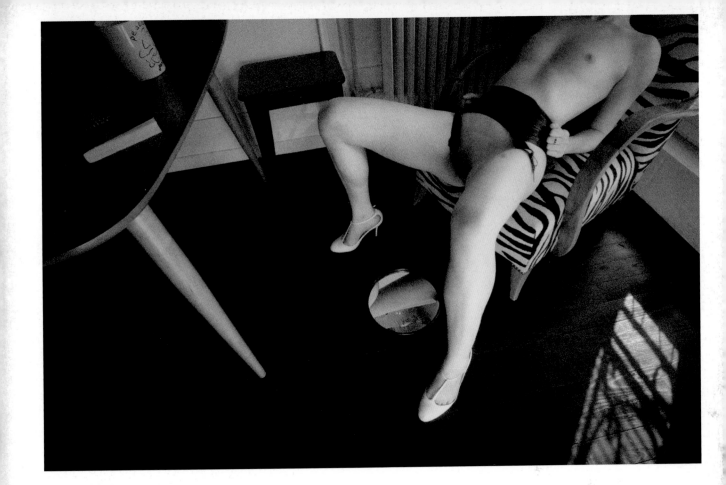

269

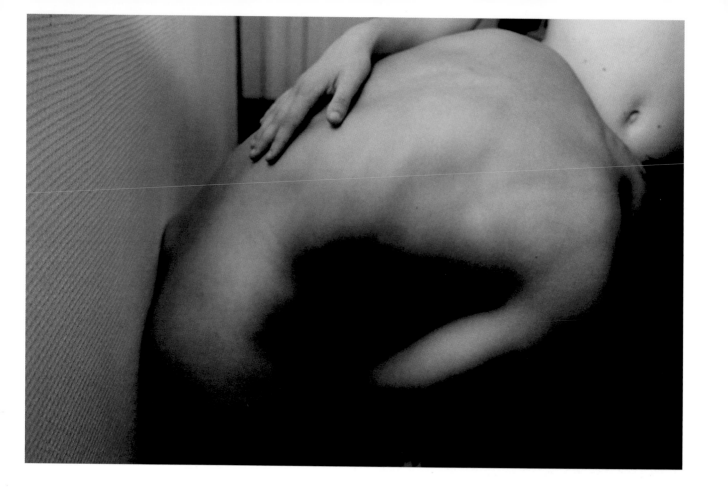

270

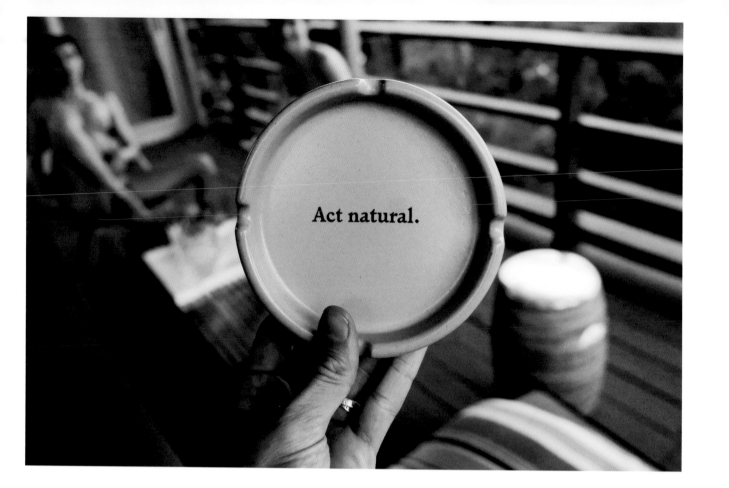

272

C.A.L.M.
Crimes Against Love Manifesto

because a life lived in fear is equal to no life at all
we won't gamble our existence on the fickle world of 'what will they think'
and wake up one day thinking we have wasted the wonderful fact of our own existence
we won't worry about fear, jealousy, solitude
the system that weighs duty against desire and pronounces desire the loser
they're all by-products of love
unavoidable obstacles implanted in our core
by generations of parents, grandparents and all the people
who fall in love and yet are unhappy
and who blaming themselves for having lived too timidly
will attack us for having dared
we live on the other side of their wall
we break through their rules of loving
searching for our own alternative ways
no matter the morals agreed collectively
the prudishness and punishments
the accepted forms of loving, family, monogamy
and far too much imprisonment
in secret, in the safety of our apartments, inside our heads
we will create a space where they don't belong
a place where we are free
our neighbours won't know about it
our families won't know about it
and those who think they can be part of it
but haven't made the sacrifice
are not welcome
there, we will practise our secret rituals
with those who have defeated their fears
days and nights, out of sight and silently

First published in Great Britain in 2020 by White Rabbit,
an imprint of The Orion Publishing Group Ltd
Carmelite House, 50 Victoria Embankment
London EC4Y 0DZ

An Hachette UK Company

10 9 8 7 6 5 4 3 2 1

A CIP catalogue record for this book is available from the
British Library.

ISBN 978 1 4746 1602 7

Design & Typography: Brian Roettinger (WP&A)
Printed in Italy by L.E.G.O. S.p.A.

www.whiterabbitbooks.co.uk
www.orionbooks.co.uk

WHITE
RABBIT